ND497

THE PAINTINGS OF
WILLIAM BLAKE

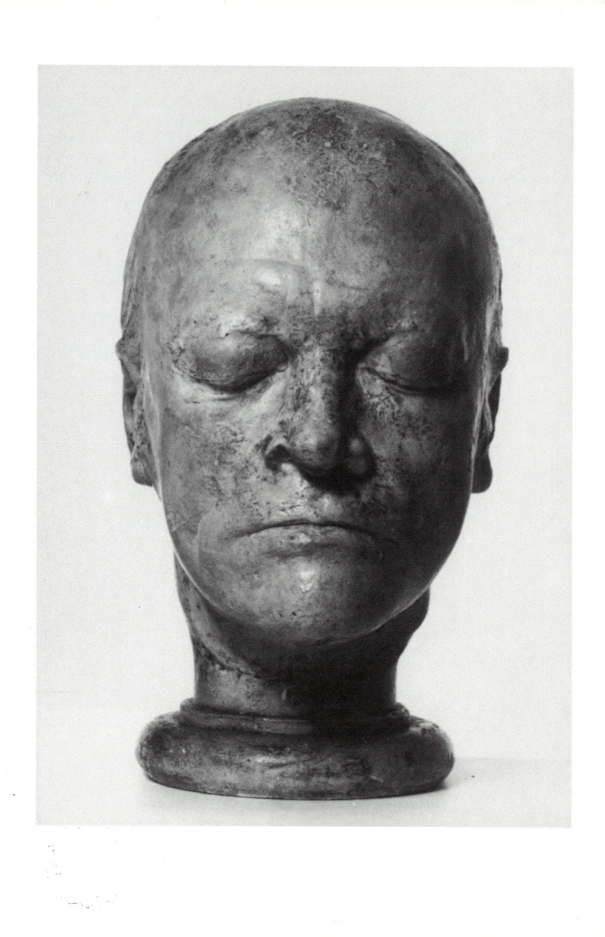

THE PAINTINGS OF WILLIAM BLAKE

Raymond Lister

The right of the
University of Cambridge
to print and sell
all manner of books
was granted by
Henry VIII in 1534.
The University has printed
and published continuously
since 1584.

Cambridge University Press
Cambridge
London New York New Rochelle
Melbourne Sydney

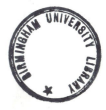

Publisher's Note

The idea for this book originated in discussions with the Pevensey Press, Cambridge. The Pevensey Press has been responsible for the commissioning and editing of the text and for the entire production process.

1561676

Published by the Press Syndicate of the University of Cambridge
The Pitt Building, Trumpington Street, Cambridge CB2 1RP
32 East 57th Street, New York, NY 10022, USA
10 Stamford Road, Oakleigh, Melbourne 3166, Australia

© Raymond Lister and the Pevensey Press 1986

First published 1986

Edited by Ruth Smith
Produced by The Pevensey Press, Cambridge

Design and production in association with Book Production Consultants, Cambridge

Typesetting by Westholme Graphics, Gamlingay, Bedfordshire
Printed in Hong Kong

Library of Congress Cataloging-in-Publication Data

Lister, Raymond.
The paintings of William Blake.
Bibliography: p.
1. Blake, William, 1757–1827. I. Title.
N6797.B57L58 1986 759.2 86–6799

British Library Cataloguing in Publication Data

Lister, Raymond
The paintings of William Blake.
1. Blake, William, *1757–1827*
I. Title
759.2 ND497.B6

ISBN 0 521 30538 1 hard covers
ISBN 0 521 31557 3 paperback

Frontispiece Plaster life-mask of Blake made in 1823 by James S. Deville of London
(Syndics of the Fitzwilliam Museum, Cambridge)

Contents

Note on the text
The letter K after a quotation indicates that the source is Sir Geoffrey Keynes's
edition of Blake's writings (see p. 176).
The number refers to the page in that edition.

Introduction

William Blake, one of England's greatest artists and poets, was born in London on 28 November 1757, the third son of James Blake, a hosier of 28 Broad Street, Golden Square. Little is known of his forbears. His two elder brothers were James, who succeeded his father in business, and John, an unsatisfactory character, who later enlisted in the Army. There was also a sister, Catherine, and a younger brother, Robert, with whom William had strong affinities.

William's childhood was happy and his parents were unusually understanding, so much so that he was never sent to school where, given his original and unusually imaginative character (as a young child he once claimed to have seen a tree filled with angels), he would probably have been miserable. Later in life he wrote:

> Thank God, I never was sent to school
> To be Flog'd into following the Style of a Fool. (K.550)

What education he had was probably provided by his mother. He was highly intelligent and always had a most receptive mind; later in life he acquired a knowledge of Hebrew, Greek and Italian. Most of all he showed an unmistakable talent for drawing, and when he was ten years old he became a pupil at the highly regarded drawing academy of Henry Pars in the Strand. He practised at home, drawing plaster casts of antique sculpture bought by his father. With his pocket money he bought many prints after works by the great masters at the auction rooms of Abraham Langford and James Christie; he was a favourite of Langford, who called him his 'little connoisseur', and knocked down cheap lots to him.

William made good progress and his parents thought of apprenticing him to a well-known artist, but in the end concluded that this would be too costly and decided instead to bind him to an engraver at a much lower premium. The first engraver they approached was William Wynne Ryland, but William took an instant dislike to him, saying that he looked as if he would live to be hanged. This turned out to be an accurate prophecy, for twelve years afterwards Ryland was executed for forgery. The engraver finally chosen was James Basire of Great Queen Street, Lincoln's Inn Fields, a member of a family of distinguished craftsmen. The seven-year apprenticeship began on 4 August 1772, the premium being 50 guineas (£52.50).

After about two years Basire engaged other apprentices, and trouble soon arose between them and Blake. So, to preserve the tranquillity of his workshop, Basire sent Blake to Westminster Abbey to draw Gothic monuments for illustrations he had in hand for publications by Sir John Ayloffe and Richard Gough (see plate 1), some of which Blake also engraved. This work in the Abbey ignited a lifelong enthusiasm for Gothic art. Years later, in about 1810, Blake inscribed an engraving which he called *Joseph of Arimathea among the Rocks of Albion* (but which he had really based on a figure by Michelangelo) with the

8

words: 'This is One of the Gothic Artists who Built the Cathedrals in what we call the Dark Ages, Wandering about in sheep skins & goat skins, of whom the World was not worthy; such were the Christians in all Ages.' (K.604) His taste was formed at this early age. For the rest of his life he preferred imaginative composition to life drawing, and Gothic outlines to accurate copies of nature.

Blake's apprenticeship was completed when he was nearly twenty-two; he had learned his trade well and with this grounding he was to become a most accomplished and versatile journeyman engraver. His training and practice as an engraver much influenced his work as a painter – the incisive and vigorous lines of his designs, his bold outlines and the energetic and powerful modelling of his forms may all be traced to his handling of the graver. There is little doubt that if Blake had been apprenticed to a painter instead of to Basire, the technique of his painting would have developed differently.

Soon after the completion of his apprenticeship he became a student at the Royal Academy, where he attended the antique and life classes. He was a decidedly prickly pupil, soon at cross purposes with the Keeper of the Academy, the Swiss artist George Michael Moser. Later he described how

> I was once looking over the Prints from Rafael & Michael Angelo in the Library of the Royal Academy. Moser came to me & said: 'You should not Study these old Hard, Stiff & Dry, Unfinish'd Works of Art – Stay a little & I will shew you what you should Study.' He then went & took down Le Brun's and Rubens's Galleries. How I did secretly Rage! I also spoke my Mind . . . I said to Moser, 'These things that you call Finish'd are not Even Begun; how can they then be Finish'd? The Man who does not know The Beginning never can know the End of Art.' (K.449)

Apart from Academy studies Blake created many works in various media from about 1779, including possibly one work, of dubious attribution (*Figure from Michelangelo's 'Last Judgment'*, Henry E. Huntington Library and Art Gallery, San Marino, California), in oil, a medium which he detested. The subjects were drawn from biblical, allegorical and other sources, and there is an especially interesting group based on English history. In these early works there are indications of Blake's mystical outlook, but it was during the early 1780s, in such works as *Pestilence* (plate 2). that this began to assume momentous importance.

While he was attending the Academy classes Blake continued to earn his living by engraving illustrations and separate plates, including subjects after Thomas Stothard, Watteau and others. He began to get to know fellow artists; in 1780 he became a friend of Stothard, who in turn introduced him to the sculptor and draughtsman John Flaxman, and early in their association the three young men spent a holiday sketching and sailing on the banks of the Medway. Later their friendship became clouded by misunderstanding, but for the time being it thrived.

Another artist who became a friend of Blake, the Swiss painter Henry Fuseli, from about 1780 lodged for a time near Blake's home in Broad Street. The two men had a considerable influence on one another's work, Fuseli once declaring that Blake was 'damned good to steal from'. Blake's work was also noticed by George Romney, who saw two drawings and a watercolour, *The Death of Earl Goodwin* (now in the British Museum), in the 1780 exhibition of the Royal Academy. This watercolour was mentioned favourably by Blake's lifelong friend, the dilettante George Cumberland, in a review in *The Morning Chronicle and London Advertiser*: 'though there is nothing to be said of the colouring, [there] may be discovered a good design, and much character'.

It was in this year that the No Popery riots, led by Lord George Gordon, flared up in London; Blake got caught up in one of them on 6 June, while he was taking a walk, and was

compelled to join the rioters on their march to Newgate, where the jail was burnt. This experience may have reinforced his natural sympathy with the persecuted and oppressed.

At about this time or soon after, Blake fell in love with a pretty, flirtatious girl named Polly Wood. He discovered that she was admitting the attentions of another admirer and remonstrated with her, only to be asked 'Are you a fool?' 'That cured me of jealousy', he said later, when telling the story. He was soon to find real happiness in a true soulmate whom he met when visiting a house in Battersea. This was Catherine Boucher or Butcher, a daughter of a market gardener. She later said that when William walked through the door she nearly fainted, realising that the man of her heart had arrived. Blake told the dark-eyed girl he had been jilted and she said she pitied him from her heart. 'Do you pity me?' he asked. 'Yes, I do,' she replied, 'most sincerely.' 'Then I love you for that', he said.

They were married in St Mary's Church, Battersea, on 18 August 1782. Catherine was at this time illiterate and signed the register with a cross; early in their marriage William taught her to read and write. It was a happy union and although they had no children, the Blakes were so perfectly attuned that it seems not to have mattered, and the couple came through times both of prosperity and of adversity with their love unimpaired. Not only did Blake teach Catherine to read and write, he also taught her to prepare his colours, to take impressions of his engravings, to colour them and to draw, so she became a helpmate as well as a wife.

A year or so after they were married, Catherine drew a portrait in profile of William (now in the Fitzwilliam Museum, Cambridge); it shows a strong face and a head surmounted by flame-like hair. Frederick Tatham, one of a circle of youths who knew Blake in old age, and with whom Mrs Blake lived after being widowed, says of his appearance as a young man, probably from a description given him by Mrs Blake: 'His hair was of a yellow brown, and curled with the utmost crispness and luxuriance; his locks, instead of falling down, stood up like a curling flame, and looked at a distance like radiations, which with his fiery eye and expansive forehead, his dignified and cheerful physiognomy, must have made his appearance truly prepossessing.'

Blake's much-loved brother Robert lived with the couple in their first home, a set of lodgings at 23 Green Street, Leicester Fields (now Leicester Square). One day he quarrelled with Catherine; William joined in and sternly rebuked his wife, saying, 'Kneel down and beg Robert's pardon directly, or you never see my face again!' Catherine meekly obeyed, and said 'Robert, I beg your pardon, I am in the wrong.' But Robert cried, 'Young woman, you lie! *I* am in the wrong.' There is no other recorded instance of dissent in the Blake household involving Robert. William taught Robert to draw and engrave, and although his surviving works are interesting, he did not live long enough to develop his talents. He died in 1787 at the age of twenty-four, after William had watched over him for a fortnight without sleeping. He said he saw his brother's spirit ascending through the ceiling, 'clapping his hands for joy'. A year or two before this, William had opened a print shop next to his father's hosiery shop, in partnership with a former fellow apprentice at Basire's, James Parker. Catherine and Robert assisted him in this venture in various ways, but despite their joint efforts it failed, and the shop closed some time after Robert's death. Afterwards the Blakes moved into lodgings at 28 Poland Street, just around the corner.

Blake never allowed material success or failure (and there was much more of the latter) to interfere with his creative output. He was always hard at work and often remained shut up for weeks while engraving or painting. Mrs Blake once said that she never saw him with his hands idle, unless reading or conversing. After a stint lasting many days he would set out with Catherine on an immensely long walk, sometimes for a distance of forty miles.

At about the time of his marriage, Blake was introduced by John Flaxman to Mrs

Harriet Mathew, wife of the Rev. A. S. Mathew. The Mathews regularly held a salon at their house, 27 Rathbone Place, which was frequented by Mrs Hester Chapone, the essayist; Mrs Anna Laetitia Barbauld, essayist and poet; Mrs Frances Brook, essayist and novelist; Mrs Elizabeth Montagu, essayist and author of *On the Writings and Genius of Shakespear*; and Elizabeth Carter, a friend of Samuel Richardson and Dr Samuel Johnson. Thus Blake came to know a fashionable intellectual coterie, which contributed an insight into current ideas and topical opinions.

A year or so before becoming an apprentice he was already composing serious poetry. His first book, *Poetical Sketches* (1783), was made possible by Mathew and Flaxman, who paid for it to be printed. But it appeared with a patronising preface which cannot have pleased the poet. In fact he was unhappy among this circle, and in his satirical *An Island in the Moon* (*circa* 1787) he poked fun at the Mathew coterie and other contemporaries, sometimes presenting them under names that were thin disguises, such as Mrs Nannicantipot (Mrs Barbauld), Inflammable Gass (Joseph Priestley) and Jack Tearguts (Dr John Hunter, the surgeon). In the present context, the most intriguing aspect of *An Island in the Moon* is its reference to Blake's method of producing his illuminated books: '"Then", said he, "I would have all the writing Engraved instead of Printed, & at every other leaf a high finish'd print – all in three Volumes folio – & sell them a hundred pounds apiece. They would print off two thousand."' (K.62)

Blake's illuminated books, which combine engraving with painting, are, in technique, among his most original contributions to the visual arts. Books similarly combining engraving and painting, especially Books of Hours, were produced in the fifteenth and sixteenth centuries in France and elsewhere by such printers as Germain and Gilles Hardouin and Philippe Pigouchet, and decorated by illuminators. Engraved devotional books were printed throughout the seventeenth and eighteenth centuries, and to some extent during the nineteenth century. Where Blake's books differed from these was that everything – engraving, printing and painting – was all his own work (sometimes, it is true, assisted by his wife); moreover, he used an original engraving technique – relief etching, which he claimed had been revealed to him in a vision by his dead brother Robert.

There are various opinions about the way Blake etched the plates; the controversy is not helped by the fact that except for one small corner fragment, all the original plates have disappeared. Some believe that he painted the design in reverse on to the copperplate in acid-resisting ink and then bit away the exposed surface in an acid bath, leaving the design in relief; others, that it was drawn on paper in acid-resisting ink and then transferred to the plate with a heated iron, like an embroidery pattern. Either way the method suited Blake's purpose very well, enabling him to use his skill as an engraver to multiply copies of his designs, yet making each an individual work by variations in hand colouring. He used it for many of his most profound designs, such as the frontispiece to *America*, and *The Ancient of Days* (plates 9 and 75).

He also used, sometimes together with relief etching, a method he described as 'wood-cutting on pewter', in which he adapted the technique of wood-engraving to a metal surface. But there is controversy here too, for some experts contend that even where the plates in the illuminated books look as if they have been engraved in this way, they have actually been painted on the copper plate and then etched.

In the 1780s, after breaking with the Mathew set, Blake became associated with a group of people with revolutionary views. He was introduced to them by the radical bookseller and publisher Joseph Johnson, who for many years commissioned commercial engravings from Blake. Johnson once served a prison sentence for circulating seditious literature, but he also published work by well-known authors such as William Cowper, John Caspar

Lavater, Horne Tooke, Erasmus Darwin, Joseph Priestley, Mary Wollstonecraft and Maria Edgeworth. Many of their works were illustrated by engravings made by Blake after designs by other artists.

Thomas Paine was one of the revolutionaries Blake came to know through Johnson. The second part of *The Rights of Man* was considered seditious by the establishment, whose apprehension was not allayed by the fact that Paine had been elected a citizen of revolutionary France. It is said that the day after he had made an inflammatory speech, Paine met Blake at Johnson's. Convinced that if the authorities could find Paine they would arrest him, Blake seized his shoulders as he was leaving and said, 'You must not go home, or you are a dead man!' Paine caught the urgency of Blake's advice and instead of going home, embarked for France. He never returned to England. Blake himself for a time supported the French Revolution (as he had the American Revolution), and walked about London wearing the revolutionary badges, the *bonnet rouge* and the white cockade. In 1791 he wrote *The French Revolution*, a poem which Johnson had intended to publish, but only one of the seven envisaged parts was printed, and even this Johnson did not take beyond the proof stage – no doubt fearing the consequences. With the onset of the Reign of Terror, Blake became disillusioned with political revolution as a solution to society's problems.

The association with Paine brings into focus yet another aspect of Blake's outlook: his highly original views of the Bible and of Christianity. Paine was attacked by Richard Watson, Bishop of Llandaff, in his extremely orthodox *Apology for the Bible in a Series of Letters Addressed to Thomas Paine*, and Blake annotated his copy with comments which indicate his own interpretations of the scriptures. On the back of the title page he wrote:

To defend the Bible in this year 1798 would cost a man his life . . .

It is an easy matter for a Bishop to triumph over Paine's attack, but it is not so easy for one who loves the Bible.

The Perversion of Christ's words & acts are attack'd by Paine & also the perversions of the Bible; Who dare defend either the Acts of Christ or The Bible Unperverted?

But to him who sees this moral pilgrimage in the light that I see it, Duty to his country is the first consideration and safety the last . . . (K.383)

In the Bishop's pompous preface, he speaks of his book as a 'Defence of Revealed Religion' against Paine's 'pernicious' attacks on the doctrine of revelation, and says that he hopes it will be 'efficacious in stopping that torrent of infidelity which endangers alike the future happiness of individuals, and the present safety of *all Christian states* . . .' Against this Blake wrote: 'Paine has not attacked Christianity. Watson has defended Antichrist.' And after Watson's phrase, 'The moral precepts of the gospel', Blake wrote, 'The Gospel is Forgiveness of Sins & has No Moral Precepts; these belong to Plato & Seneca & Nero' (K.395), foreshadowing a precept that he later engraved on one of his plates: 'If Morality was Christianity, Socrates was the Saviour.' (K.775) Orthodox believers of the time would have thrown up their hands in horror at Blake's unconventional idea that Christianity could not be equated with respectable bourgeois morality. But few people knew of his attitudes, or had the imagination to perceive them in his writings or in his visual works, both of which in any case had pitifully small circulation.

Blake's standpoint was made on his view that 'The Hebrew Bible & Gospel of Jesus are not Allegory, but Eternal Vision or Imagination of All that Exists.' (K.604) He read widely in books on religion and philosophy. For a time he leaned towards Swedenborgianism, and his annotations in his copy of Swedenborg's *Wisdom of Angels concerning Divine Love and Divine Wisdom* shows some agreement with its views. Later he annotated with less patience the same writer's *The Wisdom of Angels concerning Divine Providence*, and in his own book *The Marriage of Heaven and Hell* he dismissed Swedenborg with the statement 'Now

hear a plain fact: Swedenborg has not written one new truth. Now hear another: he has written all the old falsehoods.' (K.157) He also read and was profoundly influenced by the mystical writings of Jakob Boehme, whereas the rationalist views expressed in John Locke's *Essay concerning Humane Understanding*, so highly regarded at the time, were anathema to him. He believed in the divinity of man and all that it implied, and had little time for the purely intellectual, which he personified in his mythological character Urizen. Intellect, he thought, is acceptable in balance with the other faculties of imagination, feeling and sensation, but when it dominates these it becomes destructive.

In 1789 Blake completed what must now be his most famous work, *Songs of Innocence*, which he printed by relief etching, each page being hand-coloured, sometimes most elaborately. According to Blake's first biographer, Alexander Gilchrist, the books

> were done up in blue-gray paper covers by Mrs Blake's hand, forming an octavo volume; so that the poet and his wife did everything in making the book – writing, designing, printing, engraving – everything except manufacturing the paper: the very ink, or colour rather, they did make. Never before surely was a man so literally the author of his own book.

Songs of Innocence was the forerunner of Blake's most brilliant illuminated books, which include *Visions of the Daughters of Albion* (1793), *The Marriage of Heaven and Hell* (*circa* 1790–3), *America: A Prophecy* (1793), *Europe: A Prophecy* (1794), *Milton: A Poem* (1804–8), and *Jerusalem: The Emanation of the Giant Albion* (1804–20).

In 1790 William and Catherine moved from Poland Street to 13 Hercules Buildings, Lambeth, described by one of his friends as 'a pretty, clean house of eight or ten rooms'. In the small garden behind the house was a vine – Blake refused to prune it, declaring pruning to be unnatural – which shaded an arbour. Legend has it that William's friend Thomas Butts, visiting one day, found him and Catherine sitting there completely naked. 'Come in!' Blake is said to have cried; 'it's only Adam and Eve, you know!' Gilchrist said they had been reciting passages from *Paradise Lost* 'in character, and the garden of Hercules Buildings had to represent the Garden of Eden'. The story is of doubtful authenticity, but it is not altogether out of character.

In Lambeth the Blakes enjoyed more prosperity than at any other period of their lives. Not only did William receive regular commissions for commercial engravings, but he also executed many paintings for Thomas Butts, chief clerk in the office of the Commissary General of Musters. These include a series of small pictures of biblical subjects, for which the fee was one guinea (£1.05) apiece. Butts became a lifelong patron, the most constant and appreciative Blake was to have; as Gilchrist notes, 'For nearly thirty years he continued (with a few interruptions) a steady buyer, at moderate prices, of Blake's drawings, temperas, and colour-printed drawings; the only large buyer the artist ever had. Occasionally he would take of Blake a drawing a week . . . As years rolled by, Mr Butts's house in Fitzroy Square became a perfect Blake Gallery.' Indeed it is mainly to Butts that we are indebted for some of Blake's finest paintings and drawings, now in galleries throughout the world.

The colour-printed drawings mentioned by Gilchrist (they were developed in the 1790s but were still being offered for sale in 1818) were made by drawing the outlines and some details in black on a piece of millboard (or perhaps metal) and transferring them, probably in a press, to paper. The shapes on the millboard were then coloured and while still wet the colouring was in turn transferred to the paper; the impression was finished off by detailed painting. The technique of transferring the design to the paper in a press imparted a rich granulated or mottled effect, reminiscent of aquatint; this feature is characteristic of much of Blake's colour-printing and is present also on some pages in his illuminated books, which were sometimes similarly coloured.

It was impossible to take many impressions of these designs. Blake usually took only three, each successively weaker than its predecessor; for this reason each in turn demanded a greater amount of finishing and retouching. Yet the effect of combining a printed foundation with a hand-painted finish was extremely beautiful, and the twelve subjects of his colour-printed drawings are among Blake's most brilliant works (e.g. *Elohim creating Adam* and *Nebuchadnezzar*, plates 12 and 13). In 1805 Butts paid Blake a guinea (£1.05) apiece for them, as he had paid for the small biblical pictures.

During his Lambeth years Blake created some of his finest illuminated books, including, in addition to those already mentioned, *The Book of Urizen* and *Songs of Experience*. In the poems of these works he expounds much of his thought on politics, on freedom, on the emancipation of women, on slavery, on human experience; and his ideas are further developed in the accompanying designs and decorations. Beliefs were not mere abstractions to Blake – he was always ready to put them into practice if the occasion arose. Swinburne, in *William Blake, A Critical Essay* (1868), recorded one incident in which this happened:

> In smaller personal matters, Blake was as fearless and impulsive as in his conduct of . . . graver affairs. Seeing once, somewhere about St Giles's, a wife knocked about by some husband or other violent person, in the open street, a bystander saw this also – that a small swift figure coming up in full swing of passion fell with such counter violence of reckless and raging rebuke upon the poor ruffian, that he recoiled and collapsed, with ineffectual cudgel; persuaded, as the bystander was told on calling afterwards, that the very devil himself had flown upon him in defence of the woman; such Tartarean overflow of execration and objurgation had issued from the mouth of her champion. It was the fluent tongue of Blake which had proved too strong for this fellow's arm: the artist, doubtless, not caring for the consequences . . . of such interference with conjugal casualties.

Another incident is also worth recalling; it was told by Blake's young friend Frederick Tatham:

> Blake was standing at one of his Windows, which looked into Astleys premises (the Man who established the Theatre still called by his name) & saw a Boy hobbling along with a log to his foot such an one as is put on a Horse or Ass to prevent their straying. Blake called his Wife & asked her for what reason that log could be placed upon the boys foot: she answered that it must be for a punishment, for some inadvertency. Blakes blood boiled & his indignation surpassed his forbearance, he sallied forth, & demanded in no very quiescent terms that the Boy should be loosed & that no Englishman should be subjected to those miseries, which he thought were inexcusable even towards a Slave. After having succeeded in obtaining the Boys release in some way or other he returned home. Astley by this time having heard of Blakes interference, came to his House & demanded in an equally peremptory manner, by what authority he dare come athwart his method of jurisdiction; to which Blake replied with such warmth, that blows were very nearly the consequence. The debate lasted long, but like all wise men whose anger is unavoidably raised, they ended in mutual forgiveness & mutual respect. Astley saw that his punishment was too degrading & admired Blake for his humane sensibility & Blake desisted from wrath when Astley was pacified.

At Lambeth in 1796 Blake began work on one of his most important series of large-scale watercolours: a collection of designs for Edward Young's *Night Thoughts*, to be engraved for an edition issued in parts by the London bookseller Richard Edwards. The project failed and only the first part was published: forty-three out of a total of over five hundred designs. Their quality varies considerably, which is not surprising considering the quantity, but the best of them are splendid conceptions (plates 16 and 17).

Many of Blake's contemporaries completely failed to understand, let alone appreciate, these designs. The portrait painter John Hoppner, for example, considered them 'the

conceits of a drunken fellow or madman'. More generally, too, Blake was dogged by misunderstanding, and a reputation for eccentricity began to attach itself to him and began adversely to affect his clientele. For example, he had a difference with the Rev. John Trusler, author of *The Way to be Rich and Respectable*, over a design in watercolour (now in the Philadelphia Museum) executed for him on the recommendation of their mutual friend George Cumberland. The subject was 'Malevolence', part of a proposed series illustrating human ideas, and Blake described it in a letter to Trusler on 16 August 1799:

> A Father, taking leave of his Wife & Child, Is watch'd by Two Fiends incarnate, with intention that when his back is turned they will murder the mother & her infant. If this is not Malevolence with a vengeance, I have never seen it on Earth; & if you approve of this, I have no doubt of giving you Benevolence with Equal Vigor, as also Pride & Humility, but cannot previously describe in words what I mean to Design, for fear I should Evaporate the Spirit of my Invention. But I hope that none of my Designs will be destitute of Infinite Particulars which will present themselves to the Contemplator. And tho' I call them Mine, I know that they are not Mine, being of the same opinion with Milton when he says That the Muse visits his Slumbers & awakes & governs his Song when Morn purples the East, & being also in the predicament of that prophet who says: I cannot go beyond the command of the Lord, to speak good or bad. (K.792)

Trusler's objections no longer exist, but they excited a very forthright reply from Blake:

> I really am sorry that you are fall'n out with the Spiritual World, Especially if I should have to answer for it. I feel very sorry that your Ideas & Mine on Moral Painting differ so much as to have made you angry with my method of Study . . . You say that I want somebody to Elucidate my Ideas. But you ought to know that What is Grand is necessarily obscure to Weak men. That which can be made Explicit to the Idiot is not worth my care . . . I feel that a Man may be happy in This World. And I know that This World Is a World of imagination & Vision. I see Every thing I paint In This World, but Every body does not see alike. To the Eyes of a Miser a Guinea is more beautiful than the Sun, & a bag worn with the use of Money has more beautiful proportions than a Vine filled with Grapes. The tree which moves some to tears of joy is in the Eyes of others only a Green thing that stands in the way . . . To Me This World is all One continued Vision of Fancy or Imagination, & I feel Flatter'd when I am told so. What is it sets Homer, Virgil & Milton in so high a rank of Art? Why is the Bible more Entertaining & Instructive than any other book? Is it not because they are addressed to the Imagination, which is Spiritual Sensation, & but mediately to the Understanding or Reason? Such is True Painting, and such was alone valued by the Greeks & the best modern Artists. (K.793–4)

It is not surprising that most of his contemporaries in the 'Age of Reason' looked askance at Blake and even thought him mad, though in fact a saner man never existed. His young friend Samuel Palmer, many years after his death, described him as 'a man without a mask', and that view of Blake is nowhere more clearly demonstrated than in this second letter to Trusler. He lays bare his beliefs like an exposed nerve and, come what may, bravely declares for what he later described as 'Eternal Realities as they Exist in the Human Imagination'. (K.613)

From about this time, and after the failure of the *Night Thoughts* project, Blake fell more and more into neglect and poverty. Publishers seldom commissioned engravings from him, and friends deserted him. The brief period of prosperity at Lambeth was to be his only one. Meanwhile he had been overworking, so much that his health had begun to weaken; in a notebook he wrote, 'I say I shan't live five years. And if I live one it will be a Wonder.' (K.187) But the steadfast Butts, besides buying his works, engaged him to give drawing and engraving lessons to his son Tommy at £26 a year, and he and his wife remained firm friends of the Blakes, often entertaining them at their home.

At Lambeth Blake also created the large book of watercolours illustrating the poems of Thomas Gray, probably completed in 1798 (plates 18 and 19). One of the best groups in this series is the sequence illustrating the *Elegy in a Country Churchyard* – clearly the strongly bucolic and symbolic qualities of the poem appealed to Blake. The designs were commissioned by Flaxman as a present for his wife, to whom the artist wrote a dedicatory poem. Perhaps the nature of the commission inspired the charming lightness of touch and sense of humour of many of the illustrations, for example the characterisation of Selina, the elegantly dressed tabby cat 'drowned in a tub of gold fishes'.

Flaxman introduced Blake to William Hayley, at that time a fashionable poet and biographer, whose work has now fallen into disrepute. It was never very good, as Byron mentioned in *English Bards and Scotch Reviewers*:

> Behold! – ye tarts! one moment spare the text –
> Hayley's last work, and worst – until his next.

But Hayley was a well-intentioned man; it was for instance due to his efforts that his friend William Cowper obtained a pension of £300, and he tried, in his way, to help Blake. The effects of his kindnesses were, however, often diminished by an unfortunate tendency to tinker with the work of those he tried to help, and by a busy preoccupation with directing it into unsuitable forms. With a man of Blake's character, this inevitably led to trouble, though at first all seemed to go well.

Hayley had no legitimate issue, and was deeply attached to his natural son Thomas Alphonso, whom he called a 'dear diminutive Phidias' and apprenticed as a sculptor to Flaxman. The boy developed a spinal curvature while he was in London, and was forced to return to his father's home at Eartham in Sussex where, after two years of illness, he died, aged twenty. During this time Hayley was completing a book, *An Essay on Sculpture*; illustrations were required and at Flaxman's suggestion he commissioned Blake to engrave three of them: a portrait of Pericles, *The Death of Demosthenes*, and a portrait of Thomas Alphonso after a medallion by Flaxman. Hayley had first become aware of Blake in 1784, when Flaxman presented him with a copy of *Poetical Sketches*; and the sculptor introduced the two men during the time of Thomas Alphonso's apprenticeship. A letter to Blake of 17 April 1800 about the boy's portrait shows Hayley beginning to interfere:

> But to speak of still further alterations in yr first plate – would it not give a little younger appearance to shorten the space between the nose & the upper lip a little more by representing the mouth rather more open in the act of speaking which appears to me the Expression of the medallion? I submit the point to you & our dear Flaxman with *proper deference* to yr *superior judgment*; as I do the following Question whether making the Dot at the corner of the mouth a little deeper, & adding a darker Touch also at the Bottom of the Eye would add a little gay juvenility to the Features without producing (what I by all means wish to avoid) a *Grin* or a *Smirk* . . . [Flaxman] will, I know, kindly assist you in yr endeavours to catch the exact cast of character, that I wish you to seize – I have to thank Heaven (as I do with my whole Heart) for having been able to *gratify this dear departing angel* with a sight of his *own Portrait united* to the *completion* of a *long & severely interrupted work* . . .

Thomas Alphonso died on 2 May, days after that was written, and Blake at once sent a characteristic letter of consolation:

> I know that our deceased friends are more really with us than when they were apparent to our mortal part. Thirteen years ago I lost a brother [Robert] & with his spirit I converse daily & hourly in the Spirit & See him in my remembrance in the regions of my Imagination. I hear his advice & even now write from his Dictate. Forgive me for Expressing to you my Enthusiasm which I wish all to partake of Since it is to me a Source of Immortal Joy: even in this world by it I am the companion of Angels. (K.797)

In July 1800 Blake visited Hayley for the first time, in order to consult him about perfecting his engraving of Thomas Alphonso's portrait medallion. By this time Hayley, who had been living beyond his means, had moved from his house at Eartham to a smaller residence, a picturesque marine villa, The Turret, at the nearby coastal village of Felpham.

Hayley found further work for Blake, including engravings for his *Life of Cowper*, and as he had other work in mind for him, suggested that he move to Felpham. Blake responded with enthusiasm, and having secured a thatched cottage in the village at an annual rent of £20, he moved there with Catherine and his sister in September. The joy with which he anticipated a happy and creative life in Sussex is conveyed by some verses he sent in a letter to Mrs Flaxman:

> The Song to the flower of Flaxman's joy,
> To the blossom of hope, for a sweet decoy:
> Do all that you can or all that you may,
> To entice him to Felpham and far away:
>
> Away to Sweet Felpham, for Heaven is there;
> The Ladder of Angels descends thro' the air;
> On the Turret its spiral does softly descend,
> Thro' the village then winds, at My Cot it does end.
>
> You stand in the village & look up to heaven;
> The precious stones glitter in flights seventy seven;
> And My Brother is there, & My Friend & Thine
> Descend & Ascend with the Bread & the Wine.
>
> The Bread of sweet Thought & the Wine of Delight
> Feeds the Village of Felpham by day & by night;
> And at his own door the bless'd Hermit does stand,
> Dispensing Unceasing to all the whole land. (K.800)

'The Hermit' was Hayley, who liked so to style himself. Two days after arriving at Felpham, Blake wrote with fervour to Thomas Butts about his first impressions:

We are safe arrived at our Cottage without accident or hindrance . . . All upon the road was chearfulness & welcome; tho' our luggage was very heavy there was no grumbling at all. We travel'd thro' a most beautiful country on a most glorious day. Our Cottage is more beautiful than I thought it, & also more convenient, for tho' small it is well proportion'd, & if I should ever build a Palace it would be only My Cottage Enlarged . . . Mr Hayley receiv'd me with his usual brotherly affection. My Wife & Sister are both very well, & courting Neptune for an Embrace, whose terrors this morning made them afraid, but whose mildness is often Equal to his terrors. The Villagers of Felpham are not meer Rustics; they are polite & modest. Meat is cheaper than in London, but the sweet air & the voices of winds, trees & birds, & the odours of the happy ground, make it a dwelling for immortals. Work will go on here with God speed. – A roller & two harrows lie before my window. I met a plow on my first going out at my gate the first morning after my arrival, & the Plowboy said to the Plowman, 'Father, The Gate is Open.' – I have begun to Work, & find that I can work with greater pleasure than ever. Hope soon to give you a proof that Felpham is propitious to the Arts. (K.803)

Among his first creations for Hayley was a series of eighteen heads of poets in tempera to embellish the frieze of the library at The Turret. The subjects include Shakespeare, Milton (plate 26), Spenser, Pope, Dante and, presumably on Hayley's insistence, Thomas Alphonso, whose likeness was encircled with doves; the whole scheme may have been intended as a memorial to the dead boy.

Hayley also persuaded Blake to paint portrait miniatures, an unlikely outlet for his

mettlesome muse. Yet although they have a somewhat hard quality, far removed from the vivacious work of such fashionable practitioners as Cosway and Engleheart, his miniatures have an individual character, and could hardly have been painted by any other artist (plate 27). Hayley also set Blake to work to engrave illustrations, after Blake's own designs, of his *Ballads founded on Anecdotes relating to Animals* (see plate 38), and for his *Triumphs of Temper*, after designs by Maria Flaxman – all of which he seems to have done without complaint. But other work was less congenial, such as giving drawing lessons to the children of Lady Bathurst, and he did refuse a proposed commission from her to paint a set of handscreens. He was expected, too, to act as an amanuensis for his myopic patron, and to carry out such tasks as drawing out a design, concocted by Hayley, for Cowper's tomb: this the Hermit sent to Flaxman, 'neatly copied out by our kind Blake'.

Blake was constantly irritated by the well-meaning but unperceptive and insipid Hayley. He was also convinced (probably unfairly) that Hayley was jealous of his talents. 'The truth is,' he wrote to his brother James, 'As a Poet he is frighten'd at me & as a Painter his views & mine are opposite; he thinks to turn me into a Portrait Painter as he did Poor Romney, but this he nor all the devils in hell will never do.' (K.819) The most valuable work Blake did at Felpham was poetry, notably his long poem *Milton* (1804–8), which he subsequently realised in relief etching and illuminated. It relates how the spirit of the poet John Milton possesses Blake, so as to be able to fulfil the purpose which eluded him while he was on earth, because he submitted to the dogmas of Puritanism.

In the spring of 1803 Blake finally decided to return to London, having, as he wrote to Butts, 'the full approbation of Mr Hayley'. (K.822) He had lost touch with much of his inspiration during what in the same letter he called his 'three years' Slumber on the banks of the Ocean'. (K.823) London was necessary to him and his work, his true *genius loci*. To Butts he confided: 'I can alone carry on my visionary studies in London unannoy'd, & that I may converse with my friends in Eternity, See Visions, Dream Dreams & prophecy & speak Parables unobserv'd & at liberty from the Doubts of other Mortals; perhaps Doubts proceeding from Kindness, but Doubts are always pernicious, Especially when we Doubt our Friends.' (K.822)

But before he left Felpham an extremely unpleasant experience was in store for him. The gardener at his cottage had asked a Private John Scolfield, a Dragoon, into the garden to assist him. Innocent of the circumstances, Blake thought that Scolfield was an intruder and politely asked him to leave, but the soldier refused and threatened to knock out Blake's eyes. 'It affronted my foolish Pride', wrote Blake to Butts.

> I therefore took him by the Elbows & pushed him before me till I had got him out; there I intended to have left him, but he, turning about, put himself into a Posture of Defiance, threatening & swearing at me. I, perhaps foolishly & perhaps not, stepped out at the Gate, &, putting aside his blows, took him again by the Elbows, &, keeping his back to me, pushed him forwards down the road about fifty yards – he all the while endeavouring to turn round & strike me, & raging & cursing, which drew out several neighbours . . . (K.827)

Determined on revenge, Scolfield and his comrade falsely accused Blake of uttering seditious opinions, of damning the King, of saying that all the King's soldiers were slaves, and much more of the same. With the country at war, such charges were serious, and Blake was summoned to appear at the Quarter Sessions to stand trial for treason. Were he found guilty, he might be hanged. He was released on bail of £200, of which he put up £100 himself, while Seagrave, a printer of Chichester, put up £50 and Hayley £50. Hayley, probably at his own expense, engaged his friend, the barrister Samuel Rose, for Blake's defence. Until the trial Blake returned to London. Hayley further demonstrated his friendship by attending the trial and giving Blake an excellent testimonial.

At Chichester Guildhall on 11 January 1804 Blake was an awe-inspiring defendant, and as Scolfield piled lie upon lie in his evidence, he shouted *'False!'* in ringing tones which, as Gilchrist wrote, 'electrified the whole court and carried conviction with it'. Many years later a local inhabitant recalled that his most vivid memory of the trial was Blake's flashing eye. The jury acquitted Blake amid the plaudits of the onlookers. It was fortunate that his earlier friendship with Thomas Paine was not known to the court, for although he now viewed revolution sceptically, the times were volatile and a jury might well have concluded that he was a dangerous man and brought in a verdict of guilty.

Back in London, where he set up home at 17 South Molton Street, Blake, as always full of gratitude for kindness, did all he could for Hayley in return for his help before and during his trial, and indeed almost became the Hermit's general London factotum, besides undertaking a number of engraving commissions for him. His engraving practice began once more to thrive now that he was back at the centre of activities in the capital. There was some anxiety none the less, for Mrs Blake had become unwell, partly through worrying about the trial, and did not recover for twelve months. She also suffered a bad attack of rheumatism and her knees and legs became swollen, but a course of frictional electricity administered by the surgeon John Birch, an old friend of the Blakes, seems to have effected her recovery.

Yet London acted like a tonic on Blake, and full of euphoria he wrote to Hayley on 23 October 1804:

> For now! O Glory! and O Delight! I have entirely reduced that spectrous Fiend [i.e. critical reason, the enemy of vision] to his station, whose annoyance has been the ruin of my labours for the last passed twenty years of my life. He is the enemy of conjugal love and is the Jupiter of the Greeks, an iron-hearted tyrant, the ruiner of ancient Greece. I speak with perfect confidence and certainty of the fact which has passed upon me. Nebuchadnezzar had seven times passed over him; I have had twenty; thank God I was not altogether a beast as he was; but I was a slave bound in a mill among beasts and devils; these beasts and these devils are now together with myself, become children of light and liberty, and my feet and my wife's feet are free from fetters. O lovely Felpham, parent of Immortal Friendship, to thee I am eternally indebted for my three years' rest from perturbation and the strength I now enjoy. Suddenly, on the day after visiting the Truchsessian Gallery of pictures*, I was again enlightened with the light I enjoyed in my youth, and which has for exactly twenty years been closed from me as by a door and by window-shutters. Consequently I can, with confidence, promise you ocular demonstration of my altered state on the plates I am now engraving after Romney [one of Hayley's commissions], whose spiritual aid has not a little conduced to my restoration to the light of Art. O the distress I have undergone, and my poor wife with me: incessantly labouring and incessantly spoiling what I had done well. Every one of my friends was astonished at my faults, and could not assign a reason; they knew my industry and abstinence from every pleasure for the sake of study, and yet – and yet – and yet there wanted the proofs of industry in my works. I thank God with entire confidence that it shall be so no longer – he is become my servant who domineered over me, he is even as a brother who was my enemy. Dear Sir, excuse my enthusiasm or rather madness, for I am really drunk with intellectual vision whenever I take a pencil or graver into my hand, even as I used to be in my youth, and as I have not been for twenty dark, but very profitable years. I thank God that I courageously pursued my course through darkness. (K.851–2)

* A collection of pictures belonging to Joseph, Count Truchsess, who claimed he had lost a fortune during the French Revolution, and wished to sell the pictures as a basis for a permanent public gallery. Unfortunately the pictures, which were supposed to be the work of great masters, were dismissed as poor work and were sold separately in 1806 for negligible sums.

So far as his creative work was concerned, Blake's optimism was justified, for during the last twenty years of his life he produced some of his greatest work in painting and engraving and in poetry. But on a personal level he was to suffer bitter disappointment and discover false friends.

In 1805 the engraver and publisher Richard Hartley Cromek of Hull commissioned twelve designs to illustrate an edition he planned of Robert Blair's poem *The Grave*; the fee agreed was 20 guineas (£21), and it was understood that Blake was also to do the more lucrative work of engraving the plates. In the event this job was given to the Italian engraver Louis Schiavonetti, whose conventional method of engraving Cromek felt would have greater public appeal than the stark and stronger style of Blake.

Blake was incensed by this shabby treatment, and when he later submitted a drawing (plate 46), an engraving of which was to accompany a verse in which he dedicated the illustrations to Queen Charlotte, he asked 4 guineas (£4.20) for it. Cromek added to his injuries with a hurtful and arrogant reply, refusing to entertain his fee, and returning the design which, he said, he could do without. Cromek's sneering letter, which makes painful reading, shows the sort of treatment Blake had to receive from some quarters in his lifetime:

> When I first called on you, I found you without reputation; I *imposed* on myself the labour, and a herculean one it has been, to create and establish a reputation for you. I say the labour was herculean, because I had not only to contend with, but I had to battle with a man who had pre-determined not to be served. What public reputation you have, the reputation of eccentricity excepted, I have acquired for you . . . Your drawings have had the *good* fortune to be engraved by one of the first artists in Europe, and the specimens already shown have already produced you orders that I verily believe you otherwise would not have received. Herein I have been gratified; for I was determined to bring you food as well as reputation, though, from your late conduct, I have some reason to embrace your wild opinion, that to manage genius, and to cause it to produce good things, it is absolutely necessary to starve it; indeed, this opinion is considerably heightened by the recollection that your best work, the illustrations of *The Grave*, was produced when you and Mrs Blake were reduced so low as to be obliged to live on half a guinea [52½p] a week!

Cromek further deceived Blake, over a project that was more important to him. At Blake's house Cromek saw a drawing of the Canterbury Pilgrims setting out from the Tabard Inn. He tried to persuade Blake to allow him to take this away, and apparently commissioned a finished picture and an engraving of the subject from him. But he then commissioned instead a painting of the same subject from Thomas Stothard which was given to Schiavonetti to engrave (completed by James Heath after his death). Blake, not knowing the true position, called on Stothard while he was working on his version, and complimented him upon it. When he afterwards learned that the painting had been commissioned by Cromek, he thought that Stothard was a party to the deception and upbraided him, and later, having discovered that Stothard was innocent, he was unsuccessful in his attempt at a reconciliation. Flaxman supported Stothard in this quarrel and for a time he, too, was estranged from Blake, but they were later reconciled. (Cromek did not enjoy the fruits of his deceit for long, for he died aged forty-two on 12 March 1812, after having cheated Stothard of £40 of the fee due to him.)

Blake's pen and tempera painting of the Canterbury Pilgrims is now at Pollok House, Glasgow; the engraving of the enormous plate (30.5 × 94.9 cm) was completed probably in 1808. He was determined to show the picture to the public and in 1809 he put it on exhibition with fifteen other paintings on the first floor of his birthplace, 28 Broad Street, Golden Square, which was now the home of his brother James. In the catalogue he wrote for the exhibition he gave public expression to his views on art and artists, extravagantly

condemning the work of many great masters of the past (but praising others) and heaping equally extravagant praise on his own work. It is perhaps not surprising that the treatment he had received from Cromek and imagined he had received from Stothard should have stimulated him to react in this way; in such a situation it was characteristic of him to declare himself fully.

Some have seen in Blake's dismissal of the work of artists such as Titian and Rubens a misunderstanding caused by the fact that he knew their work only through reproductive prints, but it seems unlikely that he would have much modified his views if he had seen the originals, for they hardly conform to his preoccupation with strong and wiry outlines: 'Every Line is the Line of Beauty; it is only fumble & Bungle which cannot draw a Line; this only is Ugliness. That is not a Line which doubts & Hesitates in the Midst of its Course'. (K.603) In the preface to his catalogue he thunders in praise of Michelangelo and Raphael and against Titian, Rubens, Correggio and Rembrandt:

> The eye that can prefer the Colouring of Titian and Rubens to that of Michael Angelo and Rafael, ought to be modest and to doubt its own powers. Connoisseurs talk as if Rafael and Michael Angelo had never seen the colouring of Titian or Correggio: They ought to know that Correggio was born two years before Michael Angelo, and Titian but four years after. Both Rafael and Michael Angelo knew the Venetian, and contemned and rejected all he did with the utmost disdain, as that which is fabricated for the purpose to destroy art.
>
> Mr B. appeals to the Public, from the judgment of those narrow blinking eyes, that have too long governed art in a dark corner. The eyes of stupid cunning never will be pleased with the work any more than with the look of self-devoting genius. The quarrel of the Florentine with the Venetian is not because he does not understand Drawing, but because he does not understand Colouring. How should he? he who does not know how to draw a hand or foot, know how to colour it?
>
> Colouring does not depend on where the Colours are put, but on where the lights and darks are put, and all depends on Form or Outline, on where that is put; where that is wrong, the Colouring never can be right; and it is always wrong in Titian and Correggio, Rubens and Rembrandt. Till we get rid of Titian and Correggio, Rubens and Rembrandt, We never shall equal Rafael and Albert Durer, Michael Angelo, and Julio Romano. (K.563–4)

Later in the catalogue, in a description of the tempera painting *The Bard, from Gray* (Tate Gallery, London), Blake gives some indication of what he meant by visionary art:

> . . . shall Painting be confined to the sordid drudgery of fac-simile representation of merely mortal and perishing substances, and not be as poetry and music are, elevated into its own proper sphere of invention and visionary conception? No, it shall not be so! Painting, as well as poetry and music, exists and exults in immortal thoughts. If Mr B's Canterbury Pilgrims had been done by any other power than that of the poetic visionary, it would have been as dull as his adversary's . . .
>
> The connoisseurs and artists who have made objections to Mr B.'s mode of representing spirits with real bodies, would do well to consider that the Venus, the Minerva, the Jupiter, the Apollo, which they admire in Greek statues are all of them representations of spiritual existences, of Gods immortal, to the mortal perishing organ of sight; and yet they are embodied and organized in solid marble. Mr B. requires the same latitude, and all is well. The Prophets describe what they saw in Vision as real and existing men, who they saw with their imaginative and immortal organs; the Apostles the same; the clearer the organ the more distinct the object. A Spirit and a Vision are not, as the modern philosophy supposes, a cloudy vapour, or a nothing: they are organized and minutely articulated beyond all that the mortal and perishing nature can produce. He who does not imagine in stronger and better lineaments, and in stronger and better light than his perishing and mortal eye can see, does not imagine at all. The painter of his work asserts that all his imaginations appear to him infinitely more perfect and more minutely organized than any thing seen by his mortal eye.

Spirits are organized men. Moderns wish to draw figures without lines, and with great and heavy shadows; are not shadows more unmeaning than lines, and more heavy? O who can doubt this! (K.576–7)

Blake's explanations were in vain. Apparently nothing was sold, and there were hardly any visitors. One of the few who paid the entrance fee of half a crown (12½p), which included the catalogue, was the diarist Henry Crabb Robinson, who wrote that he 'was deeply interested by the catalogue as well as the pictures'. He asked James Blake if he might come again and was told, 'Oh! as often as you please!' The exhibition was followed by yet another parting, for Blake, for some reason not recorded, fell out with his brother James soon afterwards and within a few years they were not on speaking terms.

From about 1809 to 1815 little is known of Blake's life except that he was still living in South Molton Street. There are occasional references to him. In a diary entry on 24 July 1811, Crabb Robinson mentions a party at Charles Lamb's where he met Robert Southey, who had seen Blake and had thought him mad. On another occasion Robinson read some of Blake's poems to William Wordsworth, who thought highly of them. The artist Seymour Kirkup, who had once thought Blake mad, revised his opinion; he later told Swinburne (*William Blake: A Critical Essay*, p. 81) that Blake would never embarrass anybody by talking about his spiritual life if he felt it was incomprehensible to them. 'I never suspected him of imposture,' he said in 1870 in a letter to Richard Monckton Milnes,

> His manner was too honest for that. He was very kind to me, though very positive in his opinion, with which I never agreed. His excellent old wife was a sincere believer in all his visions. She told me seriously one day, 'I have very little of Mr Blake's company; he is always in Paradise.' She prepared his colours, and was as good as a servant. He had no other. (T.W. Reid, *The Life, Letters, and Friendships of Richard Monckton Milnes, First Lord Houghton* (London, 1890), Vol.II, pp. 222–3)

During these obscure years Blake continued to engrave for others: for instance he engraved plates after work by Flaxman to illustrate an edition of Hesiod (1817), and even eighteen pages for a catalogue of pottery wares issued by the Wedgwood manufactory. But he also painted some exquisite watercolours illustrating Milton's *L'Allegro* and *Il Penseroso* (plates 54 and 55), and designed and engraved the hundred relief-etched plates for his *Jerusalem, the Emanation of the Giant Albion* (plate 35); of this work only five complete copies exist, four of them uncoloured – by any standards a discouraging initial circulation for one of the great poems of the English language.

As he approached old age Blake lost many friends by death, estrangement or simply loss of contact. Even Butts bought less of his work (possibly because he had run out of wall-space). Of the friends of his early and middle years only George Cumberland remained constant, corresponding with him until just before his death. To Cumberland's son Blake owed his introduction in 1818 to a young man who was to be one of the most important friends of his declining years, the painter John Linnell. Through Linnell Blake made a whole new circle of friends, who included the watercolour painters John and Cornelius Varley, Henry Richter and James Holmes, and the group of young men calling themselves 'The Ancients', whose central figure was Samuel Palmer; this group included the painters George Richmond and Francis Oliver Finch, the sculptor Frederick Tatham, and the engravers Edward Calvert and Welby Sherman.

To Blake, one of the most congenial of these new friends was John Varley, a tremendous character. Full of energy, he used to box with his pupils to relieve the monotony of work; and when that failed to satisfy his high spirits he divided them into two teams, who would throw a screaming Mrs Varley from one to the other across the dining table. He dabbled in astrology, which he believed in implicitly, and was delighted when his house caught fire

after he had predicted that something serious was going to happen to him that day, and had timed it to within a few minutes. He was continually in debt, and when arrested for it by the tipstaff, asked him to wait a few moments while he got his paintbox to take with him, so that he could paint some pictures while he was in prison, in order to pay off his debt.

Varley believed in Blake's visions quite literally and it was for him that Blake drew his series of 'visionary portraits' (see commentaries to plates 57 and 58). These included *King Edward the First* (National Gallery of Art, Washington, D.C.), *Richard Coeur de Lion* (Private Collection, Los Angeles) and *Owen Glendower* (National Gallery of Canada, Ottawa). Varley sat next to Blake on the nights when he was making these portraits and strained his eyes to see the ghostly sitters, but the literal-minded Varley's idea of a vision was different from that of Blake, whose visions were almost certainly an extension of the imagination. Gilchrist relates how Blake indicated their true nature one day at a party when he described one of them to a lady:

> 'The other evening, taking a walk, I came to a meadow and at the farther corner of it I saw a fold of lambs. Coming nearer, the ground blushed with flowers; and the wattled cote and its woolly tenants were of an exquisite pastoral beauty. But I looked again, and it proved to be no living flock, but beautiful sculpture.' 'I beg pardon, Mr Blake', said the lady, 'but *may* I ask *where* you saw this?' '*Here*, madam,' answered Blake, touching his forehead.

During these later years Blake continued to engrave plates after the designs of other artists, but he had become a largely forgotten figure, and the number of such commissions was diminishing. His most important works at this time were either commissioned by Linnell or resulted from his introductions. One of the most attractive groups done in his last years was the series of wood-engravings – the only ones he ever made – for an adaptation of Virgil for use in schools published by Linnell's family doctor, Robert John Thornton (plate 64). They had an enormous influence on 'The Ancients', who hero-worshipped Blake: many echoes of the Virgil wood-engravings are present in their early work. Blake's preliminary drawings for them in pencil, pen and wash, or pencil and pen, are most poetic little designs (plate 63), and show the artist in a mood far removed from the earth-shaking conception of much of his other work; it is like comparing Beethoven's 'Moonlight Sonata' with *Fidelio*.

In 1821, the year in which the Virgil wood-engravings were published, the Blakes moved from South Molton Street to two rooms in 3 Fountain Court, Strand, not far from where the Savoy Hotel now stands. Mrs Blake's brother-in-law, Mr Baines, occupied the remainder of the house. They were now very poor and Blake was forced to sell the collection of prints which he had gathered together from boyhood; the painters William Collins and Abraham Cooper drew the attention of the Royal Academy to the plight of the old couple, and they were granted a donation of £25. Throughout all this poverty Blake remained true to his ideals which had caused his obscurity. The story is told that one day Fuseli, visiting him, found him sitting down to a frugal meal of cold mutton. 'Ah! by God!' exclaimed Fuseli, 'this is the reason you can do as you like. *Now I can't do this.*' But, as Samuel Palmer later remarked, 'he ennobled poverty, and, by his conversation and the influence of his genius, made two small rooms in Fountain Court more attractive than the threshold of princes.'

By 1823 the Blakes were on the verge of destitution. They were saved by John Linnell, who commissioned what many believe to be Blake's greatest group of engravings, the *Illustrations of the Book of Job* (plate 70). They were based on a series of watercolours illustrating the story of Job, made for Thomas Butts (plates 68 and 69); Blake borrowed these to show to Linnell, who immediately commissioned him to make a duplicate set and then to engrave them. Blake received £5 for each of the twenty plates.

23

Linnell and his family lived at Collins's Farm, Hampstead, then in the country, and Blake sometimes visited them, though he was convinced that the Hampstead air disagreed with him. The Linnells provided the childless Blake with a happy family background: Gilchrist wrote that 'Linnell's manner was that of a son'. He further relates how one of Linnell's children recalled Blake:

> She remembers how Blake would take her on his knee, and recite children's stories to them all: recollects his kind manner; his putting her in the way of drawing, training her from his own doings. One day he brought up to Hampstead an early sketch-book, full of most singular things, as it seemed to the children. But, in the midst of them, they came upon a finished Pre-Raphaelite-like drawing of a grasshopper, with which they were delighted.

A. H. Palmer, Samuel Palmer's son, recalled in his *The Life and Letters of Samuel Palmer* (1892) that

> the aged composer of *The Songs of Innocence* was a great favourite with the [Linnell] children, who revelled in those poems and in his stories of the lovely spiritual things and beings that seemed to him so real and so near. Therefore as the two friends [Blake and Palmer] neared the farm, a merry troop hurried out to meet them led by a little fair-haired girl of some six years old [Hannah Linnell, who later married Samuel Palmer]. To this day she remembers cold winter nights when Blake was wrapped up in an old shawl by Mrs Linnell, and sent on his homeward way, with the servant, lantern in hand, lighting him across the heath to the main road (pp. 27–8).

In old age, as in youth, Blake had an impressive presence; though only about 5 feet 6 inches tall, he was strongly built with wide shoulders. Palmer recalled that

> His eye was the finest I ever saw: brilliant, but not roving, clear and intent, yet susceptible; it flashed with genius, or melted in tenderness. It could also be terrible. Cunning and falsehood quailed under it, but it was never busy with them. It pierced them, and turned away. Nor was the mouth less expressive; the lips flexible and quivering with feeling. I can yet recall it when, on one occasion, dwelling upon the exquisite beauty of the parable of the Prodigal, he began to repeat a part of it; but at the words, 'When he was yet a great way off, his father saw him', could go no further; his voice faltered, and he was in tears (Gilchrist, pp. 301–2).

Once, when he met a beautiful little girl (whose identity is unrecorded), he said, stroking her hair, 'May God make this world to you, my child, as beautiful as it has been to me!' She wondered how such a poor and shabbily dressed old man could have found the world beautiful. Blake's appearance was truly shabby, his clothes shining and threadbare; even when he went out he dressed in sober black clothes of a quakerish plainness, a broad-brimmed hat, a black suit with knee breeches, plain worsted stockings and tie-up shoes. Sometimes when Catherine complained that the money was running out he would testily reply, 'Oh, damn the money! it's always the money!' And so it would continue, until there came a meal when she put an empty plate in front of him; he would then sit down to some mundane but remunerative work he had in hand.

Linnell's support did not cease with the Job commission, for he ordered a series of drawings illustrating Dante's *Divine Comedy*, later to be engraved. Blake died without finishing the work, but he did complete over a hundred watercolours. He also began work on seven engravings, which, though only partly finished, are magnificent and powerful. But the watercolours are even more remarkable; their colour especially is wonderful, and in many cases as bright and radiant as stained glass (plates 59–61).

Nor were these the only paintings of his old age, for in 1824 he executed a series of watercolours illustrating *The Pilgrim's Progress* (plate 62); and at about the same time he began, again for Linnell, a series of illustrations to the Book of Genesis, but only a few of these were completed (plate 74).

By 1826 Blake's health was fast deteriorating; he was suffering from gallstones and inflammation. On 19 May he wrote to Linnell:

> I have had another desperate Shivering Fit; it came on yesterday afternoon after as good a morning as I have ever experienced. It began by a gnawing Pain in the Stomach, & soon spread a deathly feel all over the limbs, which brings on the shivering fit, when I am forced to go to bed, where I contrive to get into a little perspiration, which takes it quite away. It was night when it left me, so I did not get up, but just as I was going to rise this morning, the shivering fit attacked me again & the pain, with its accompanying deathly feel. I got again into a perspiration, & was well, but so much weaken'd that I am still in bed. (K.872)

By April 1827 he was writing to George Cumberland: 'I have been very near the Gates of Death & have returned very weak & an Old Man feeble & tottering, but not in Spirit & Life, not in The Real Man The Imagination which Liveth for Ever.' (K.878)

But he continued to work, and was still at work on his deathbed: he coloured a print of *The Ancient of Days* (plate 75) for Frederick Tatham, and when he had finished it, looked up and saw Catherine sitting near. 'Stay Kate!' he exclaimed, 'keep just as you are – I will draw your portrait – for you have been ever an angel to me.' On the day of his death, Sunday 12 August 1827, he sang joyful songs, saying to Catherine, 'My beloved, they are not mine – no – they are not mine.' He ceased breathing at about six o'clock in the evening while Catherine sat beside him. The only other person present was a humble woman who lived nearby, who said, 'I have been at the death, not of a man, but of a blessed angel.' The fullest account of Blake's death was written by one of his young followers, George Richmond, in a letter to Samuel Palmer:

> Lest you should not have heard of the Death of Mr Blake I have Written this to inform you – He died on Sunday Night at 6 Oclock in a most glorious manner. He said He was going to that Country he had all His life wished to see & expressed Himself Happy hoping for Salvation through Jesus Christ – Just before he died His Countenance became fair – His eyes Brighten'd and He burst out in Singing of the things he Saw in Heaven. In truth He Died like a Saint as a person who was standing by Him Observed.

Richmond, Calvert and Tatham were among the few who followed his body to Bunhill Fields Burial Ground, where it was laid in an unmarked grave.

Catherine, who survived him for just over four years, went immediately after his death to live with the Linnells, and afterwards with Frederick Tatham and his wife, for whom she kept house. Finally she moved into lodgings at 17 Charlton Street, supporting herself by selling William's works. She died in Tatham's arms on 18 October 1831, after, Gilchrist informs us, 'calling to her William as if he were only in the next room, to say that she was coming to him, and would not be long now.'

In selecting the seventy-five works reproduced on the following plates, I have tried to illustrate important aspects of Blake's art and thought. But it will readily be appreciated that seventy-five works out of the many hundreds he created cannot reflect every nuance of the man's mind and work; this is essentially an introductory study, and for a more detailed view the reader is referred to the list of suggestions for further reading at the end of the book.

It will be obvious that I have interpreted the term 'paintings' somewhat broadly. But in Blake's case that is essential, for without consideration of those of his works realised partly in engraving and partly in painting – the illuminated books, colour-printed drawings and coloured engravings – the presentation of Blake as a painter would be incomplete and therefore distorted. For much the same reason I have included one or two uncoloured engravings closely related to his painting.

1. King Sebert, from the Wall-Painting on the Sedelia above his Monument

circa 1775
Pen, watercolour and gold, sheet 39.8 × 26 *cm*
Society of Antiquaries, London

This is one of a series of nine drawings supposed to have been executed by Blake in Westminster Abbey during his apprenticeship. They are signed and dated 'Basire 1775', but the work of any apprentice or employee would have been similarly inscribed with his master's name. The drawings have been accepted by many experts as Blake's work, although others have been prepared to accept them only as 'probable'.

King Sebert or Sigebert was a legendary East Anglian king who is said to have flourished around the year 637. The wall-painting in the Presbytery of the Abbey, from which Blake's watercolour was taken, has been attributed to Thomas of Durham (early fourteenth century); with the other paintings in the group it had been hidden by tapestries and wainscot until these were removed during the summer of 1775. Sir Joseph Ayloffe, Bart, read a paper on the paintings to the Society of Antiquaries in March 1778, entitled *An Account of Some Ancient Monuments in Westminster Abbey* and published by the Society in 1780. It was illustrated with engravings from the drawings, some of which were arranged two to a plate; the portrait of King Sebert was paired with one of King Henry III. Duplicates of the nine drawings are in the Bodleian Library, Oxford.

Blake also made a series of drawings (and engravings from them) of monuments in Westminster Abbey for Dr Richard Gough's *Sepulchral Monuments of Great Britain*; many of these also are in the Bodleian.

The album at the Society of Antiquaries which contains the Sebert watercolour also contains two rough studies and two finished drawings of King Edward I in his coffin. These are probably by Blake, who almost certainly was in Westminster Abbey when Edward's coffin was exhumed and opened by Sir Joseph Ayloffe on 2 May 1774, in the presence 'of a select Party, chiefly members of the Society [of Antiquaries]'; Richard Gough was also present. The coffin was open for about an hour, and once the cerecloths had been laid open, it was possible to see the King's face, well preserved but turned a dark brown colour; he was dressed in a dalmatic and held two sceptres; there was also some jewellery.

The two rough sketches were probably made at this time, one showing the body wrapped in cerecloths and the other showing the corpse partly revealed. In a letter to a fellow antiquary, Thomas Pennant, Gough stated that he regretted that no draughtsman was present, so Blake (if he was the artist) must have been sketching nearby unnoticed.

The elongated figures of these early designs is a hallmark of Blake's subsequent style; see for instance *The Fly*; *Goliath cursing David*; *Comus, disguised as a Rustic* and *Melancholy* (plates 15, 29, 33 and 55).

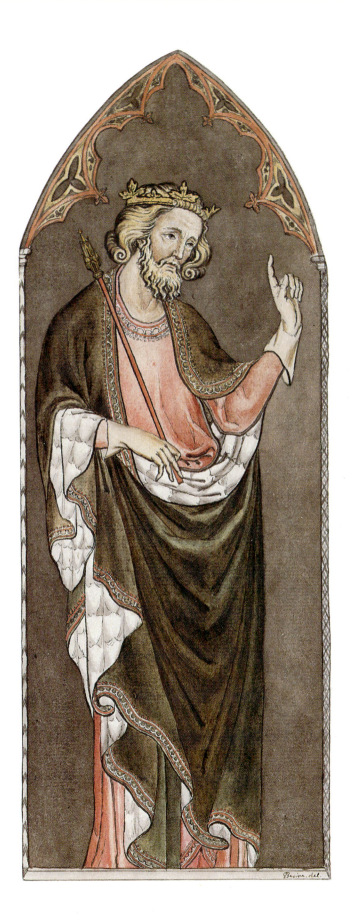

2. Pestilence

circa 1780–4
Pen and watercolour, 18.5 × 27.5 cm
Collection of Robert N. Essick, Altadena, California

It is likely that the idea of *Pestilence* was based on the Great Plague of London of 1665. Blake used the subject several times: a drawing in Steigal Fine Art at Edinburgh (*circa* 1779–80) is a preliminary study for the composition of this watercolour; three others, different in composition from this one but similar to one another, are in the City of Bristol Museum and Art Gallery, the Museum of Fine Arts, Boston, and in an American private collection.

The scene, set against a background of classical architecture, depicts people dead and dying, some in the last stages of illness being supported by others not yet stricken. Before a shed at the right a dead child lies across the lap of its mother, herself on the point of death. Just in front of this group a young man supports a dying woman; between these and another young couple at the right in a similar plight, a man lies face down on the cobbles (many died on the streets in 1665) and behind him lies a dead horse. Beyond the horse two men are loading a corpse on to a dead-cart against a background of smoke. In the far background is a sinister black-clad bellman, one of those who during the plague year preceded the carts crying 'Bring out your dead'. (In the Edinburgh drawing the wall above this figure is inscribed 'Lord have mercy on us', as ordered by the City authorities.) Lightly indicated in the building behind him are people with their arms raised in frenzied prayer.

The bellman and the pair of figures at the left, all somewhat varied in detail, appear again in plate 7 of Blake's illuminated book *Europe: A Prophecy* (1794).

The drawing and composition of *Pestilence* shows considerable development over Blake's earlier work, such as *The Kings of Calais* (*circa* 1779, Beinecke Rare Book and Manuscript Library, Yale University, New Haven, Connecticut). Not only are the figures in *Pestilence* more skilfully drawn; the background architecture being in distorted perspective and, measured against the bellman's figure, colossal, the combination imparts a dreamlike, almost surreal quality to the work. This must have been deliberate, for Blake was capable of working 'realistically' (see for example plate 25) – though he seldom chose to do so. Such distortions appear throughout his *oeuvre*, and if he is to be properly understood his departures from verisimilitude must be accepted.

The figures are derived from neoclassical types; they can be compared, for instance, with figures by the neoclassical painter James Barry, such as those in his paintings in the Great Room at the Royal Society of Arts in London. Blake was much influenced by Barry and referred indignantly to his treatment by the Society in his annotations, written in about 1808, to Sir Joshua Reynolds's *Discourses*: 'Who will Dare to Say that Polite Art is Encouraged or Either Wished or Tolerated in a Nation where The Society for the Encouragement of Art Suffer'd Barry to Give them his Labour for Nothing . . . Barry told me that while he Did that Work, he Lived on Bread & Apples.' (K.446)

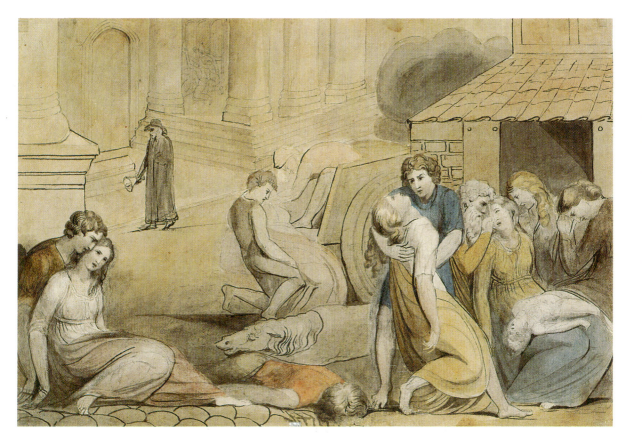

3. The Witch of Endor raising the Spirit of Samuel

1783
Pen and watercolour, 28.3 × 42.3 cm
New York Public Library

The Bible was central both to Blake's visual work and to his poetry: much of his mythological poetry has grand biblical cadences, close to the poetry of Ezekiel, Isaiah and Revelation, and he painted biblical subjects throughout his life. In this watercolour he illustrates the passage in *I Samuel* XXVIII.8–14, a favourite theme also of several of his contemporaries:

> And Saul disguised himself, and put on other raiment, and he went, and two men with him, and they came to the woman by night: and he said, I pray thee, divine unto me by the familiar spirit, and bring me him up, whom I shall name unto thee . . .
> Then said the woman, Whom shall I bring up unto thee? And he said, Bring me up Samuel.
> And when the woman saw Samuel, she cried with a loud voice: and the woman spake to Saul, saying, Why hast thou deceived me? for thou art Saul.
> And the king said unto her, Be not afraid: for what sawest thou? And the woman said unto Saul, I saw gods ascending out of the earth.
> And he said unto her, What form is he of? And she said, An old man cometh up; and he is covered with a mantle. And Saul perceived that it was Samuel, and he stooped with his face to the ground, and bowed himself.

Blake's rendering of the subject has a number of details which may have been based on *Abraham and the Three Angels*, an engraving he made in about 1781 for *The Protestants Family Bible* after another engraving taken from the painting in Raphael's Loggie in the Vatican. The kneeling figure of Saul resembles that of Abraham, and the gestures of the figures behind him those of the angels.

The treatment closely follows the Bible passage. The prostrate and distorted figure of Saul, his head only tentatively related to his body and one hand fearfully reaching towards the ghost, his eyes fixed and looking at only the lower part of Samuel's figure, well expresses the last sentence of the biblical passage. Saul's companions look on unbelievingly, their hands extended in alarm, preparing to flee. The witch, the only one to look Samuel in the face, gazes with a more intense, yet dismayed expression at the apparition she has called forth.

The impression of depth, achieved with minimal perspective, is accentuated by the colouring: the strong red of the cloak worn by the nearest of Saul's companions dominates the mauve and purple of the King's garments and of his second companion, and the green and yellow of the witch's dress. The bright grey and white of Samuel's mantle, set against the darker portion of the cave-like background, ensure that he is the superior figure in the composition.

Blake painted a pen and watercolour drawing of this subject in about 1800 for his patron Thomas Butts (National Gallery of Art, Washington, D.C.). It is much more dramatic than this gentler rendering of the scene, and indeed verges on the hysterical.

4. Oberon, Titania and Puck with Fairies dancing

circa 1785
Pencil and watercolour, 47.5 × 62.5 cm (irregular)
Tate Gallery, London

Shakespeare's works provided Blake with many themes; he drew on thirteen of the plays for subject matter (see also plates 43 and 44). This watercolour illustrates the closing moments of *A Midsummer Night's Dream*, when the reconciled Oberon and Titania make their final entry (V.ii.21–30):

> *Oberon* Through the house give glimmering light
> By the dead and drowsy fire;
> Every elf and fairy sprite
> Hop as light as bird from brier;
> And this ditty after me
> Sing and dance it trippingly.
>
> *Titania* First, rehearse your song by rote,
> To each word a warbling note:
> Hand in hand, with fairy grace,
> Will we sing and bless this place.

Blake has set the scene in a grove, with a ring of fairies dancing hand in hand in a glow of moonlight under a starry sky. To the left Puck, his butterfly-winged hands held above his head, and trefoils in his hair, prepares to join the dance; Oberon and Titania stand beside him, the arms of the fairy queen lovingly encircling her husband. There is an appropriate lightness about all these figures: it seems they might disappear in a twinkling, for the dancers' feet seem hardly to touch the ground and each one is glowing as if nearly translucent. The picture was cleaned in 1972 and the subtlety of its colour emerged after being hidden for many years. The cleaning also showed that Blake had originally made Titania's figure much taller than Oberon's: the eyes of the original version are now visible on her forehead. The clinging drapery on the figures, a feature that appears over and over again in Blake's works, was probably derived initially from the work of neoclassical painters such as Gavin Hamilton, David Allan and James Barry.

Blake was to make considerable symbolic use of fairies in both his painting and his poetry. In *A Descriptive Catalogue* (1809) he explained what he thought they meant to Shakespeare and Chaucer and incidentally what they symbolise in his own work: 'Shakespeare's Fairies also are the rulers of the vegetable world, and so are Chaucer's; let them be so considered, and then the poet will be understood, and not else.' (K.570)

On another, perhaps playful, level, Blake once described a fairy's funeral to a lady; his early biographer Allan Cunningham records his words in *The Lives of the Most Eminent British Painters* (London, 1830):

> I was walking alone in my garden, there was great stillness among the branches and flowers and more than common sweetness in the air; I heard a low and pleasant sound, and I knew not whence it came. At last I saw the broad leaf of a flower move, and underneath I saw a procession of creatures of the size and colour of green and gray grasshoppers, bearing a body laid out on a rose leaf, which they buried with songs, and then disappeared.

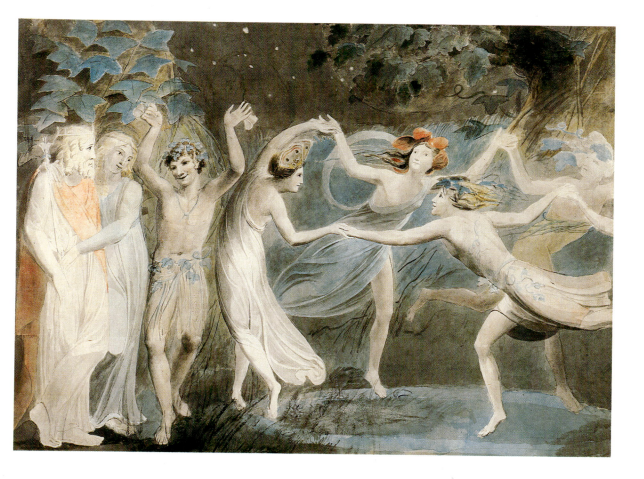

5. Age teaching Youth

circa 1785–90
Pen and watercolour, 10.8 × 8 *cm*
Tate Gallery, London

In this little watercolour Blake symbolises his attitude to conventional education and learning. 'There *is* no use in education', he once said. 'I hold it wrong – It is the great Sin. It is eating of the tree of knowledge of Good and Evil.' Here an aged and bearded instructor, his knees pulled up towards his chest in a pose that became a typical motif in Blake's work, is teaching two children. He is of a type Blake used throughout his work from about this time to represent the Creator, or, more often, his own mythological figure Urizen, who, in broad terms, personifies the rational faculty devoid of spiritual aspirations or values. In Blake's work the Old Testament God is represented as a somewhat ambiguous deity, sometimes benign, but often vengeful (see commentary to plate 12).

The old man holds out a book representing conventional learning to a young girl or boy who gestures upwards, testifying to a preference for spiritual values. At a later date Blake would probably have shown the right rather than left hand raised, for he came to associate the advanced left hand or foot with material actions and the right with spiritual actions. An almost androgynous youth, wearing a beautifully decorated coat of gem-like colouring, pores over a book in which he is writing; he is apparently engrossed by the old man's learning. The pattern on the youth's coat, consisting of leaf and tendril motifs, was used by Blake in several works, indicating in some places that its wearer had the powers of a sorcerer, in others that he was under a spell or enchantment, as in the present watercolour, in which the youth is under the spell of the old man's false wisdom.

Blake also used aged figures of this kind to personify ignorance and materialism, as for example in plate 11 of his emblem book *For Children: The Gates of Paradise* (1793). This depicts, under a tree representing vegetative life, a bespectacled and bearded old man, not unlike the one in *Age teaching Youth*, clipping the wings of an Eros-like boy, who represents soaring spiritual values; a rising sun shines in the background, symbolising the source of those values.

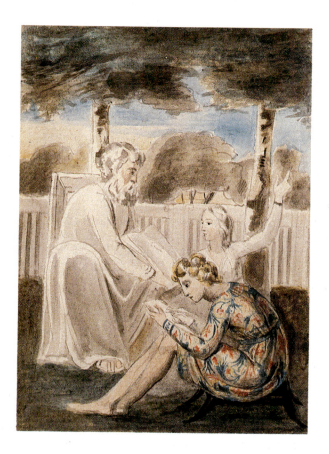

6. 'Indeed We Are Very Happy! – '

circa 1790
Pen and wash, sheet 14 × 6.7 *cm*
Library of Congress, Washington, D.C. (Rosenwald Collection)

One of a series of designs for ten illustrations, of which nine were engraved, commissioned from Blake by the publisher Joseph Johnson for Mary Wollstonecraft's *Original Stories from Real Life* (1791; reissued in 1796 with retouched plates). The novel concerns a governess, Mrs Mason, and her two charges, Mary and Caroline, and her attempts to inculcate them with high moral principles.

Blake's excellent illustrations demonstrate that his genius did not necessarily depend on grand or spiritual themes. Yet the ideas expressed in *Original Stories* can hardly have pleased him, for the novel relates a series of moralistic incidents in which the two young girls are continually shown the grief and cruelty of life without reference to its lighter and happier aspects. In one characteristic episode, illustrated by Blake, Mrs Mason takes them to see a starving family living with their sick and unemployed father in a fusty attic:

> They ascended the dark stairs, scarcely able to bear the bad smells that flew from every part of a small house, that contained in each room a family, occupied in such an anxious manner to obtain the necessaries of life, that its comforts never engaged their thoughts. The precarious meal was snatched, and the stomach did not turn, though the cloth, on which it was laid, was died in dirt. When to-morrow's bread is uncertain, who thinks of cleanliness? Thus does despair encrease the misery, and consequent disease aggravate the horrors of poverty!

In another chapter Mrs Mason tells the girls a story, also illustrated by Blake, about a debtor who is sent to jail; his wife and two of his children, left to fend for themselves, fall ill and die; his remaining two children and his dog join him in prison, where the children die of fever, and only the dog survives. One day the prisoner manages to escape with the dog, but even this last companion is lost to him when it is shot by a horseman whose mount it has startled; soon after this the miserable man himself expires. Incident after incident harrows the emotions to drive home the lesson that happiness depends on obeying moral laws. The joylessness, and the way in which material prosperity is advanced as a main reason for right-doing and the basis of contentment, must have angered Blake; it is possible indeed to read in his illustrations subtle, ironic comment on Wollstonecraft's novel. Here, for example, Mrs Mason has taken the children to visit 'honest Jack', a sailor who has had many painful adventures, but has now achieved happiness. As they listen to his stories, the little girls hide their faces and weep on Mrs Mason's lap, while the sailor's own daughter weeps on his shoulder, and his son, close to tears, stands behind his chair. But the adults sit completely relaxed, making no effort to comfort the children; indeed Mrs Mason's expression seems to show approval of their distress. In this way Blake questions the honesty of adults and their motives in upsetting children's natural optimism.

Every prospect smiled

7. 'Non Angli sed Angeli'

circa 1793
Pen and watercolour, 18.3 × 27.4 *cm*
Victoria and Albert Museum, London

In 1793 Blake was apparently planning to issue a set of engravings entitled *The History of England, a Small Book of Engravings. Price 3*.s (15p). In his Notebook (the Rossetti MS, so called because it was once in the possession of the Preraphaelite artist Dante Gabriel Rossetti; it is now in the British Museum) he enumerates some twenty subjects (of which a number are deleted), most of them dealing with the history of England; it is thought that these were to be the designs for the engraved set. It is doubtful if the engravings were ever made, for no copy has been traced. The designs were executed between about 1779 and 1793.

This drawing is not among those listed, but it is possible that at some stage Blake intended to include it. It illustrates the occasion when Pope Gregory the Great is said to have exclaimed at the sight of some handsome British captives offered for sale in Rome, 'Non Angli sed Angeli' ['Not Angles but Angels'].

The figures in the composition, all male, are arranged like a frieze against a simple architectural background. At the left the bearded patriarchal Gregory, accompanied by three other Romans, stands with his hands extended in surprise at the magnificence of the chained and nearly naked captives. In contrast another captive at the extreme right appears to be deformed; perhaps Blake added this figure to throw into greater prominence the beautiful naked blond boy who stands near him.

Gregory is portrayed as the white-bearded type of Blake's tyrannous Urizen (see commentary to plate 5). This may have been because, in common with others, Blake read into Gregory's words not an exclamation at the beauty of the captives, but a vow to convert the Angles into Angels (i.e. Christians), in pursuance of which St Augustine was sent to accomplish the mission. Gregory, however laudable his intentions, would therefore have appeared to Blake as an arbitrary and authoritative, hence Urizenic, figure, seeking to impose his theocratic will on the Angles. On the whole, though, Blake's priority seems to have been to show Gregory surprised, almost startled by the beauty and dignity of the Angles, who are made more poignant by their captivity; and perhaps he presents both points of view in his portrayal.

There is a pencil sketch for this watercolour in an American private collection; it differs in some details from the finished work, and lacks the architectural background.

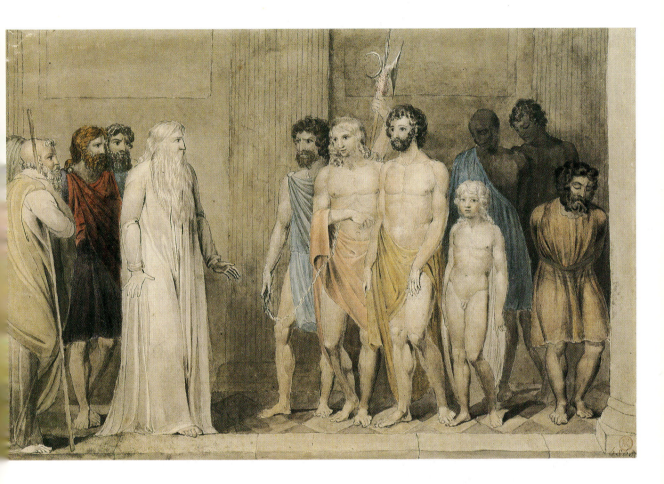

8. The Good and Evil Angels

circa 1793–4
Pen and watercolour, 29.2 × 44.5 cm
Cecil Higgins Museum, Bedford

Blake used the design of this watercolour in about 1790–3, much reduced in size, in his illuminated book *The Marriage of Heaven and Hell*. Later (1795) it was used again, in reverse, for a colour-printed drawing.

It is a simple design. At the left the blond good angel, balancing on clouds above a seascape with the sun half below the horizon, protectively holds a young child away from the angel at the right. This, the dark evil angel, with one ankle shackled and chained, is poised against a background of flames as if restrained in flight; he reaches out with his right hand and nearly touches the child.

Blake held unorthodox views of the meaning of good and evil; he believed they were necessary contraries and that one could not exist without the other (see commentary to plate 12). In his own words (*The Marriage of Heaven and Hell*, plate 3):

> Without Contraries is no progression. Attraction and Repulsion, Reason and Energy, Love and Hate, are necessary to Human existence.
>
> From these contraries spring what the religious call Good & Evil. Good is the passive that obeys Reason. Evil is the active springing from Energy.
>
> Good is Heaven. Evil is Hell. (K.149)

Here passive reason ('good') and active energy or will to power ('evil') are shown struggling for possesion of the child's soul – in Jungian terms, which Blake anticipated, its anima.

Blake takes his beliefs a stage further on plate 4 of *The Marriage:*

> The voice of the Devil
>
> All Bibles or sacred codes have been the causes of the following Errors:
>
> 1. That Man has two real existing principles: Viz: a Body & a Soul.
> 2. That Energy, call'd Evil, is alone from the Body; & that Reason, call'd Good, is alone from the Soul.
> 3. That God will torment Man in Eternity for following his Energies.
>
> But the following Contraries to these are True:
>
> 1. Man has no Body distinct from his Soul; for that call'd Body is a portion of Soul discern'd by the five Senses, the chief inlets of Soul in this age.
> 2. Energy is the only life, and is from the Body; and Reason is the bound or outward circumference of Energy.
> 3. Energy is Eternal Delight. (K.149)

It is at the foot of this plate that the design of the good and evil angels appears. In some of Blake's other prophetic writings, for example *Europe*, produced in the following year, aspects of the dark angel are developed in the character of Orc, who is opposed to Los, representing the unfettered imagination.

The figure of the child is of a type used by Thomas Stothard, and was modelled on a putto in an engraving by Blake after Stothard in Joseph Ritson's *A Select Collection of English Songs* (1783, published by Joseph Johnson).

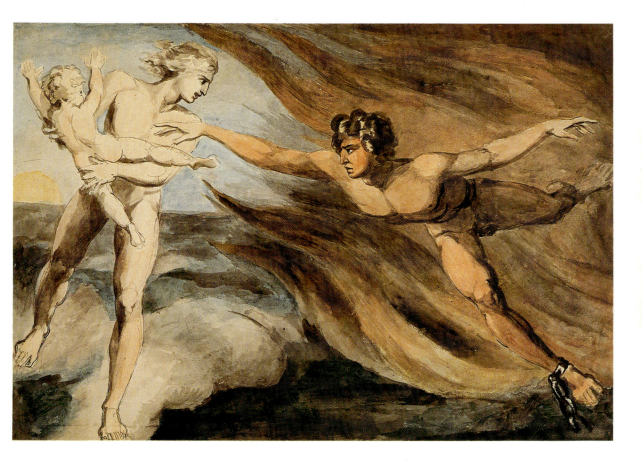

9. Frontispiece to *America: A Prophecy*

1793
Relief etching, 24.1 × 17.1 *cm (approx.)*
Private Collection, England

America was the first of Blake's large 'prophecies'. He summed up his meaning of the word in 1798 in his annotations to Watson's *Apology*: 'Every honest man is a Prophet; he utters his opinion both of private & public matters. Thus: If you go on So, the result is So. He never says, such a thing shall happen let you do what you will. A Prophet is a Seer, not an Arbitrary Dictator.' (K.392) Blake's prophecies are of this Old Testament nature: warnings that if man persists in following the path of falsehood, certain reactions or disasters will result from it.

America is an apocalyptic poem on eighteen plates dealing with the American struggle for independence. The American Revolution is symbolised by Orc (energy; see also commentary to plate 8), and the reactionary forces against which it is directed are personified by Urizen (see commentary to plate 5). The poem describes their mighty and terrible conflict, the consequent plagues and blights, and subsequent revolutions in Europe. But finally his opponents are 'unable to stem the fires of Orc', who triumphs.

Although it occupies a very small area, the frontispiece to this work is one of Blake's most monumental and tremendous designs. It shows a colossal winged and chained Promethean figure seated in a breach in a wall, against a louring sky, his head sunk between his knees in despair; a naked woman sorrowfully embracing her children sits on the right, and remnants of a battle – a cannon and the hilt of a sword – lie on the ground. It is uncertain to which lines in the poem this design refers, but probably it relates to Orc's prophecy of the Revolution (plate 6):

> Let the inchained soul, shut up in darkness and in sighing,
> Whose face has never seen a smile in thirty weary years,
> Rise and look out; his chains are loose, his dungeon doors are open;
> And let his wife and children return from the oppressor's scourge. (K.198)

When Blake first advertised *America*, in October 1793, he described it as 'America, a Prophecy, in Illuminated Printing. Folio, with 18 designs, price 10s.6d. [52½p]' By 1827, the last year of his life, the price had been increased to six guineas (£6.30). Few copies were coloured, only five out of the total of seventeen now recorded; but one or two others contain plates with a certain amount of posthumous colouring. The plate illustrated here is uncoloured except for the dark blue-green of the original printing (most copies are printed in varying shades of black and brown). Although coloured copies of Blake's illuminated books are beautiful, it is always impressive to see unpainted impressions, in which the penetrating strength of his basic etched work becomes apparent.

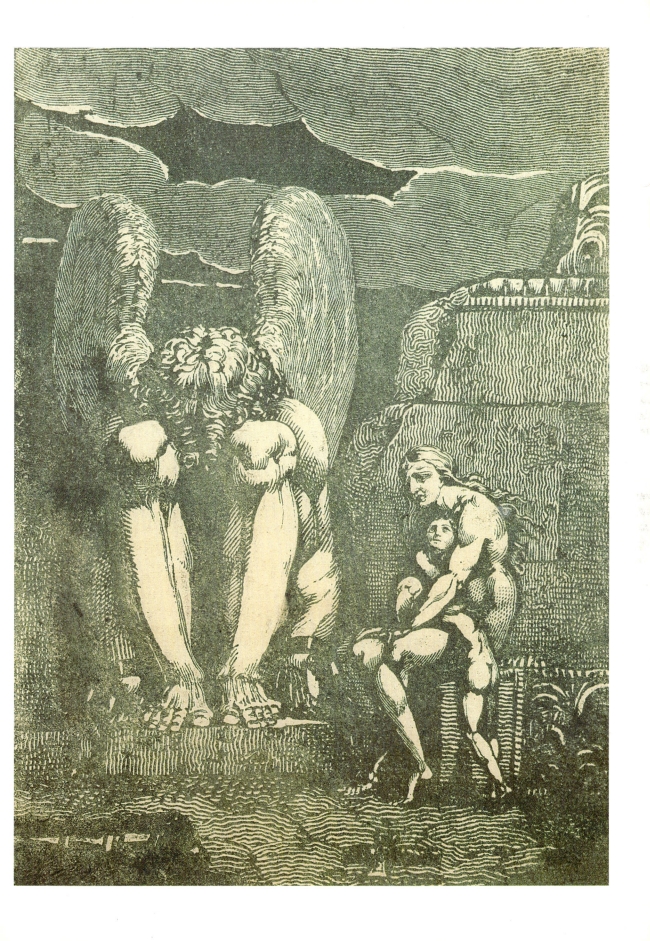

10. The Dance of Albion

circa 1794–6
Colour-printed line engraving, finished in pen and watercolour, 27.2 × 19.9 cm (plate mark)
British Museum, London

Also known as *Albion Rose* and *Glad Day*, this engraving was based on a pencil drawing (Victoria and Albert Museum, London) made in about 1780. Because of the opaque colouring (no uncoloured impression of the first state is known) it is not possible to see if it is dated; but in the second state (*circa* 1804) the date 'inv 1780' appears and is thought to refer to the drawing.

The figure may have been based on a diagram in Vincenzo Scamozzi's treatise *Idea dell' Architettura Universale* (Venice, 1615), in which an almost identical figure illustrates the proportions of the human body. It is even more likely that Blake based it on illustrations of a Roman bronze of a dancing faun from Herculaneum in the book *De' Bronzi Ercolano* (1767–71, author unknown), for on the reverse of the Victoria and Albert drawing he made a pencil drawing resembling its back view, which closely resembles what the figure of Albion would look like from behind.

The second state of the engraving is inscribed: 'Albion rose from where he labour'd at the Mill with Slaves: / Giving himself for the Nations he danc'd the dance of Eternal Death [i.e. self-sacrifice].' Because of this, some have claimed that the design is a celebration of Blake's first year (1780) of freedom from his apprenticeship, and moreover that Albion's face is an idealised self-portrait.

It is more likely that Blake intended a less personal symbolism, and that Albion's triumphant attitude represents the dawn of what Blake called 'fourfold vision', the supreme clarity of true spiritual insight. This is possibly confirmed by two features present only in the second state: a bat-winged moth flying towards the background from between Albion's ankles and a worm close to his left foot. These symbols of darkness are being dismissed by Albion as he achieves mystical ecstasy. But some interpreters have seen the worm as a chrysalis from which the moth has freed itself, signifying a new birth.

Yet another interpretation sees the nude youth as the resurrection of the spirit of Albion (England) after the Industrial Revolution, offering himself in absolute self-sacrifice for the good of all nations – the 'Eternal Death' of the inscription.

Perhaps all these readings are valid, for one of the sources of Blake's strength is the multiplicity of meaning in much of his work. Even the character of Albion is not simple. In places he represents England (it was the original Greek and Roman name for England), and he is shown in this aspect here. Elsewhere he is an Adam-like character representing Ancient Man, the universal father-figure; again in places he has something of the nature of the mythological giant, conqueror of the island of Britain to which he gave his name, Spenser's 'mightie *Albion*, father of the bold / And warlike people, which the *Britaine* Islands hold' (*Faerie Queene* IV.XI.xv).

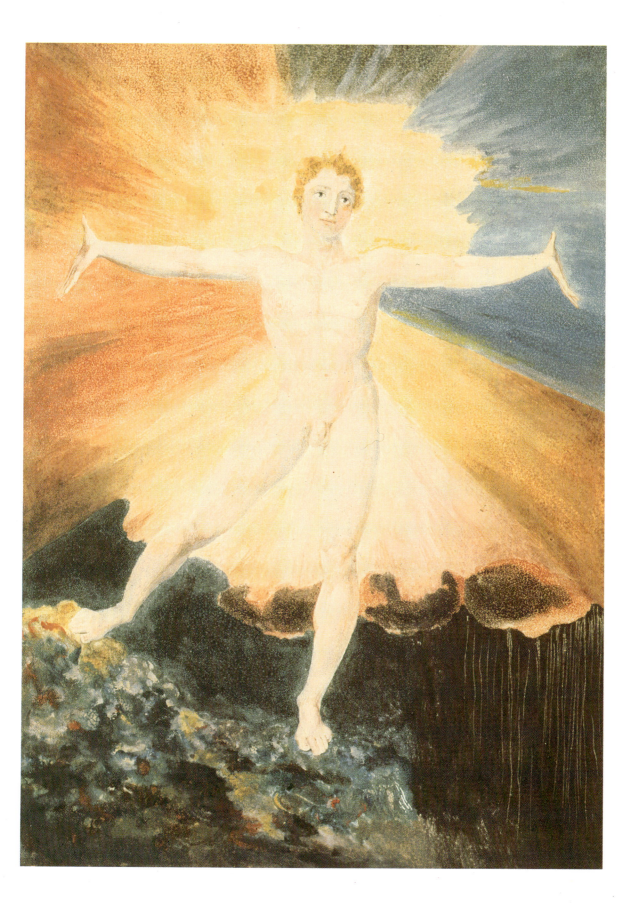

11. Joseph of Arimathea preaching to the Inhabitants of Britain

circa 1794
Colour-printed relief etching finished in pen and watercolour, 7.7 × 10.7 cm
British Museum, London

Only two impressions of this small work are recorded. The reticulated, mottled and granulated surface is typical of Blake's colour-printing and was caused either by the variegated surface of the millboard or, if a metal plate was used, by the tendency of the paint to adhere to the plate when it was lifted. The design is based on a pencil drawing of *circa* 1780 in the Rosenbach Museum and Library, Philadelphia.

The title is not universally accepted; the etching was called *An Aged Man addressing a Multitude* by W. M. Rossetti in the list of works he compiled for the first edition of Gilchrist's *Life* (1863), and it has been argued that the expressions of the faces betray consternation and guilt and not the joy of the newly converted. However, it could equally be argued that people newly converted or on the point of conversion would feel guilty and confounded by their past beliefs and behaviour. There is no real reason to doubt the 'Joseph of Arimathea' title, probably Blake's own, for much of Joseph's story must have been attractive to Blake. He would have found congenial the character of the 'honourable counsellor' who 'went in boldly unto Pilate, and craved the body of Jesus' (*Mark* XV.43). Moreover, legend claimed that Joseph fled to Britain, carrying with him the Holy Grail, and planted his staff at Glastonbury, where it took root, becoming the Glastonbury Thorn which blossomed annually on Christmas Day; and here Joseph founded the first Christian church in England. This was just the kind of symbolic Englishness that appealed to the Blake who wrote 'All things begin & end in Albion's ancient Druid rocky shore.' (K.486)

The composition is simple: a frieze-like group of people is dominated by the figure of Joseph of Arimathea standing at the right on a mound, with his right arm extended and his finger pointing above their heads; with his left hand he is pushing his staff into the soil. The other figures are all individuals, not a characterless crowd: their facial characteristics and expressions vary greatly, from the young man under Joseph's arm who looks up at him as if puzzled, to the elderly bearded man in a purple garment with his eyes closed as if in meditation.

The hues of the listeners' clothing are vivid, yet harmonious. The big red shape in the sky is an important component in the composition, and helps to hold the colourful scheme together. It is not certain what it represents: it might be a cloud, but equally it could be the foliage of trees – the dark shape behind Joseph is the trunk of a tree; it is clearer in the second impression of the work (National Gallery of Art, Washington, D.C.), in which the colouring is thinner.

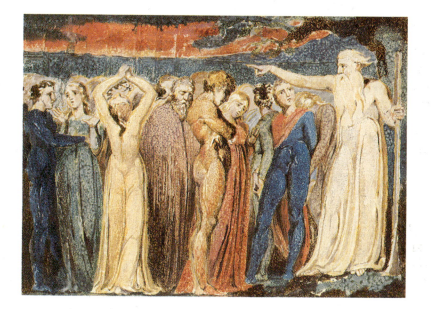

12. Elohim creating Adam

1795

Colour-printed drawing finished in pen and watercolour, 43.1 × 53.6 *cm*
Tate Gallery, London

Blake's large colour-printed drawings, all dated 1795, include some of his greatest work. He created twelve subjects in the medium, but few impressions were taken – no more than three of any one subject are known and it is very unlikely that he printed more than these. He refers to them in a letter of 9 June 1818 to the antiquary Dawson Turner. The reference follows a price list of his illuminated books:

> 12 Large Prints, Size of Each about 2 feet by 1& ½ [60.9 × 45.7 cm], Historical & Poetical, Printed in Colours . . . Each 5 5 0 [£5.25].

> These last 12 Prints are unaccompanied by any writing.

> The few I have Printed & Sold are sufficient to have gained me great reputation as an Artist, which was the chief thing Intended. But I have never been able to produce a Sufficient number for a general Sale by means of a regular Publisher. (K.867)

The subject of *Elohim creating Adam* is based on *Genesis* I.27: 'So God created man in his own image, in the image of God created he him.' Elohim is one of several Hebrew names for God (see also commentary to plate 39). A literal translation (it is a respectful plural) is 'judges', and as such it alludes to God in his judicial (or in Blakean terms, Urizenic) aspect, as opposed to the name Jehovah or Yahveh, which alludes to him in his merciful aspect. Elohim was both creator and judge, and therefore represented the vengeful aspect of God; in Blake's view he created man in order to judge him. A somewhat strange aspect of this design is that Adam is not depicted as being made in the image of God, whereas in the colour-printed drawing *God judging Adam* (also in the Tate Gallery) his features are identical with the Creator's.

Blake's portrayal of the Creation is full of *Sturm und Drang*. The winged and bearded Elohim, weary after the first five days of creation, his face strained with the titanic exertion of bringing the cosmos to birth, hovers against the background of a vast sun setting beneath gloomy clouds. He reaches out unseeingly with his arms and gives the impression of blindly, literally, moulding into form and life from clay the horrified creature Adam, the natural man or mortal worm, who is entwined by the coils of the serpent of materialism.

Blake saw the act of creation as Error, or Fall. Before the Creation there was unity and eternity, but the act of creation brought division: male and female, good and evil, body and soul, all of which must be reunited if eternity is to be regained. In 'A Vision of the Last Judgment' in his Notebook he wrote, 'Error is Created. Truth is Eternal. Error, or Creation, will be Burned up, & then, & not till Then, Truth or Eternity will appear. It is Burnt up the Moment Men cease to behold it.' (K.617) The atmosphere of Error is effectively portrayed in this sublime but terrifying work, which despite its comparatively small size is as impressive as Michelangelo's poetic portrayal of the event in the Sistine Chapel.

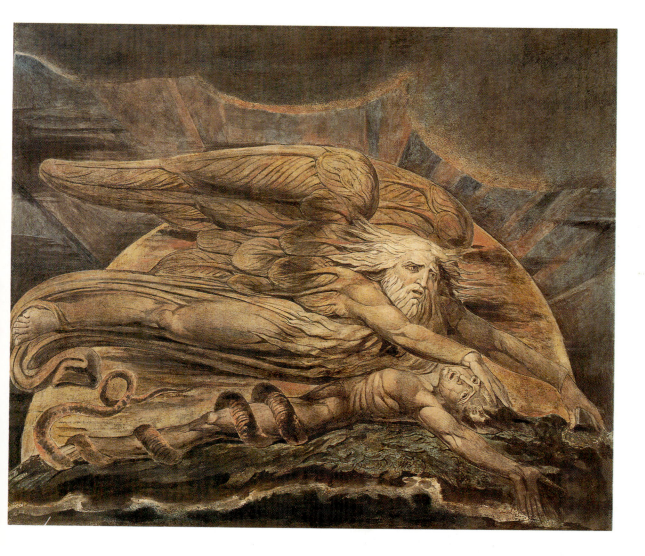

13. Nebuchadnezzar

1795

Colour-printed drawing finished in pen and watercolour, 44.6 × 62 cm
Tate Gallery, London

Another of Blake's large colour prints in the same series as plate 12, this work illustrates an episode in the life of Nebuchadnezzar, King of Babylonia, builder of the walls of Babylon and perhaps also of the Hanging Gardens, one of the Seven Wonders of the World.

As told in *Daniel* IV, the King had a dream in which he saw an enormous tree; 'the height thereof reached unto heaven, and the sight thereof to the end of all the earth'. Messengers descended from heaven and told him to cut it down, but to leave its stump. They continued, 'Let his heart be changed from man's, and let a beast's heart be given unto him.' This was interpreted by the prophet Daniel, who said that the tree was Nebuchadnezzar; and the King was duly 'driven from men, and did eat grass as oxen, and his body was wet with the dew of heaven, till his hairs were grown like eagles' feathers, and his nails like birds' claws', until he acknowledged God's universal dominion, when his reason was restored.

Nebuchadnezzar's hauntingly crazed expression, as if he were witnessing some horrifying nightmare, is so like some recorded expressions of mental patients suffering from appalling terror as to prompt the thought that Blake must have seen sufferers of chronic insanity.

The detailed musculature of the figure, and indeed of many of Blake's figures, indicates the knowledge of anatomy which he acquired at the Royal Academy life classes. The body is like an *écorché* model of the kind used to teach anatomy in figure drawing, and in this context gives the frightening impression that the King has been flayed. The two crossed tree trunks in the background probably refer to the great tree in Nebuchadnezzar's dream.

Some think that Blake's design may have been influenced by a drawing by his contemporary John Hamilton Mortimer, *Nebuchadnezzar recovering his Reason* (British Museum). That is possible, but Blake's design is much closer to that of an anonymous wood-engraving in an edition of Cicero, published in Augsburg in 1531. This portrays Nebuchadnezzar in almost exactly the same pose that Blake has used, and it is even closer to a sketch of the King on page 44 of Blake's Notebook. There is no evidence that Blake ever saw the Augsburg book but the closeness of the two designs suggests that he was following it or something copied from it. Another possible source is Dürer's engraving *The Penance of St John Chrysostomus*, which depicts the saint on all fours in the background of the composition.

Blake had already portrayed Nebuchadnezzar on plate 24 of his illuminated book *The Marriage of Heaven and Hell* (1790–3), but there he is facing to the left and wears a crown. Beneath is the aphorism 'One Law for the Lion & Ox is Oppression' (K.158): the fierce lion is governed by different laws from the gentle ox, the experience of one being is not necessarily another's, and to force different natures to live under the same rule is to oppress them. Nebuchadnezzar, enslaved to his senses, deprived of reason and understanding, is condemned to lead the life of a beast, subjected to the laws for grazing animals instead of those for men.

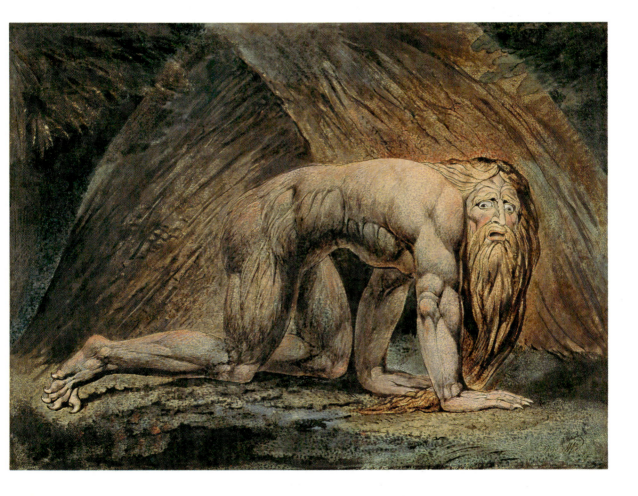

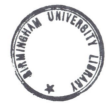

14. 'Infant Joy' from *Songs of Innocence*

circa 1794–5
Relief etching finished in watercolour, 11 × 7 cm (approx)
Private Collection, England

Songs of Innocence, completed in 1789, is Blake's most famous group of poems, containing some of the finest lyrics in the English language; it is also the best known of his illuminated books. The songs are misleadingly simple, for their apparently straightforward verse clothes a deep symbolism; the same is true of the designs. The lyric reproduced here is 'Infant Joy':

'I have no name Pretty joy!
'I am but two days old.' Sweet joy but two days old,
What shall I call thee? Sweet joy I call thee:
'I happy am, Thou dost smile,
'Joy is my name.' I sing the while,
Sweet joy befall thee! Sweet joy befall thee! (K.118)

In common with others in the book, the design adds further dimensions to the poem – it is not a mere illustration. The poem celebrates the birth of a child, the sequel of love; the design depicts an open bud, probably symbolising a barren womb, and a flower in full bloom, probably symbolising a fecund womb, for it holds at its centre a group consisting of a mother nursing her new-born baby with a butterfly-winged Psyche (the soul) blessing them.

It may be argued that this kind of symbolism is inappropriate in the setting for such a song; but that would be to deny Blake's characteristic style, for such symbols proliferate throughout his work, from apparently simple designs like those of *Songs of Innocence*, through those of his complicated 'prophetic' books like *America* and *Europe* (plates 9 and 75) to those of his vast late poems *Milton* and *Jerusalem* (plate 35).

The painting of copies of the *Songs* varies considerably. The present example belongs to the years 1794–5 and, like most early copies, is coloured with simple washes. The plates in this copy were printed back to back on each side of the leaves, which is uncommon. Another unusual feature is the blue colour of the flowers: they are normally red, and I am unable to assign any particular symbolism to this variation. Later, when the book was issued with the addition of *Songs of Experience* as *Songs of Innocence and of Experience* (1794 onwards), elaborate body colour was used and gold highlights were added. It is a matter of taste as to which is the better; the elaborate colouring is beautiful, but the simple washes enable the underlying etching to be seen more clearly.

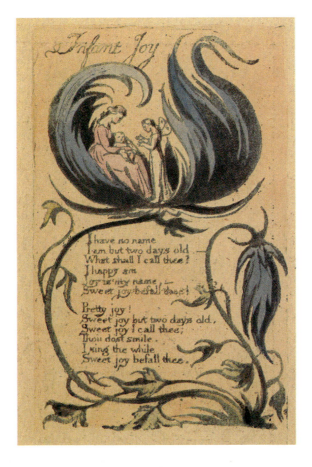

Infant Joy

I have no name
I am but two days old —
What shall I call thee?
I happy am
Joy is my name, —
Sweet joy befall thee!

Pretty joy!
Sweet joy but two days old,
Sweet joy I call thee;
Thou dost smile.
I sing the while
Sweet joy befall thee.

15. 'The Fly' from *Songs of Experience*

circa 1794
Colour-printed relief etching finished in watercolour, 11.8 × 7 cm (approx.)
Private Collection, England

Songs of Experience is a collection of poems illustrating the period of man's spiritual development which succeeds the joyful state of Innocence, in which beauty and love were supreme. In Experience man becomes conscious of disappointment, of sorrow, of soul-limiting artificial morality and of social evils. The carefree child becomes a hard-driven adult; the romantic youth becomes a cynical entrepreneur; the innocent virgin becomes an experienced mother or even a harlot. Not only mankind, but nature itself provides evidence of such contraries; so the innocent lamb is contrasted with the terrible tyger (Blake's spelling). Not that the tyger is evil – it is another aspect of a world in which, in Blake's words, 'Everything that lives is holy'. (K.199) Lamb and tyger each provide evidence of the enormous richness of the world.

Like 'Infant Joy' in *Songs of Innocence* (plate 14), 'The Fly' is an apparently simple song, its short fitful lines recalling an insect's nimble flight:

Little Fly,
Thy summers play
My thoughtless hand
Has brush'd away.

For I dance,
And drink & sing,
Till some blind hand
Shall brush my wing.

Then am I
A happy fly,
If I live,
Or if I die. (K.213)

Am not I
A fly like thee?
Or art not thou
A man like me?

If thought is life
And strength & breath,
And the want
Of thought is death;

Having thoughtlessly killed a fly, the poet realises that the same could happen to himself with no more effect on the world. The life of both fly and man are equally important in a world in which 'Everything that lives is holy'.

The design appears to take this a stage further by commenting on the transitoriness of life. A carefree young girl plays happily, her flying shuttlecock recalling the fly of the poem; beside her a mother is helping her little boy to take his first steps. The impermanence of life is illustrated here, for the innocent child will one day become an adolescent like the girl playing battledore and shuttlecock, who herself will one day become an experienced woman and mother, whose own child will again begin the everlastingly repeated cycle.

It is possible that Blake's theme was suggested by Thomas Gray's 'Ode on the Spring' (ll.43–4): 'Poor moralist! and what art thou? / A solitary fly!' 'Ode on the Spring' was one of the poems by Gray which Blake illustrated in about 1797–8 (see commentary to plate 18).

No separate issue of *Songs of Experience*, without *Songs of Innocence*, is known, despite an advertisement in which Blake once offered the work in this form at 5s. (25p).

THE FLY

Little Fly
Thy summers play,
My thoughtless hand
Has brushd away.

Am not I
A fly like thee?
Or art not thou
A man like me?

For I dance
And drink & sing;
Till some blind hand
Shall brush my wing

If thought is life
And strength & breath;
And the want
Of thought is death;

Then am I
A happy fly,
If I live,
Or if I die.

16. Illustration to Edward Young's *Night Thoughts*: Night IV, Page 8

circa 1795–7
Pen and watercolour over pencil, 42 × 32.5 *cm*
British Museum, London

Blake's illustrations to Young's *Night Thoughts* are one of the biggest groups of works in his *oeuvre*. The intention was to engrave them to illustrate an edition to be published by Richard Edwards of New Bond Street, London. But the publication was a failure and only the first part, containing forty-three engravings, appeared. The engraved designs were only a fraction of the total, for Blake made 537 watercolours (of which it was originally intended to engrave 200); for this he received 20 guineas (£21), which works out at about 9d (about 4p) apiece, surely putting them among the cheapest designs ever commissioned from a great artist. Richard Edwards' brother Thomas said that Blake's watercolours took him two years to complete.

The format was constricting, each design encircling an area of text printed in a conventional type which does not relate well to the freely drawn designs. If Blake had been allowed to do the lettering as well, the designs would have been even more compelling. Blake was usually at his best when he used pen and watercolour, for it afforded him a freedom impossible in more highly wrought methods; moreover it enabled him to practise his aphorism, 'The great and golden rule of art, as well as of life, is this: That the more distinct, sharp, and wiry the bounding line, the more perfect the work of art.' (K.585)

Blake's skill in the use of wash colour is also evident in the *Night Thoughts* watercolours, where he used it to portray a whole range of surface textures and spatial tensions. In these designs he began with a preliminary drawing in light pencil or chalk, which provided a foundation for the finished work, the lines being strengthened with brush or pen in indian ink or, in a number of cases, with firmer pencil. Broad washes of colour followed, and highlights and retouchings were added in watercolour or pen and ink.

The 'bounding line' dominates this design, which illustrates 'Till *Death*, that mighty Hunter, earths them all', the line marked with a cross on this page. The sharp nervous outlines, especially of the figure on the ground with a hound at his throat, are full of tension. The triumphant figure of Death, represented as a devil with a spear in his right hand, and in his left, a leash holding a couple of hounds, is almost equally tense. The conception is reminiscent of the horrific designs of Fuseli, such as *Teiresias Drinks the Sacrificial Blood* (British Museum) and *David Slays Goliath* (City of Auckland Art Gallery). It is interesting to note in Death's outstretched foot a persistent trait that Blake probably picked up during his apprenticeship – the use of the 'classical foot', the second toe longer than the big toe.

A related pencil drawing, *Let Loose the Dogs of War* (?1793), is in the Nelson-Atkins Museum, Kansas City. The main difference between this and the *Night Thoughts* drawing is that the principal figure (Nimrod instead of Death) is seen running towards the quarry rather than poised over it.

(8)

Touching his Reed, or leaning on his Staff,
Eager Ambition's fiery Chace I see;
I see the circling Hunt, of noisy Men,
Burst Laws Enclosure, leap the Mounds of Right,
Pursuing and pursued, each other's Prey;
As Wolves, for Rapine; as the Fox, for Wiles;
Till *Death*, that mighty Hunter, earths them all.

Why all this Toil for Triumphs of an Hour?
What, tho' we wade in Wealth, or soar in Fame?
Earth's highest Station ends in "Here he lies", *100.*
And "Dust to Dust" concludes her noblest Song.
If this Song lives, Posterity shall know
One, tho' in *Britain* born, with Courtiers bred,
Who thought even Gold might come a Day too late;
Nor on his subtle Deathbed plan'd his Scheme
For future Vacancies in Church, or State;
Some Avocation deeming it --- to die;
Unbit by Rage canine of dying Rich;
Guilt's Blunder! and the loudest Laugh of Hell.

O my

17. Title Page to Night VIII of Edward Young's *Night Thoughts*

circa 1795–7
Pen and watercolour over pencil, 42 × 32.5 *cm*
British Museum, London

Of the title pages Blake designed for each of the nine nights of Young's poem, this is the most colourful and spectacular. It underlines the last words of the subtitle, 'The AMBITION and PLEASURE, with the WIT and WISDOM of the WORLD', and is based on the figure of the Whore of Babylon in *Revelation* XVII.3–5:

> . . . I saw a woman sit upon a scarlet coloured beast, full of names of blasphemy, having seven heads and ten horns.
>
> And the woman was arrayed in purple and scarlet colour, and decked with gold and precious stones and pearls, having a golden cup in her hand full of abominations and filthiness of her fornication.
>
> And upon her forehead was a name written, MYSTERY, BABYLON THE GREAT, THE MOTHER OF HARLOTS AND ABOMINATIONS OF THE EARTH.

Blake illustrates this literally, but uses the seven heads of the beast to symbolise his hatred of those who set themselves up to judge and control their fellow men, of repressive religion and of war. Reading from the top left they represent a priest in a Cranmer cap, a bishop wearing a mitre encircled with two crowns, a king, a pope with unseeing eyes wearing a triple tiara, a warrior king, a soldier and a judge. All but the first are horned.

At the right sits the richly attired and bejewelled Whore, holding a gold and scarlet chalice. She has in her eyes an expression of assumed modesty, belied by the tight-lipped, half-hidden lubricity of her mouth. The word 'MYSTERY' on her forehead – to Blake the most important word in the inscription, for it is the only one he has made clear – indicates that she symbolises the false church of deliberate mystification and conventional morality. The 'accursed Tree of Mystery' (K.252) occurs in several places in Blake's writing: it is the Tree of Death, of the forbidden knowledge of good and evil, and is ultimately the rood on which Jesus was crucified. Like the Whore it symbolises the loss of Innocence; for to the innocent there is no mystery, all is clear. As Blake wrote:

> Jesus supposes every Thing to be Evident to the Child & to the Poor & Unlearned. Such is the Gospel.
>
> The Whole Bible is fill'd with Imagination & Visions from End to End & not with Moral Virtues; that is the business of Plato & the Greeks & all Warriors. The Moral Virtues are continual Accusers of Sin & promote Eternal Wars & Dominency over others. (K.774)

The title page to Night VIII of *Night Thoughts* perfectly emphasises this.

Blake painted another watercolour of *The Whore of Babylon* in 1809 (British Museum). It is more horrific than the present one, and more meticulously painted.

THE

COMPLAINT.

OR,

𝕹𝖎𝖌𝖍𝖙-𝕿𝖍𝖔𝖚𝖌𝖍𝖙𝖘

ON

LIFE, DEATH, and IMMORTALITY.

NIGHT *the* EIGHTH.

VIRTUE's APOLOGY:

OR,

The MAN *of the* WORLD *Answer'd.*

In which are Considered,

The LOVE *of* THIS LIFE;

The AMBITION *and* PLEASURE, *with the* WIT
and WISDOM *of the* WORLD.

LONDON:

Printed for G. HAWKINS, at *Milton*'s Head, between the *Two Temple-
Gates, Fleet-ſtreet,* near *Temple-Bar.*
And Sold by M. COOPER, at the *Globe,* in *Pater-noſter Row.*

MDCCXLV.

18. Illustration to Thomas Gray's 'Ode on a Distant Prospect of Eton College'

circa 1797–8
Pen and watercolour over pencil, 42 × 32.5 cm
Collection of Mr and Mrs Paul Mellon, Upperville, Virginia

Blake's 116 large watercolour illustrations to Gray's *Poems* were commissioned by Thomas Flaxman for his wife Ann, who had admired the *Night Thoughts* designs (see plates 16 and 17). In 1797 she wrote that '[Blake] has sung his wood-notes wild – of a strong and singular Imagination he has treated his Poet [Young] most Poetically – Flaxman has employ'd him to Illuminate the works of Gray for my Library.'

The book was planned, like the *Night Thoughts* illustrations, with the designs surrounding areas of type. It seems that notwithstanding the awkwardness of this format Blake was strongly attracted to it, for in addition to these two works he wrote out and adapted in the same way *Vala, or the Four Zoas* (1795–1804), his unfinished epic. And on a smaller scale the designs of many of the pages in his illuminated books were similarly conceived, though in those text and design are more closely integrated.

In this series Blake dissected the 1790 edition of Gray's *Poems*, retaining the title page and the poems but discarding the introductory pages and the notes at the end. He then cut apertures in large sheets of Whatman paper in which he inlaid the poems before making the surrounding designs.

This design illustrates some of the most famous lines from Gray's 'Ode on a Distant Prospect of Eton College' (ll. 51–62; Blake has marked the penultimate line of the page):

> Alas, regardless of their doom,
> The little victims play!
> No sense have they of ills to come,
> Nor care beyond to-day:
> Yet see how all around 'em wait
> The Ministers of human fate,
> And black Misfortune's baleful train!
> Ah, shew them where in ambush stand
> To seize their prey the murth'rous band!
> Ah, tell them, they are men!
> These shall the fury Passions tear,
> The vulturs of the mind . . .

In the foreground children are at play: two boys, one carrying a cricket bat, the other running with his arms uplifted and waving his hat; and two girls, one playing with a ball, the other nursing a doll. The background is occupied by horrid apparitions that would not be out of place in a work by Hieronymus Bosch. Dominating the others are three 'vulturs of the mind', one of them reaching down with a human arm towards the children; at the left is the scaly figure of Jealousy with the snake of materialism entwined around his left arm; a serpent at the right points its head towards one of the girls. Just behind the children and in places grasping at them are a routing pig (Gluttony), a brooding lion (Pride), a devil (Avarice) and a blind spectre (Despair). The landscape is grim and depressing, the sky threatening, with birds of ill omen flying in it. The power of the images indicates how fully Blake sympathised with Gray's vision of Innocence as a temporary blessing.

58 ODE ON A DISTANT PROSPECT

Theirs buxom Health, of rosy hue,
Wild wit, Invention ever-new,
And lively Cheer of Vigour born;
The thoughtless day, the easy night,
The spirits pure, the slumbers light,
That fly th' approach of morn.

Alas! regardless of their doom,
The little victims play!
No sense have they of ills to come,
Nor care beyond to-day:
Yet see, how all around 'em wait
The ministers of human fate,
And black Misfortune's baleful train!
Ah, show them where in ambush stand,
To seize their prey, the murderous band!
Ah, tell them they are men!

+ These shall the fury passions tear,
The vultures of the mind,
 Disdainful

19. Illustration to Thomas Gray's 'A Long Story'

circa 1797–8
Pen and watercolour over pencil, 42 × 32.5 cm
Collection of Mr and Mrs Paul Mellon, Upperville, Virginia

This is an illustration to a light-hearted poem about a visit paid to Gray by two young ladies, Lady Schaub and Miss Speed. They admired his 'Elegy written in a Country Churchyard', and promised to introduce the poet to their hostess, Lady Cobham, who lived at Stoke Poges Manor, near to Gray's mother's home. When they arrived he was out, so they left their name on the parlour table, written on a piece of paper.

Gray made his poem out of this, portraying the two young women as Amazons hunting the poet, who was supposed to be bewitching children, farm animals and game. Being unable to find him they rushed into his house, ransacked the rooms, and finally flew out of the window, having left a spell written on a paper; in this he was bidden to appear at the Manor House before a tribunal of 'high dames of honour', presided over by a peeress, before whom he confessed that he had from time to time written a sonnet. At which, to the resentment of the tribunal, who

> Already had condemn'd the sinner.
> My Lady rose, and with a grace –
> She smiled, and bid him come to dinner. (ll.130–2)

This watercolour illustrates the moment when the women fly out of the window amid flashes of lightning, leaving their spell 'upon the table'.

It is possible that Blake's portrayal of Gray's two 'Amazons' was influenced by the reputation of the 'Ladies of Llangollen', Lady Eleanor Butler and Miss Sarah Ponsonby, who had run away from their Irish home, resolving to live together in isolation from society. They settled in a house called Plas Newydd in the Vale of Llangollen. They were well-known characters by the time Blake was painting these watercolours, and he would almost certainly have heard of them, if only through the poem 'Llangollen Vale', written in their honour by Anna Seward (a friend of Hayley) in 1796. Further, they wore top hats, and one of Blake's young ladies is similarly covered. Blake could have been prompted to parallel them with Gray's ladies because the two Irish ladies were in love with one another, and from this to Gray's reference to 'Amazons' was but a step.

Blake's combination of nervous bounding lines and lucent colouring is at its best in his rendering of the two figures, which are fully convincing even though their flight is a fantasy. The background wall hung with vines, illuminated over a considerable area by flashes of lightning, is less meticulously delineated than the figures, and the colouring apparently more carelessly applied, but the effect can be taken to represent the momentary dazzle amid darkness typical of lightning.

So Rumour fays: (Who will, believe.)
But that they left the door a-jar,
Where, fafe and laughing in his fleeve,
He heard the diftant din of war.

Short was his joy. He little knew
The power of magic was no fable ;
Out of the window, whifk, they flew,
But left a fpell upon the table.

The words too eager to unriddle
The poet felt a ftrange diforder :
Tranfparent birdlime form'd the middle,
And chains invifible the border,

So cunning was the Apparatus,
The powerful pothooks did fo move him,
That, will he, nill he, to the Great-houfe
He went, as if the devil drove him.

 Yet

20. Eve tempted by the Serpent

circa 1799–1800
Tempera and gold on copper, 27.3 × 38.5 *cm*
Victoria and Albert Museum, London

Between about 1799 and 1809 Blake painted some 135 biblical subjects for Thomas Butts. The first commission was for fifty small pictures, of which this is one (others are reproduced on plates 21–4). They were executed in what Blake called 'fresco', which he later advertised in his *Descriptive Catalogue* (1809):

THE INVENTION OF A PORTABLE FRESCO

A Wall on Canvas or Wood, or any other portable thing, of dimensions ever so large, or ever so small, which may be removed with the same convenience as so many easel Pictures; is worthy the consideration of the Rich and those who have the direction of public Works. If the Frescos of APELLES, of PROTOGENES, of RAPHAEL, or MICHAEL ANGELO could have been removed, we might, perhaps, have them now in England. I could divide Westminster Hall, or the walls of any other great Building, into compartments and ornament them with Frescos, which would be removable at pleasure.

Oil will not drink or absorb Colour enough to stand the test of very little Time and of the Air; it grows yellow, and at length brown. It was never generally used till after VANDYKE's time. All the little old Pictures, called cabinet Pictures, are in Fresco, and not in Oil.

Fresco Painting is properly Miniature, or Enamel Painting; every thing in Fresco is as high finished as Miniature or Enamel, although in Works larger than Life. The Art has been lost: I have recovered it. (K.560)

But Blake confused painting in tempera with fresco. He had not 'recovered' fresco, for his 'fresco' was a form of tempera in which carpenter's glue replaced the usual egg yolk. Fresco is worked in colours ground in water, on a wet, freshly applied lime-plaster wall; the colour unites with the plaster and after drying it cannot be altered or removed without destroying the plaster.

Blake's technique is described by J. T. Smith in the second volume of his *Nollekens and his Times* (2nd edn, 1829):

[Blake's] ground was a mixture of whiting and carpenter's glue, which he passed over several times in thin coatings: his colours he ground himself, and also united them with the same sort of glue, but in a much weaker state. He would, in the course of painting a picture, pass a very thin transparent wash of glue-water over the whole of the parts he had worked upon, and then proceeded with his finishing . . . Blake preferred mixing his colours with carpenter's glue, to gum, on account of the latter cracking in the sun, and becoming humid in moist weather. The glue-mixture stands the sun, and change of atmosphere has no effect upon it.

These temperas have not endured well and have in most cases darkened prematurely, probably because of the glue.

Blake portrays Eve as a narrow-hipped and almost androgynous figure. The serpent, an enormous crested reptile in coils behind her and around her feet, reaches around and above the sleeping Adam. A crescent moon (signifying activity and so, perhaps, the onset of the Fall) is in the dark sky, above a waterfall cascading into a river. In Blake's symbolism as it developed during the Lambeth period, water represents matter; he may have acquired this from the Neoplatonists (especially Thomas Taylor), who much influenced him. The tree at the left is the Tree of Mystery (see commentary to plate 17).

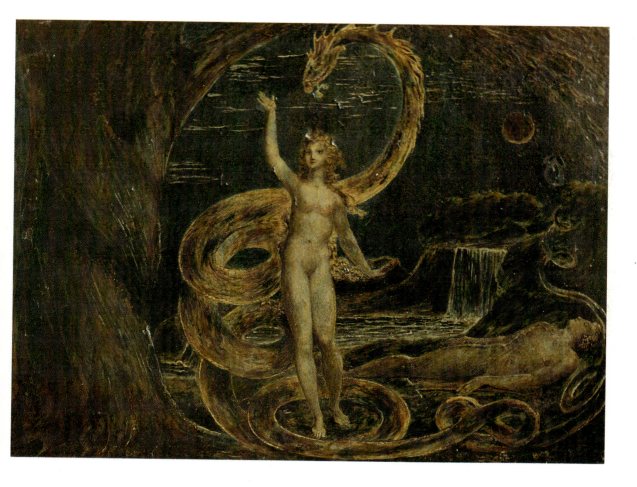

21. Abraham and Isaac

circa 1799–1800
Pen and tempera on canvas, 26 × 37.5 *cm*
Yale Center for British Art, New Haven, Connecticut (Paul Mellon Collection)

Abraham and Isaac, another of the tempera paintings for Thomas Butts (see commentary to plate 20), is based on *Genesis* XXII, in which Jehovah 'tempts' Abraham in order to test the extent of his devotion. 'Take now thy son, thine only son Isaac, whom thou lovest,' Abraham is instructed, 'and get thee into the land of Moriah; and offer him there for a burnt offering upon one of the mountains which I will tell thee of.' Abraham does as he is told.

> And they came to the place which God had told him of; and Abraham built an altar there, and laid the wood in order, and bound Isaac his son, and laid him on the altar upon the wood.
>
> And Abraham stretched forth his hand, and took the knife to slay his son.
>
> And the angel of the Lord called upon him out of heaven, and said, Abraham, Abraham: and he said, Here am I.
>
> And he said, Lay not thine hand upon the lad, neither do thou any thing unto him: for now I know that thou fearest God, seeing thou has not withheld thy son, thine only son from me.
>
> And Abraham lifted up his eyes, and looked, and behold behind him a ram caught in a thicket by his horns: and Abraham went and took the ram, and offered him up for a burnt offering in the stead of his son.

Blake's interpretation of this story differs in detail from the biblical passage. It shows the naked Isaac not bound upon the altar, but in an excited, dynamic, almost balletic pose before his father, pointing with his left hand at the entrapped ram. The bearded Abraham looks upwards with an expression of thankfulness, one outstretched hand on the ram, the other poised on the altar and holding a sacrificial knife. The red sky at the right perhaps indicates the presence of the angel sent to stay his hand.

Blake intended the picture as more than a simple illustration of the traditional story. This is why he departs from the biblical narrative in showing Isaac, instead of his father, discovering the ram in the thicket: youth is pointing out to age that the time has come for mankind to turn from human sacrifice to the sacrifice of animals. The Druids are supposed to have offered human sacrifices and, to Blake, Abraham was one of the last Druids; in his *Descriptive Catalogue* (1809) he wrote: 'Adam was a Druid, and Noah; also Abraham was called to succeed the Druidical age, which began to turn allegoric and mental signification into corporeal command, whereby human sacrifice would have depopulated the earth.' (K.578) He saw the story of Abraham and Isaac representing a significant stage in man's spiritual development.

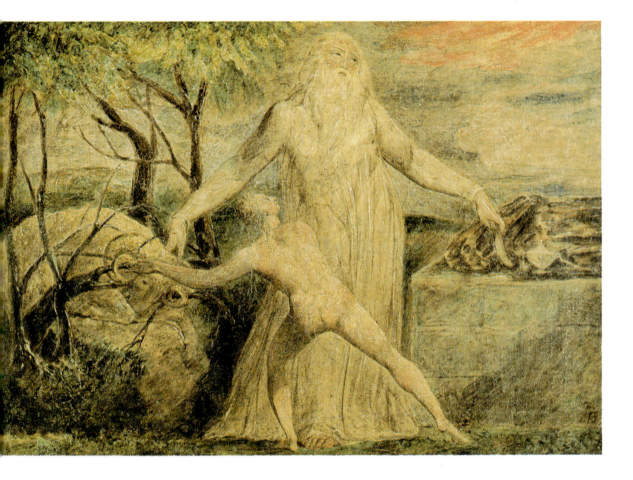

22. Bathsheba at the Bath

circa 1799–1800
Tempera on canvas, now mounted on board, 26.3 × 37.6 *cm*
Tate Gallery, London

Another of the tempera paintings for Thomas Butts (see commentary to plate 20). Here Blake is in an unusual but properly erotic mood, portraying the incident described in *II Samuel* XI.2: 'And it came to pass in an eveningtide, that David arose from off his bed, and walked upon the roof of the king's house: and from the roof he saw a woman washing herself; and the woman was very beautiful to look upon.' There is no doubt of the beauty of Blake's Bathsheba, as she steps, almost dances, towards the pool in front of her, supported by two comely children; her servant, sitting at the edge of the pool with her feet in the water, beckons to her with one hand and rests the other on an unguent jar. (Neither the children nor the servant occur in the biblical account.) From the roof of his palace in the distance at the right the crowned David watches Bathsheba, his hands lifted in surprise at her beauty.

In the background are trees and redolent flowers: lilies, roses, and honeysuckle, a branch of which entwines one of the four columns, decorated with palm leaves, which frame the composition. The opalescent sky is bathed in the golden reflection of the setting sun.

Blake has again modified and interpreted the biblical account; he has given the scene an idyllic, delicate quality, especially by the introduction of the children – Bathsheba is a tender mother, not just an object of desire. The delectable atmosphere conveys Blake's rejection of the conventional, restrictive attitude towards women and sex. (See further his poem *Visions of the Daughters of Albion*, which he published as an illuminated book in 1793.) The story of Bathsheba continues with an account of her adultery with David and the birth of their son, Solomon. Blake accentuates his liberal view of this in his long poem *Jerusalem* (1804–20), where he reverses the biblical statement that St Joseph was directly descended from this union (*Matthew* I.1–16) and names Bathsheba as one of the ancestors of Mary (K.696), envisaging her as a character of singular nobility and importance in Christian belief, in no way diminished by adultery.

Despite his strictures on Venetian painting (see Introduction), here Blake has conceived a work which seems to be strongly influenced by the Venetian school, though it is difficult to say exactly which artists – probably an amalgam of details picked up from prints or copies of such works as Veronese's *Susanna and the Elders* (Cassa di Risparmio, Genoa, and Prado, Madrid) or Titian's *Diana and Callisto* (National Gallery of Scotland, Edinburgh). The figures in *Bathsheba* seem also to show the influence of the Emilian mannerist painter Parmigianino; compare for instance his *Madonna of the Long Neck* and *The Madonna of St Zachary* (both Uffizi, Florence). But if Blake did adapt such details, he thoroughly assimilated them; the portrayal is very much his own.

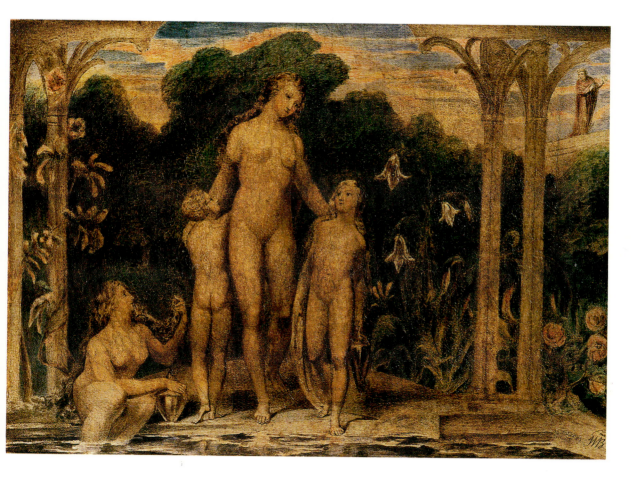

23. The Nativity

circa 1799–1800
Tempera on copper, 27.3 × 38.2 cm
Philadelphia Museum of Art

This is one of the most poetic depictions of the Nativity by any artist. On a bed of straw at the left Joseph supports his exhausted spouse. The figure of the child Jesus, surrounded by a halo of glory, is shown leaping from Mary's womb towards the extended arms of Elizabeth, who supports the child John the Baptist on her lap. Behind her, two oxen feed at a manger, and the huge star of the Magi shines through the window.

This portrayal of the moment of birth is entirely original, and effectively concentrates attention on the miraculousness of the event. Blake used it once again (with almost the same composition, in reverse, within a Gothic stable) for *The Descent of Peace*, one of a set of watercolours illustrating Milton's ode 'On the Morning of Christ's Nativity' painted for Butts in about 1815 (Henry E. Huntington Library and Art Gallery, San Marino, California). In this later work the symbolism of the subject is extended, following Milton's text: a descending angel (Peace) spreads his wings over the stable roof, while in front of the stable the naked figure of Nature lies half buried in the snowy ground, awakened by the call of Peace.

In the tempera there is a distinct opposition in tension between Joseph and Mary on the left and Elizabeth and the infant John on the right. Mary's passive form is supported in the gentle arms of Joseph, who himself looks with astonishment at the leaping child. In contrast Elizabeth holds out her arms to catch him, in a gesture charged with anxious vigour that suggests mankind reaching for its salvation. Even the child John on her lap holds up his little hand in wonder.

The temperas Blake painted for Butts (see commentary to plate 20) have been seen as a new dawn, the inception of a more hopeful element in his outlook after the gloomy forebodings of his earlier years at Lambeth (see plates 8, 9, 12, 13, 15–18). There is a lightening of atmosphere in several of them, compared with the grim and tenebrous melancholy of the Urizenic mythological world. The Nativity was for Blake a powerful symbol of the dawn of new light, for by the birth of the Divine Child the old gods are destroyed; even the Old Testament God is eclipsed – as he expressed it in his Notebook commentary to *A Vision of the Last Judgment* (plate 47): 'Thinking as I do that the Creator of this World is a very Cruel Being, & being a Worshipper of Christ, I cannot help saying: "the Son, O how unlike the Father!" First God Almighty comes with a Thump on the Head. Then Jesus Christ comes with a balm to heal it.' (K.617)

But for all the divine content of *The Nativity*, Blake did not really believe in the virgin birth; he did not subscribe to any conventional religious dogma. To him the humanity of Jesus was of greater importance than his divinity. In *The Everlasting Gospel* (*circa* 1818), Blake wrote – in striking contrast to this picture –

> Was Jesus Born of a Virgin Pure
> With narrow Soul & looks demure?
> If he intended to take on Sin
> The Mother should an Harlot been,
> Just such a one as Magdalen
> With seven devils in her Pen. (K.756)

Both views are entirely characteristic of the man Kathleen Raine calls 'our greatest Christian artist'.

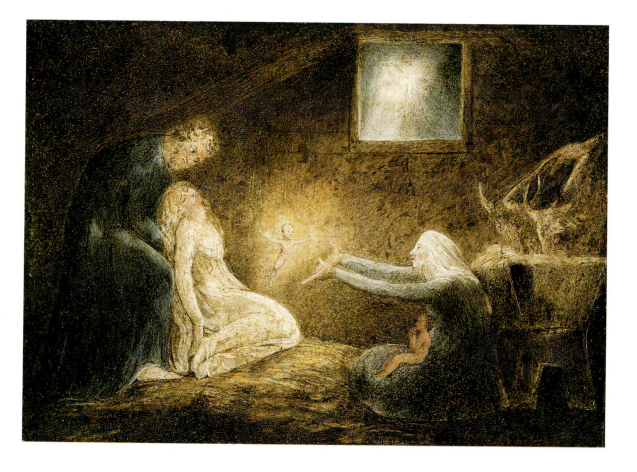

24. Our Lady with the Infant Jesus riding on a Lamb

1800

Pen and tempera on canvas, 27.3 × 38.7 cm
Victoria and Albert Museum, London

Blake here uses again the device of trees on each side to frame the composition (see also plate 22). The background is a landscape of hills, with the River of Life meandering through it. The Christ child, his arms extended, perhaps in a reference to the Crucifixion, rides on the back of a lamb, another symbol of his coming sacrifice. His mother, the same gentle and beautiful girl as in *The Nativity* (plate 23), walks behind, anxiously holding out her hands ready to balance him.

The child John the Baptist, in a pose reminiscent of *The Dance of Albion* (plate 10), walks before the lamb, encouraging it by holding out a bunch of hay. In his other hand he holds two entwined flower stems, a pattern repeated in the vine encircling the tree on the right. This is an ancient symbol, derived from the Roman practice of training vines on elm trees, which in time came to signify marriage or unity: here it probably represents Christ's concord with man. The stems in the hand of the Baptist might similarly symbolise the convolution of Christ's life with his own.

The trees with arching branches, close the the river, are very likely meant to be weeping willows, in further reference to the coming sacrifice of Christ. Yet the holy group seem happy and unaware of what is in store for them; it is only by oblique references that the onlooker is reminded of their fate. A true visual Song of Innocence, the picture recalls Blake's poem, 'The Lamb':

> Little Lamb, who made thee?
> Dost thou know who made thee?
> Gave thee life, & bid thee feed
> By the stream & o'er the mead;
> Gave thee clothing of delight,
> Softest clothing, wooly, bright;
> Gave thee such a tender voice,
> Making all the vales rejoice?
> Little Lamb, who made thee?
> Dost thou know who made thee?
>
> Little Lamb, I'll tell thee,
> Little Lamb, I'll tell thee:
> He is called by thy name,
> For he calls himself a Lamb,
> He is meek, & he is mild;
> He became a little child.
> I a child, & thou a lamb,
> We are called by his name.
> Little Lamb, God bless thee!
> Little Lamb, God bless thee! (K.115)

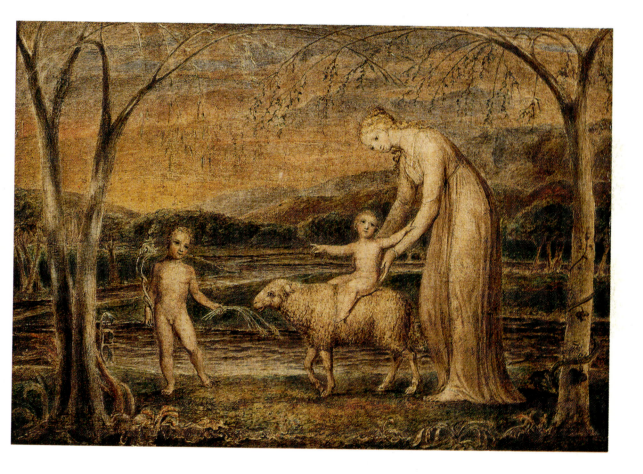

25. Landscape near Felpham

circa 1800
Pencil and watercolour, 30 × 41.2 *cm*
Tate Gallery, London

This unfinished landscape with the village of Felpham in the distance was probably painted soon after Blake's arrival there (see Introduction). It amply demonstrates what the main body of his work has led some to doubt, that he was capable of painting straightforward landscapes.

At the left is a large windmill, since dismantled; in the distance at the left is the church of St Mary and at the centre is The Turret, the house of his new patron William Hayley. Farther to the right of this is Blake's cottage (which he described to Thomas Butts as 'of Cottages the prettiest' (K.810)), picked out by a sunbeam – a characteristically Blakean touch, perhaps meant to denote the light of inspiration shining on his home.

The realism of this watercolour perhaps indicates a cleansing of Blake's vision, which he hoped was to lead to a new onset of inspiration, already tentatively begun in some of his tempera paintings for Butts (plates 22–4). Blake was so moved by his new prospects that in a euphoric letter to Hayley, whom he addressed as 'Leader of My Angels', he exclaimed, 'My fingers Emit sparks of fire with Expectation of my future labours.' (K.801) And in a letter to Butts written on 2 October 1800, he expressed his happiness in a poem beginning:

> To my Friend Butts I write
> My first Vision of Light,
> On the yellow sands sitting.
> The Sun was Emitting
> His Glorious beams
> From Heaven's high Streams.
> Over Sea, over Land
> My Eyes did Expand
> Into regions of air
> Away from all Care,
> Into regions of fire
> Remote from Desire;
> The Light of the Morning
> Heaven's Mountains adorning:
> In particles bright
> The jewels of Light
> Distinct shone & clear.
> Amaz'd & in fear
> I each particle gazed,
> Astonish'd, Amazed;
> For each was a Man
> Human-form'd. Swift I ran,
> For they beckon'd to me
> Remote by the Sea,
> Saying: Each grain of Sand,
> Every Stone on the Land,
> Each rock & each hill,
> Each fountain & rill,
> Each herb & each tree,
> Mountain, hill, earth & sea,
> Cloud, Meteor & Star,
> Are Men Seen Afar.
> I stood in the Streams
> Of Heaven's bright beams,
> And Saw Felpham sweet
> Beneath my bright feet . . . (K.804–5)

26. Head of Milton

circa 1800–3
Pen and tempera on canvas, 40.1 × 90.9 *cm*
City of Manchester Art Galleries

Among the first tasks Hayley set Blake after he had settled at Felpham was to paint in tempera eighteen heads, just under life size, mostly of poets, for a frieze in the library at The Turret.

Blake wrote to Hayley on 26 November 1800 that he was 'Absorbed by the poets Milton, Homer, Camoens, Ercilla, Ariosto and Spenser, whose physiognomies have been my delightful study'. (K.806) In fact the somewhat idiosyncratic choice of subjects was Hayley's, and comprised, in addition to those mentioned by Blake, Cicero, Demosthenes, Shakespeare, Otway, Dryden, Pope, Cowper, Dante, Tasso, Klopstock, Voltaire, and Hayley's natural son Thomas Alphonso, whose portrait was based partly on a medallion by Flaxman. Some of the compositions contained elements drawn from designs by Thomas Alphonso; his picture *The Death of Demosthenes*, which Blake had already engraved for Hayley's *Essay on Sculpture* (1800), provided the design for the Demosthenes portrait.

The painting of the heads is unequal, but in the best of them it is fine, and Milton's head, which Blake based on a crayon portrait by William Faithorne, is amongst the most impressive. The blind poet is surrounded by a wreath of fruiting bay and oak leaves, the bay symbolising his poetic achievements, the oak leaves his errors. The oak, with its Druidic associations, was frequently used by Blake to denote Error (see also commentaries to plates 28, 35, 48, 69 and 74); he was aware of the traditional belief that oak was used for the cross. Towards the base of the wreath on the right is an apple and along the lower part of the design is a crested serpent with an apple between its fangs – references to the story of the Fall in *Paradise Lost*. At the left is the edge of a harp, probably referring to Milton's hymns and psalm translations, and at the right is part of a pastoral pipe, a reminder of his pastoral verse. The palm trees at either side probably refer to classical victors' prizes.

Milton was a central figure in Blake's thought. He made illustrations of several of his works (see plates 33, 34, 40, 45, 48, 49, 51, 54 and 55) and also wrote a poem, *Milton*, which he made into an illuminated book. It is a long and complicated work, of which the central theme tells how Milton, 'unhappy tho' in heav'n' (K.481), decides to return to earth to correct errors made in his previous existence, during which he was dominated by reason to the detriment of his emotional relationships with his wife and family – Blake was highly critical of Milton and disapproved especially of his repressive views on sexual morality. *Milton* is also bound up with many aspects of Blake's disappointing life at Felpham; as he wrote to Butts, 'none can know the Spiritual Acts of my three years' Slumber on the banks of the Ocean . . . unless he should read My long Poem descriptive of those Acts . . . I have written this Poem from immediate Dictation, twelve or sometimes twenty or thirty lines at a time, without Premeditation & even against my Will.' (K.823)

The poem's preface contains what is now Blake's most famous song, beginning:

> And did those feet in ancient time
> Walk upon England's mountains green?
> And was the holy Lamb of God
> On England's pleasant pastures seen? (K.480)

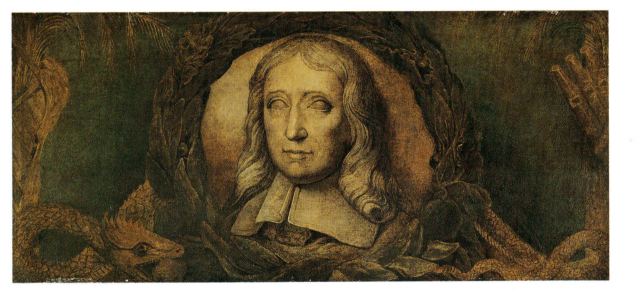

27. Miniature of the Rev. John Johnson

1802
Watercolour on card, 9 × 7.8 cm
Collection of Miss Mary Barham Johnson

Writing from Felpham to Thomas Butts on 10 May 1801, Blake referred to Hayley's kindness and to another branch of art which, at the Hermit's behest, he had begun to practise: miniature painting, which was in Hayley's opinion 'the only lucrative walk of art in those days'.

Mr Hayley acts like a Prince. I am at complete Ease, but I wish to do my duty, especially to you, who were the precursor of my present Fortune. I never will send you a picture unworthy of my present proficiency. I soon shall send you several; my present engagements are in Miniature Painting. Miniature is become a Goddess in my Eyes, & my Friends in Sussex say that I Excel in the pursuit. I have a great many orders, & they Multiply. (K.808)

From the number of portraits that have apparently survived – six – it seems that 'a great many orders' may have been an exaggeration. There are miniatures of Mr and Mrs Butts and of their son Thomas in the British Museum, and there are two of the poet William Cowper, whom Hayley had befriended, one in the Ashmolean Museum, Oxford, and the other in the possession of the Misses Cowper Johnson. Two miniatures of George Romney have not been seen since 1801. There is evidence of a miniature of Mrs Hayley, but that too remains untraced.

The miniature of Johnson (called 'Johnny of Norfolk' by his second cousin, Cowper) was painted when he visited Hayley in January 1802. He is shown seated, leaning on a book with his left arm: this is probably an allusion to his plan for a new edition of Cowper's translation of Homer. There is a church tower and spire in the background resembling the spires of Chichester and Norwich Cathedrals; Johnson was rector of the combined parishes of Yaxham and Welborne in Norfolk, and the spire symbolises his aspirations to a prebendary stall in one of these cathedrals.

It is impossible to know for certain if the miniature is an accurate likeness of Johnson, but Hayley said that Blake 'executed some portraits in miniature very happily, particularly a portrait of Cowper's beloved relation, the Revd Dr Johnson', which suggests that this depiction of an alert, intelligent expression was convincingly lifelike.

Blake was not slow to tire of miniature painting, and the reason, apart from his impatience with it as an art, is not far to seek, for Hayley's pompous patronage lay behind the whole idea. In a letter of 13 May 1801, he wrote to a friend how 'I have recently formed a new artist for this purpose by teaching a worthy creature (by profession an Engraver) who lives in a little Cottage very near me to paint in miniature.'

Blake used the technique of miniature painting long after he had left Felpham (e.g. plates 30, 56), but it is improbable that he ever painted portrait miniatures after his return to London.

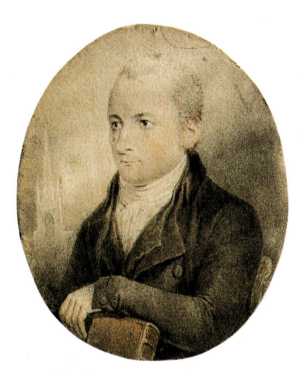

28. The Creation of Eve: 'And She shall be called Woman'

circa 1803–5
Pen and watercolour, 41.8 × 33.5 *cm*
Metropolitan Museum of Art, New York

In about 1800 Blake again took up watercolour as his main pictorial medium, and during the next five years he painted some eighty watercolours of biblical subjects for Thomas Butts. He executed many of them while he was still at Felpham. Writing from there to Butts on 6 July 1803, he mentions seven of the series by title; and on 16 August, presumably referring to the same works, he writes: 'I send 7 Drawings, which I hope will please you; this, I believe, about balances our account'. (K.826) At about the same time he sent Butts an account for 14 guineas (£14.70) for payment for eleven drawings delivered in July and August, including one – *The Three Mairies* (Fitzwilliam Museum, Cambridge) – mentioned in the letter of 6 July. As will be seen in *The Creation of Eve* and the four following plates, they vary considerably in style and technique.

Here the Elohim, with Urizenic beard, standing on the edge of a cloud, holds Adam's hand with his right hand and the newly created Eve's with his left. The birth of Eve is not shown in the usual way, with Eve issuing from Adam's side; she stands on the cloud with the Elohim, her left foot forward to symbolise her physical aspect.

Adam lies on a vast oak leaf that symbolises both Error and the suffering which materialism, evoked by the creation of woman, causes mankind. At his feet, sheep and a lion stand together, and behind the Elohim another flock of sheep is grazing – symbols of paradisal peace. To the left is a tree entwined with a vine bearing grapes, symbol of marriage (see commentary to plate 24), and on it are perched two colourful birds, traditional symbols of the soul. The background consists of a hilly landscape with the River of Life flowing through it, and behind the hills a black, threatening sky indicates the coming Fall.

Some idiosyncratic features will be noticed: the feet of the Elohim and of Eve are drawn in the classical manner, with the second toe longer than the great toe (see commentary to plate 16); there is also some disproportion, as in the small size of Adam's head and in the drawing of his left, supporting arm. Blake was not interested in verisimilitude, and made proportion subservient to beauty of line and spiritual intensity (see commentary to plate 2).

On the back of the watercolour is a rough pencil sketch of the composition in reverse, presumably a preliminary study.

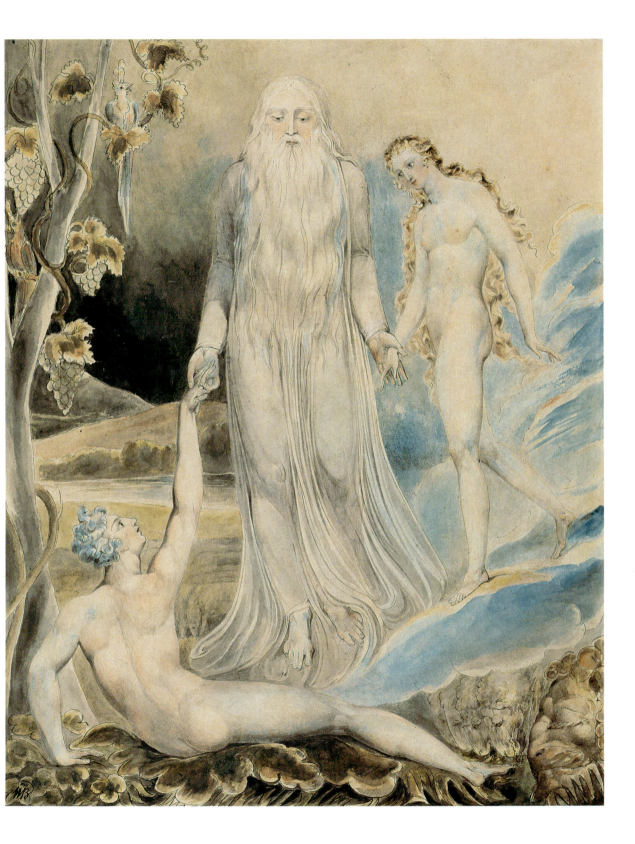

29. Goliath cursing David

circa 1803–5
Pen and watercolour, 34.9 × 36.8 *cm*
Museum of Fine Arts, Boston, Massachusetts

Blake painted this subject twice: in a pen over pencil drawing of *circa* 1780–5 (also in the Museum of Fine Arts, Boston), and in the watercolour reproduced here. The earlier study treats the subject differently – Goliath is depicted as an ordinary, though huge, bearded man, nearly naked. In this work the composition is based on the earlier drawing, but the giant is now a terrifying armoured figure striding before the Israelite army, with an attendant bearing his sword and his shield decorated with a dragon. This closely follows the biblical account in *I Samuel* XVII.4–7:

> And there went out a champion out of the camp of the Philistines, named Goliath, of Gath, whose height was six cubits and a span.
>
> And he had an helmet of brass upon his head, and he was armed with a coat of mail; and the weight of the coat was five thousand shekels of brass.
>
> And he had greaves of brass upon his legs, and a target of brass between his shoulders.
>
> And the staff of his spear was like a weavers' beam: and his spear's head weighed six hundred shekels of iron: and one bearing a shield went before him.

According to the most conservative interpretation of the measurements given in the biblical account the Philistine was nearly 3 metres (over 9 feet) high. Here he is depicted extending his left hand towards the youthful David, who has been sent out by the Israelites as their champion, and jeers at him, his ugly hook-nosed face distorted with rage, cursing the boy by his gods. The curly-haired shepherd-boy, holding only his crook, meets the Philistine's menace with confidence; but the armed and armoured Israelites are afraid and half turn away from the threatening giant.

With the exception of David, the figures are all drawn in the accepted academic proportions, but David has been given a disproportionately small head (like that of Adam in plate 28), and a slender body; and his legs, so far as they are visible, are more like a girl's than a boy's. All of this effectively removes him from the ordinary world and evokes the boy hero who, in the biblical account, was 'but a youth, and ruddy, and of a fair countenance', and came to Goliath 'in the name of the Lord of hosts, the God of the armies of Israel'.

Some commentators have seen a resemblance between the figure of Goliath and the similarly armed figure of Hamlet's father in a drawing by Henry Fuseli (Private Collection, Zurich), but whether Blake had actually seen this is impossible to say, although he certainly made such borrowings (see commentaries to plates 2, 10, 44, 45, 51, 61, 68).

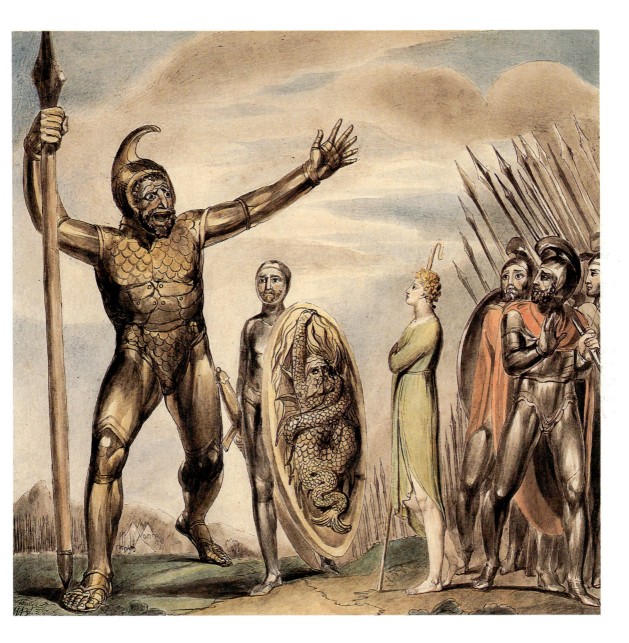

30. Ezekiel's Wheels

circa 1803–5
Black chalk, pen and watercolour over pencil, 39.5 × 29.5 *cm*
Museum of Fine Arts, Boston, Massachusetts

This awe-inspiring design illustrates the vision described in *Ezekiel* I. The prophet lies on his back, partly immersed beneath the waters of the River Chebar, during his Babylonian captivity, looking up as 'the heavens opened and I saw visions of God', his forearms raised and his hands spread in wonder. Above his diminutive figure is his gigantic vision of

> The likeness of four living creatures . . . they had the likeness of a man.
> And every one had four faces, and every one had four wings . . .
> As for the likeness of their faces, they four had the face of a man, and the face of a lion, on the right side: and they four had the face of an ox on the left side; they four also had the face of an eagle . . .
> Now as I beheld the living creatures, behold one wheel upon the earth by the living creatures, with his four faces . . . and they four had one likeness: and their appearance and their work was as it were a wheel in the middle of a wheel . . .
> As for their rings, they were so high that they were dreadful; and their rings were full of eyes round about them four.

Above this is 'the appearance of the likeness of the glory of the Lord', with his right hand raised in benediction.

To Blake Ezekiel was one of the most important of the Old Testament prophets (see also plate 40), and much of his symbolism, particularly in his unfinished epic *Vala, or the Four Zoas* and in his last and greatest poem *Jerusalem*, may be traced back to the prophet. The four living creatures (Blake does not depict their animal faces), which were the precursors of the four beasts in the Book of Revelation, became in Blake's mythology the four Zoas.

It is beyond the scope of this book to consider the Zoas in detail, but we may briefly name them and mention their main characteristics: Los (or Urthona) is the faculty of the imagination or intuition; Luvah the emotions or feeling; Tharmas the body or sensation; and Urizen, as we have already seen (commentary to plate 5), the faculty of reason or thinking. (They can be equated with the four functions of Jungian psychology: intuition, feeling, sensation and thinking.) The biblical passage quoted above shows that Ezekiel's four living creatures are also related to the four standard iconographical symbols of the Evangelists: a man (Matthew), a lion (Mark), an ox (Luke) and an eagle (John).

The technique used in this watercolour, especially on the body of the facing creature, employs a large amount of stippling, the advantages of which in modelling must have become especially apparent to Blake in the miniature painting he was doing at about this time. There is greater freedom of handling in other parts of the work, akin to that in illustrations for Young's *Night Thoughts* and Gray's *Poems*.

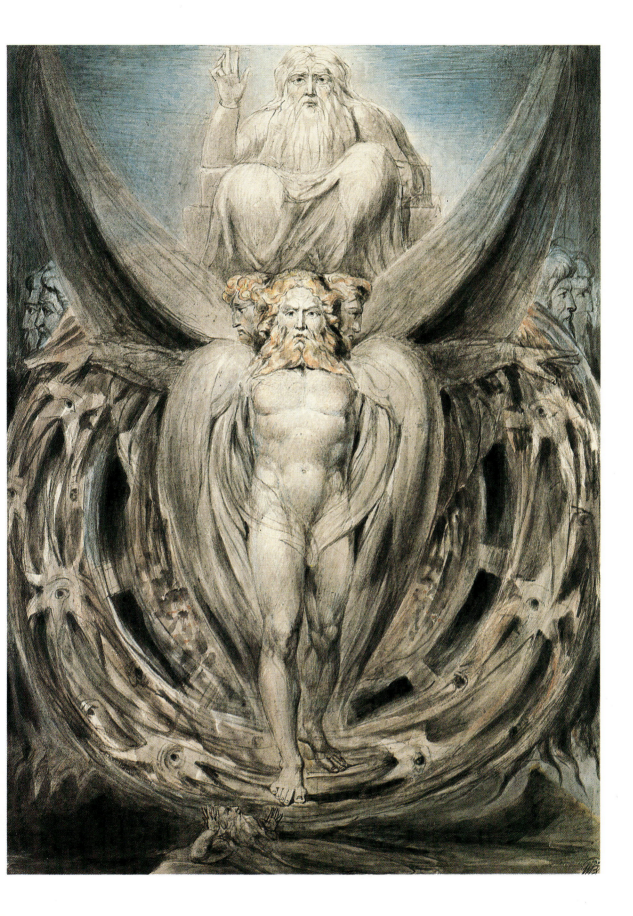

31. Death on a Pale Horse

circa 1800
Pen and watercolour over pencil, 39.5 × 31.1 *cm*
Fitzwilliam Museum, Cambridge

This is Blake's visual rendition of *Revelation* VI.7–8:

> And when he had opened the fourth seal, I heard the voice of the fourth beast say, Come and see.
>
> And I looked, and behold a pale horse: and his name that sat on him was Death, and Hell followed with him. And power was given unto them over the fourth part of the earth, to kill with sword, and with hunger, and with death, and with the beasts of the earth.

(The fourth beast in this passage is one of the four beasts related to the four living creatures of Ezekiel's vision, see commentary to plate 30.) The Urizenic armour-clad and crowned figure of Death flourishes his great sword in his right hand while he points threateningly with his left; his sword appears the more menacing and far-reaching by exceeding the bounds of the design. His neck seems to fall sharply under the back of his head as if Blake were emphasising the death's head beneath the hair and the flesh. The pale animal on which he is seated is no noble horse, but a raging brute maddened with terror, akin to that in Fuseli's *Nightmare* (Detroit Institute of Arts; another version is in the Goethe Museum, Frankfurt), not galloping, but flying across a louring sky. Blake had used a similar flying horse in his frontispiece to Gottfried Augustus Bürger's poem *Leonora* (London, 1796). Below is the equally evil figure of Hell, wild-eyed, dressed in armour with saurian scales and riding a fire-breathing black horse amid flames that partially envelop the hind legs of Death's steed.

The angelic figure rolling up a scroll at the top of the composition, against the disc of the sun, refers to a passage a little later in the same chapter of *Revelation* (v.14): 'And the heaven departed as a scroll when it is rolled together.' His suspended, hovering position emphasises the terrifying onward surge of Death and Hell. It is difficult to interpret the meaning of the feathered rays behind the sun, but they might have been inspired by winged suns illustrated in plates that Blake perhaps worked on (during his apprenticeship with Basire) for Jacob Bryant's *A New System, or, An Analysis of Ancient Mythology* (London, 1774; see especially plate VIII). He certainly engraved one tailpiece for the third volume of this work: an ark shaped like a crescent moon floating on the sea under a rainbow, with a dove returning to it with a sprig of olive in its beak.

The composition of *Death on a Pale Horse* is drawn in strong pen outlines (Blake's 'distinct, sharp, and wirey . . . bounding line' (K.585)), and the colouring is applied in broad washes.

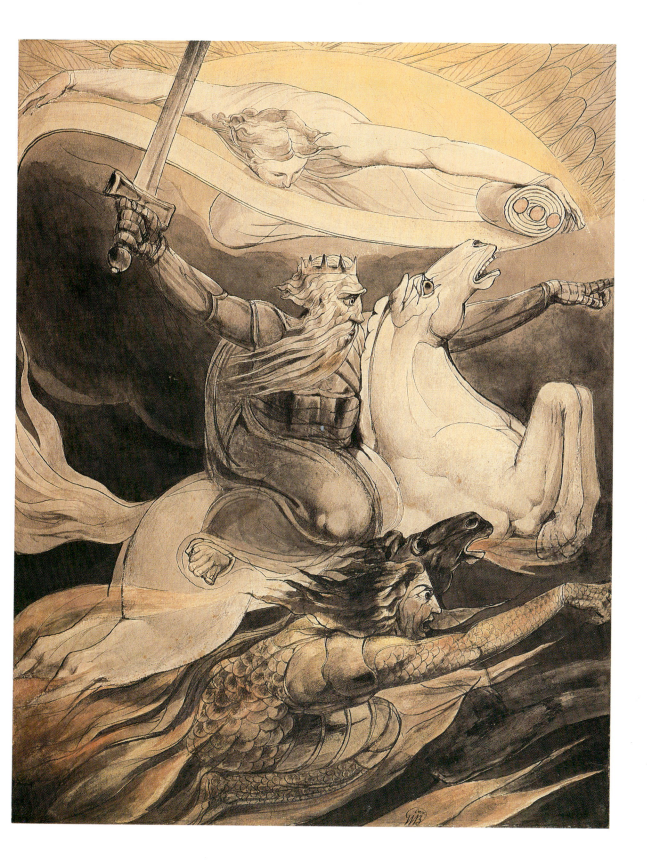

32. The Great Red Dragon and the Woman clothed with the Sun

circa 1803–5
Pen, black chalk and watercolour, 43.5 × 34.5 cm
Brooklyn Museum, New York

Another of Blake's watercolours of the Apocalypse, this is his representation of *Revelation* XII.1–4:

> And there appeared a great wonder in heaven; a woman clothed with the sun, and the moon under her feet, and upon her head a crown of twelve stars:
> And she being with child cried, travailing in birth, and pained to be delivered.
> And there appeared another wonder in heaven; and behold a great red dragon, having seven heads and ten horns, and seven crowns upon his heads.
> And his tail drew the third part of the stars of heaven, and did cast them to the earth: and the dragon stood before the woman which was ready to be delivered, for to devour her child as soon as it was born.

Blake's composition is dominated by the back view of the awesome figure of the dragon (an aspect of Satan), half-human, half-devil, his pterodactyl wings spread out so as to dominate the starry firmament and so large that the paper is not big enough to contain their full spread. Three of his seven crowned heads are visible: the one rising from the top of his spine is horned like a ram's. His tail, a continuation of vertebrae that appear to issue from a buttock-like formation in the centre of his back, curls around the prostrate figure of the terrified woman clothed with the sun. He stands with his legs straddled and his feet poised on clouds, ready to spring and devour the woman's child. The whole effect is portentous and dreadful.

A painting in the Rosenwald Collection in the National Gallery of Art, Washington, D.C., a further version of this subject, illustrates the moment of the woman's escape after she has been given 'two wings of a great eagle, that she might fly into the wilderness, into her place, where she is nourished for a time, and times, and half a time, from the face of the serpent' (v.14). It is less horrific than the present watercolour, but is nevertheless a tremendous conception, showing the dragon flying above the newly winged woman against a black sky with flashes of lightning.

Blake drew on many of his technical resources in painting this watercolour, for instance stippling on the modelling of the dragon's body, bold outlining and detailing on his wings. The figure of the woman is realised in outline and washes like that of the Elohim in *The Creation of Eve* (plate 28), and the sky and clouds are freely drawn in washes.

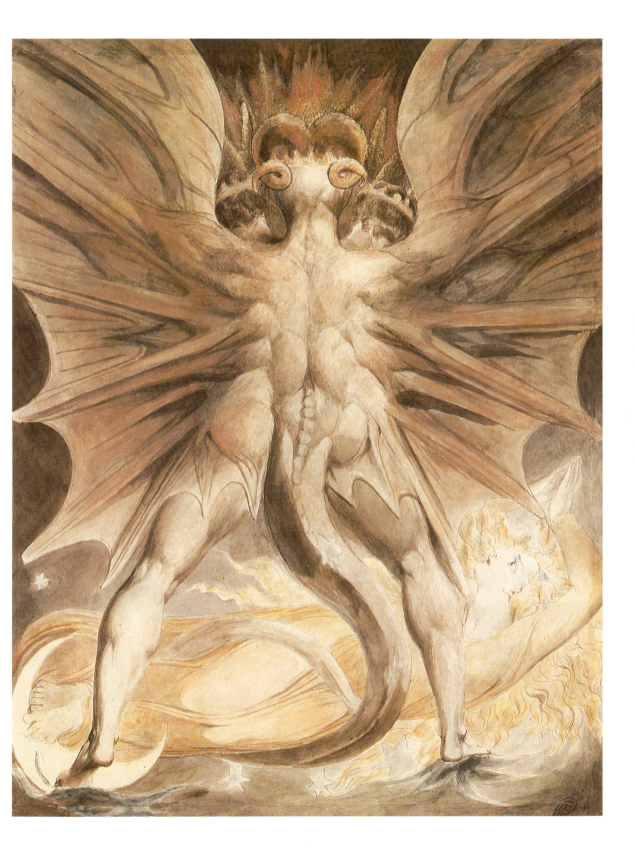

33. Comus, disguised as a Rustic, Addresses the Lady in the Wood

circa 1801
Pen and watercolour, 21.8 × 18.4 *cm*
Henry E. Huntington Library and Art Gallery, San Marino, California

This is one of eight illustrations to Milton's masque *Comus*, commissioned in 1801 by the Rev. Joseph Thomas of Epsom, at the suggestion of John Flaxman. Blake referred to these in a letter written from Felpham on 19 October 1801: 'Mr Thomas, your friend to whom you was so kind as to make honourable mention of me, has been at Felpham & did me the favor to call on me. I have promis'd him to send my designs for Comus when I have done them, direct to you!' (K.810) All eight watercolours are now in the Huntington Library and Art Gallery. Another, later, set is in the Museum of Fine Arts, Boston, Massachusetts (see plate 34).

Milton's masque was first performed at Ludlow Castle in 1634. Comus, the son of Bacchus and Circe, is an enchanter, who entraps travellers in his palace and, by making them drink a magic potion, transforms their countenances into the faces of wild beasts. In Milton's masque, a Lady and her two brothers are benighted in a wood; the Lady becomes separated from her brothers and, drawn by the sound of Comus' rout, encounters the magician disguised as a shepherd. He offers her shelter, which she accepts. Although she is spellbound, she is watched over by a good Attendant Spirit, who warns the brothers of her plight; they burst into the palace and disperse the rout as Comus is attempting to make their sister drink his potion. However, they omit to secure his magic wand, so the Lady is unable to rise from the enchanted chair in which she is seated; but at their entreaty she is released by Sabrina, goddess of the nearby River Severn, who enables her and her brothers to return to their parents in Ludlow Castle.

Milton's text may be seen as a defence of the virtues of virginity, or at least temperance. But, as usual, Blake instils his own interpretation into the illustrations, and it has been suggested that these show the Lady progressing from sexual timidity to an acceptance of a full sexual life. It seems more likely, though, that Blake saw the story as a parallel to that of one of his characters, the virgin Thel in *The Book of Thel* (1789), who, on the verge of Experience, and frightened of motherhood, flees back to Har (primal Innocence). The somewhat puzzled and sad expressions on the faces of the sister, brothers, parents and Attendant Spirit in the last illustration in the series, *The Lady returned to her Parents*, seem to indicate that she also has refused to face sexual reality, represented by Comus.

The simple composition in this illustration depicts the Lady, her hands raised in a gesture of innocence, and Comus in the disguise of a shepherd (his magic staff hidden from the Lady's view), in a wood; the Attendant Spirit, holding a flower, an image often used by Blake to symbolise sexual joy, hovers at the right (see commentary to plate 14). The dominantly blue colouring and lustrous lighting effectively transmit an enchanted atmosphere: a pleasing ambience concealing underlying sorcery.

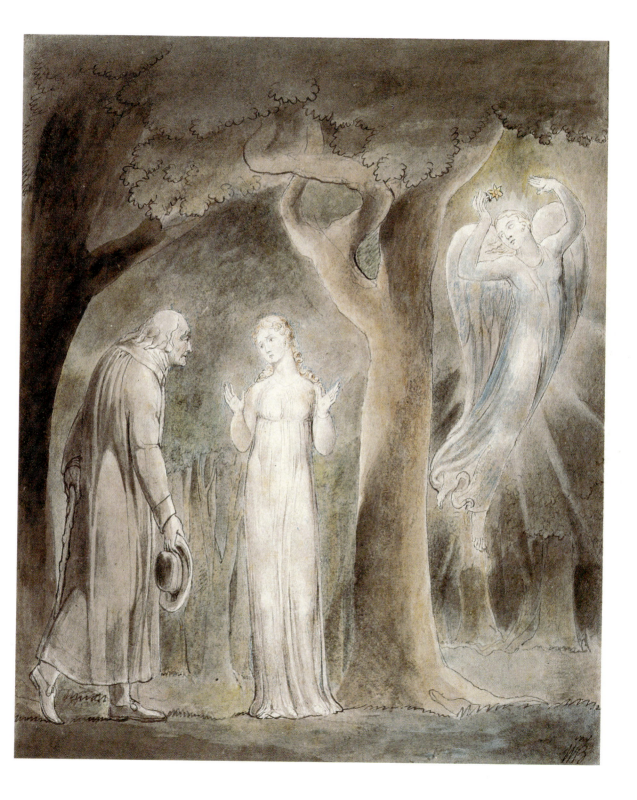

34. The Magic Banquet with the Lady Spell-Bound

circa 1815
Pen and watercolour, 15.3 × 12 cm
Museum of Fine Arts, Boston, Massachusetts

Blake's second series of illustrations for *Comus* was painted for Thomas Butts. They are not so lightly executed as the Thomas set (see plate 33) in either colouring or modelling, but are drawn with greater confidence, with more accurate attention to anatomy, and with greater depth.

The Magic Banquet shows the Lady entrapped by Comus' magic. According to Milton's stage directions, 'The Scene changes to a stately Palace, set out with all manner of deliciousness: soft Musick, Tables spred with all dainties. *Comus* appears with his rabble, and the Lady set in an inchanted Chair, to whom he offers his Glass, which she puts by, and goes about to rise.' Comus stands with a chalice in his left hand, and his wand, in his right, is held over the Lady. He is dressed in a skin-tight translucent garment which displays the structure of his body but conceals his genitals, a device Blake used frequently to symbolise the sexual shame originated by the Fall. The Lady, spellbound, sits in the sorcerer's enchanted chair, while behind her an attendant with an imbecile face holds a vessel containing Comus' magic potion. Around the table are some of the rout, with the countenances of a cat, an elephant, a lion, a dog and a stork; to the left of these is a serpent with its mouth wide open, perhaps another metamorphosed head, though this is not clear. The wall of the chamber is arcaded, and three burning lamps hang on chains from the ceiling.

It is a somewhat heavy setting for Comus' flattering appeals to the Lady to taste the joys of the sexual fulfilment he offers (see commentary to plate 33), and perhaps represents the Lady's fears:

> Why are you vext Lady? why do you frown?
> Here dwel no frowns, nor anger, from these gates
> Sorrow flies farr: See here be all the pleasures
> That fancy can beget on youthfull thoughts,
> When the fresh blood grows lively, and returns
> Brisk as the *April* buds in Primrose-season.
> And first behold this cordial Julep here
> That flames, and dances in his crystal bounds
> With spirits of balm, and fragrant Syrops mixt.
> Not that *Nepenthes* which the wife of *Thone*,
> In *Egypt* gave to *Jove*-born *Helena*
> Is of such power to stir up joy as this,
> To life so friendly, or so cool to thirst.
> Why should you be so cruel to your self,
> And to those dainty limms which nature Pent
> For gentle usage, and soft delicacy?
> But you invert the cov'nants of her trust,
> And harshly deal like an ill borrower
> With that which you receiv'd on other terms,
> Scorning the unexempt condition
> By which all moral frailty must subsist,
> Refreshment after toil, ease after pain,
> That have been tir'd all day without repast,
> And timely rest have wanted, but fair Virgin
> This will restore all soon. (ll.666–89)

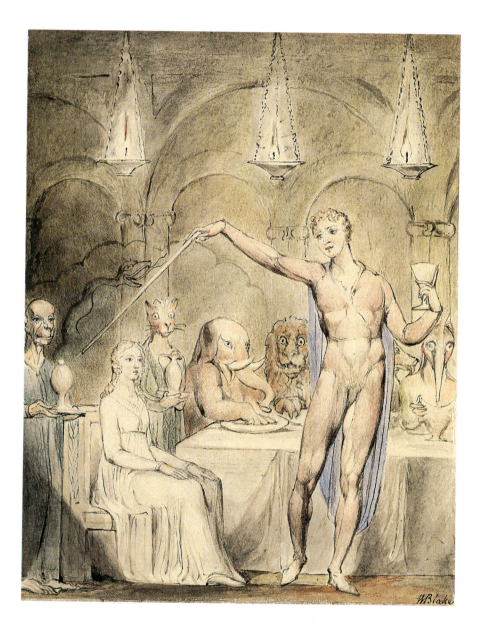

35. *Jerusalem*, Plate 76

1804–20 (?)

Relief etching and watercolour, 22.2 × 16.5 cm (approx.)

Collection of Mr and Mrs Paul Mellon, Upperville, Virginia

In 1804 Blake began work on his last illuminated book, *Jerusalem, the Emanation of the Giant Albion*. He was still working on it in about 1818–20. He made only one complete coloured copy, from which this plate is reproduced; he mentions it in a letter to his friend George Cumberland, written on 12 April 1827: 'The Last Work I produced is a Poem Entitled Jerusalem the Emanation of the Giant Albion, but find that to Print it will Cost my Time the amount of Twenty Guineas [£21]. One I have Finish'd. It contains 100 Plates but it is not likely that I shall get a Customer for it.' (K.878) Another incomplete coloured copy exists; plate 76 is not among its twenty-five plates. Apart from that, only eight uncoloured copies are known, of which four were printed posthumously, plus a few separate leaves.

Briefly, the theme of the poem is the recovery of Albion's lost soul – Albion being equated both with mankind and with England (see commentary to plate 10). Jerusalem is his female counterpart or emanation, divided from him at the Fall; during the poem they are reunited and Albion's spirit is liberated. On another level the poem also represents Blake's own mental, religious and spiritual struggle and his final triumph.

This plate depicts Jesus crucified on the Tree of Mystery – which is an oak, and therefore linked with Druidical Natural Religion (see commentaries to plates 21, 26, 48, 51, 52 and 74). Albion stands in adoration with his arms similarly extended, in a gesture symbolising the sacrifice of selfhood, and with his right foot forward, indicating the ascendancy of the spirit. His attitude is almost exactly a rear view of his figure in *The Dance of Albion* (plate 10). In the distance the light of dawn begins to shine below the overcast sky.

The page facing this design contains the following related lyric:

> England! awake! awake! awake!
> Jerusalem thy Sister calls!
> Why wilt thou sleep the sleep of death
> And close her from thy ancient walls?
>
> Thy hills & valleys felt her feet
> Gently upon their bosoms move:
> Thy gates beheld sweet Zion's ways:
> Then was a time of joy and love
>
> And now the time returns again:
> Our souls exult, & London's towers
> Recieve the Lamb of God to dwell
> In England's green & pleasant bowers. (K.718)

Contemporary public incomprehension of Blake's work is illustrated by a reference to *Jerusalem* in *The London Magazine* in 1820:

> [A forthcoming article] is an account of an ancient, newly discovered, illuminated manuscript, which has to name 'Jerusalem the Emanation of the Giant Albion!!!' It contains a good deal anent one *'Los'*, who it appears, is now, and hath been from the creation, the *sole* and fourfold dominator of the celebrated city of *Golgonooza* [the ideal city of art in Blake's mythology]!... the redemption of mankind hangs on the universal diffusion of the doctrines broached in this M.S. – But, however, this is'nt the subject of this *scrinium*, scroll, or scrawl, or whatever you may call it.

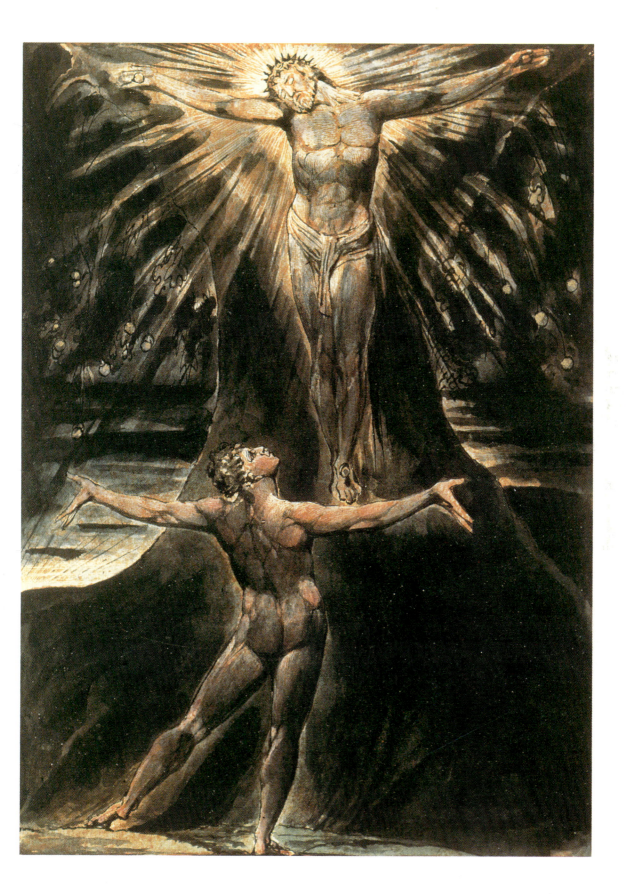

36. The Spiritual Form of Pitt guiding Behemoth

1805 (?)
Tempera heightened with gold on canvas, 74 × 62.7 cm
Tate Gallery, London

This and the companion work, *The Spiritual Form of Nelson guiding Leviathan* (also in the Tate Gallery), were shown in Blake's abortive exhibition of 1809. The extended titles he gave to each briefly state what he meant them to symbolise:

NUMBER I

The spiritual form of Nelson guiding Leviathan, in whose wreathings are infolded the Nations of the Earth.

NUMBER II

The spiritual form of Pitt, guiding Behemoth; he is that Angel who, pleased to perform the Almighty's orders, rides on the whirlwind, directing the storms of war: He is ordering the Reaper to reap the Vine of the Earth, and the Plowmen to plow up the Cities and Towers. (K.564–5)

Both paintings are apocalyptic in character and can be taken to illustrate Blake's hatred of war, which he saw as perverted energy, and consequently Error, yet a necessary prelude to the Last Judgment. On the other hand, some interpreters have seen the two pictures as Blake's expression of the justness of the wars against Napoleon.

The sea-monster Leviathan (thought to be based on the crocodile) and the land-monster Behemoth (thought to be based on the hippopotamus) appear several times in the Old Testament, especially in the Book of Job, which was especially important to Blake (see plates 68–70). But Blake's versions of them are his own, Leviathan being depicted as a sea-serpent, Behemoth as half-reptile, half-mammal, with cloven hoofs. He refers to them in *Jerusalem* in a passage that further elucidates the meaning of these two pictures:

> . . . Leviathan
> And Behemoth, the War by Sea enormous & the War
> By Land astounding. (K.738)

Pitt (William Pitt the younger, who was Prime Minister at about the time these pictures were painted – though this is not strictly a portrait) stands at the centre of the composition just above Behemoth, against a river of fire, his arms lifted on each side, his right hand lightly holding a controlling rein attached to the monster. Through Behemoth's transparent skin are seen the large heads of four kings he has swallowed; his mouth is wide open to receive other victims who are being driven into it by a sickle-wielding giant. At the right another giant drives more men and women towards Behemoth with a plough; a building blazes in the background. Other people in attitudes of despair and horror occupy the lower part of the composition; elsewhere troops fire at one another. Against the starry firmament float a number of translucent globes containing unidentified figures.

Pitt's oriental dress and his large halo of eastern form (which also represents a whirlwind) are among the work's most interesting features. Blake draws attention to an eastern influence in his *Descriptive Catalogue*: 'The two pictures of Nelson and Pitt are compositions of a mythological cast, similar to . . . Apotheoses of Persian, Hindoo, and Egyptian Antiquity.' (K.565)

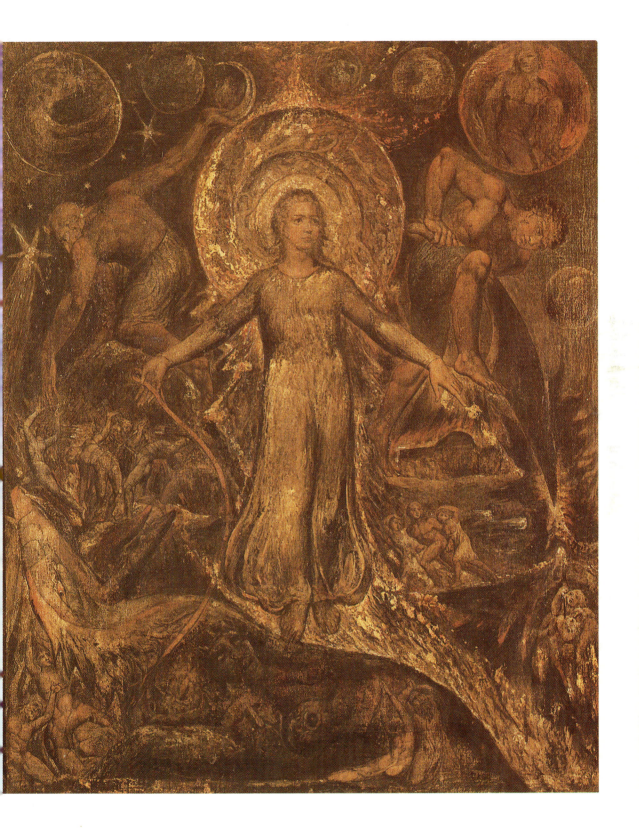

37. Fire

circa 1805
Pen and watercolour, 31.7 × 42.8 cm
Pierpont Morgan Library, New York

Although it was not painted until 1805, *Fire*, in so far as it illustrates disaster, is related to an earlier group of works including *Pestilence* (plate 2), which were painted between ten and fifteen years previously. Blake painted several works with themes of disaster in about 1805 for Thomas Butts; in addition to *Fire* the subjects are *Pestilence*, *Famine* (both in the Museum of Fine Arts, Boston) and *War* (Fogg Art Museum, Harvard University, Cambridge, Massachusetts).

The 1805 watercolours are different in style from the earlier ones, as will be seen by comparing plate 2 with this one, in which the figures are more rounded, the countenances more individual and more detailed (if somewhat conventional), and the whole scene rendered with a greater sense of depth.

Against a terrifying conflagration, people in the background run hither and thither in panic. In the foreground at the left an old man, partly covered in a blue mantle, reaches up to take a bundle from a youth, dressed in olive-green, skin-tight garments, who is striding towards him; beside this youth another, similarly clad, carries a great chest on his shoulders. At the right are two women: one, looking aghast, sits on her belongings with frightened children huddled around her; the other stands holding a baby and seems more composed. Two children near her raise their hands in prayer.

In his 'Descriptive Catalogue' of Blake's works in Gilchrist's *Life* W. M. Rossetti gives a vivid description of this watercolour:

> Blake, the supreme painter of fire, in this his typical picture of fire, is at his greatest; perhaps it is not in the power of art to transcend this treatment of the subject in its essential features. The water-colour is unusually complete in execution. The conflagration, horrid in glare, horrid in gloom, fills the background; its javelin-like cones surge up amid conical forms of buildings . . .

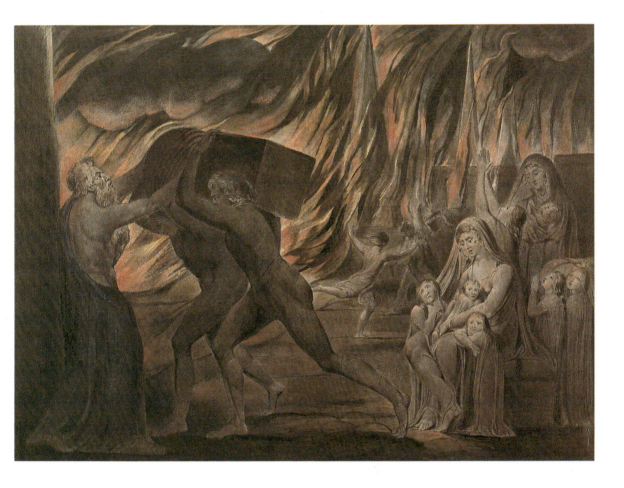

38. The Horse

1805 (?)

Pen and tempera on gesso priming on a copper engraving plate, 10.7 × 6.7 cm
Collection of Mr and Mrs Paul Mellon, Upperville, Virginia

Among William Hayley's projects for helping Blake was a series of 'Ballads founded on Anecdotes relating to Animals', written by himself. Blake, who was to be the sole beneficiary, was to provide engraved illustrations after his own designs, and was to be responsible to the printer, Joseph Seagrave of Chichester, another of Hayley's protégés, for the cost of printing and paper; Hayley's only contribution was the poems, and they were such poor stuff that it is not surprising that the venture ended in failure. They were first issued in 1802 as *Designs for a Series of Ballads*; when this failed to sell they were published in 1805 as *Ballads by William Hayley Esq founded on Anecdotes relating to Animals, with Prints designed and engraved by William Blake*; this also failed, but here Blake was not fully responsible for the cost (see his letter quoted below), and any profits were to be equally divided between him and the publisher, Richard Phillips of Blackfriars, London.

The engraving of *The Horse* did not appear in the 1802 edition, and apparently narrowly missed exclusion from that of 1805. Blake wrote to Hayley about this from London on 4 June 1805:

> I have fortunately, I ought to say providentially, discovered that I have engraved one of the plates for that ballad of *The Horse* which is omitted in the new edition; time enough to save the extreme loss and disappointment which I should have suffered had the work been completed without the ballad's insertion. I write to entreat that you would contrive so as that my plate may come into the work, as its omission would be to me a loss that I could not now sustain, as it would cut off ten guineas from my next demand on Phillips, which sum I am in absolute want of; as well as that I should lose all the labour I have been at on that plate, which I consider as one of my best; I know it has cost me immense labour. (K.861)

The painting reproduced here is the same composition as the engraving and almost exactly the same size, but it is uncertain which was produced first. It is a beautiful little work, of far greater quality than the verses it illustrates and as intense as a miniature in an illuminated manuscript; it shows Blake's art at its most painstaking, bearing out his reference to 'immense labour'.

The ballad tells how a mother, walking in the country with her child, confronts a fierce horse that has thrown its rider and is galloping towards them. In the face of her courage the horse is suddenly tamed:

> Noble parent! nature saw,
> Virtue shining in thy soul,
> And with sudden, wond'rous awe
> Struck the beast, that spurn'd controul:
>
> For, as if thy fixed eyes
> Darted fascinating flame,
> He, to thy devout surprise,
> Stood before thee fondly tame:
>
> He, as touched by powers above,
> That can demons dispossess,
> View'd thee, with submissive love,
> Like a spaniel's mild caress.

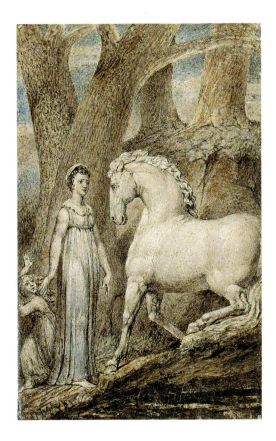

39. God blessing the Seventh Day

circa 1805
Pen and watercolour, 42 × 35.5 cm
Private Collection, Great Britain

In this resplendent watercolour, his interpretation of *Genesis* II.2–3, Blake shows the Elohim in an attitude of blessing, within a mandala or aureole consisting of six angels, the whole group being encircled by golden rays:

> And on the seventh day God ended his work which he had made; and he rested on the seventh day from all his work which he had made.
>
> And God blessed the seventh day, and sanctified it: because that in it he had rested from all his work which God created and made.

The poet Kathleen Raine, who has sought to link Blake's thought and symbolism with that of the Gnostic and Platonist traditions, quotes, in connection with this watercolour, a passage from *The Divine Pymander of Hermes Mercurius Trismegistus* (translated from the Arabic by Dr John Everard, 1650), in which the Elohim is seen as the 'Workman', the demiurge (subordinate to the Supreme God) who created the natural universe (see commentary to plate 12):

> For the *Mind* being God, *Male and Female, Life and Light*, brought forth by his *Word* another *Mind* or *Workman*; which being God of the *Fire*, and the *Spirit*, fashioned and formed seven other *Governors*, which in their circles contain the *Sensible World*, whose Government or disposition is called *Fate* or *Destiny*.
>
> *Straightway* leaped out, or exalted itself from the downward Elements of God, *The Word of God*, into the clean and pure Workmanship of Nature, and was united to the *Workman, Mind*, for it was *Consubtantial . . .* But the *Workman, Mind*, together with the *Word*, containing the circles, and whirling them about, turned round as a wheel, his own Workmanships; and suffered them to be turned from an indefinite Beginning to an indeterminable end, for they always begin where they end. (*Blake and Tradition*, vol. II, p. 21.)

Blake's aureole does indeed give the impression of the whirling circles of this passage, with the Elohim at the centre as the Workman, and the angels as the Governors (or the 'angelic architects' of Gnosticism), although he depicts only six instead of the seven mentioned.

The composition may have been derived from the design of Gothic roof bosses, possibly from one in York Minster which was drawn by Flaxman; Blake may have seen this drawing before it was engraved and printed in Flaxman's *Lectures on Sculpture* (1829).

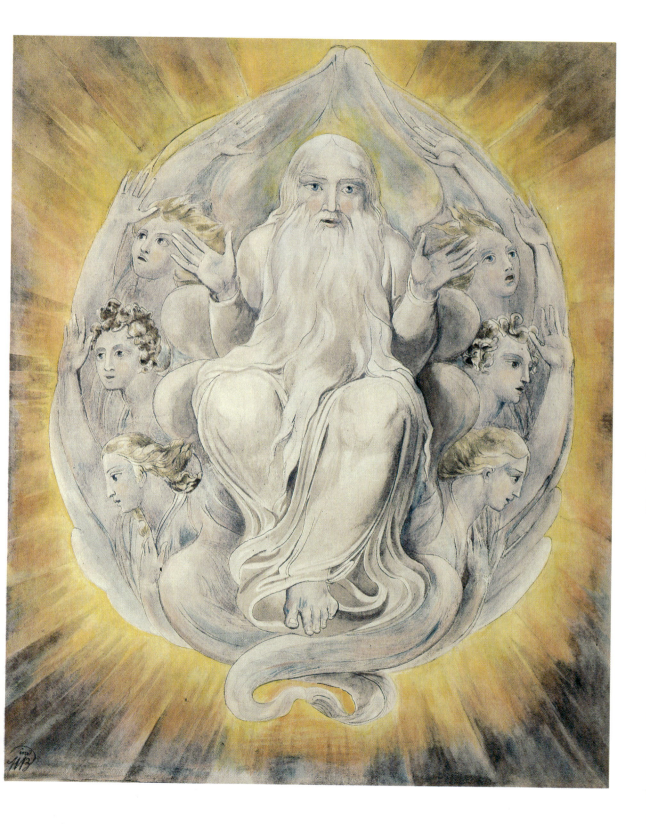

40. Satan in his Original Glory

circa 1805
Pen and watercolour, 42.9 × 33.9 *cm*
Tate Gallery, London

An illustration of *Ezekiel* XXVIII.13–15:

> Thou hast been in Eden the garden of God; every precious stone was thy covering, the
> sardius, topaz, and the diamond, the beryl, the onyx, and the jasper, the sapphire, the
> emerald, and the carbuncle, and gold: the workmanship of thy tabrets and of thy pipes was
> prepared in thee in the day that thou wast created.
>
> Thou art the anointed cherub that covereth; and I have set thee so: thou wast upon the holy
> mountain of God; thou hast walked up and down in the midst of the stones of fire.
>
> Thou wast perfect in thy ways from the day that thou wast created, till iniquity was found
> in thee.

This is a message entrusted by God to the prophet to give to the King of Tyre, but it is
usually read as a reference to Satan; it was originally interpreted thus by the early
Christian apologist Tertullian.

In Blake's view Satan was not a being, but a state of Error (see commentary to plates 8
and 12); he is also the Accuser, the Adversary, Death and War; as with most of Blake's
symbols and personages, he is anything but simple, a many-faceted typification. The
selfhood, called also the covering cherub in the passage from the Book of Ezekiel,
represents the ultimate Error, the final enemy to be defeated, which is yet another aspect
of Satan. Blake uses the symbol of the covering cherub in this sense in many places in his
poetry.

Blake's view of the progress of Satan, 'Lucifer, son of the morning' (*Isaiah* XIV.12),
chief of the angels, was partly shaped by Milton's *Paradise Lost*. When God the Father
proclaims the Son, Lucifer is maddened by jealousy, and from his head gives birth to Sin.
He copulates incestuously with her, fathering Death. A third of the angelic host joins him
in an attempt to seize the heavenly throne, but they are defeated by the Son, who drives
them and their leader from heaven, and they fall into hell. Renamed Satan ('the
Adversary'), Lucifer seeks revenge on God by seducing the newly created Eve, who falls
for his deception and is with Adam driven from Paradise, though with a promise of
eventual salvation.

The many-winged figure of Satan is depicted with his right foot forward to denote his
earlier spiritual aspect, and with his head decked out with flowers. His outstretched hands
hold an orb and a sceptre, symbols of earthly dominion. He is nude except for a flowing
cloak held over one shoulder with a strap; parts of his wings disguise his genitals, which,
with his almost feminine face and figure, calls attention to his original androgynous state.

He is surrounded by a myriad of stars and a retinue of tiny spirits executing his orders;
some blow trumpets and strike drums (the pipes and tabrets in the passage from *Ezekiel*),
and some carry or pore over books and scrolls. Two others, to the left of Satan's right foot,
appear to be arguing whether they should join him or return to heaven, an indication
perhaps that he is about to begin his revolt.

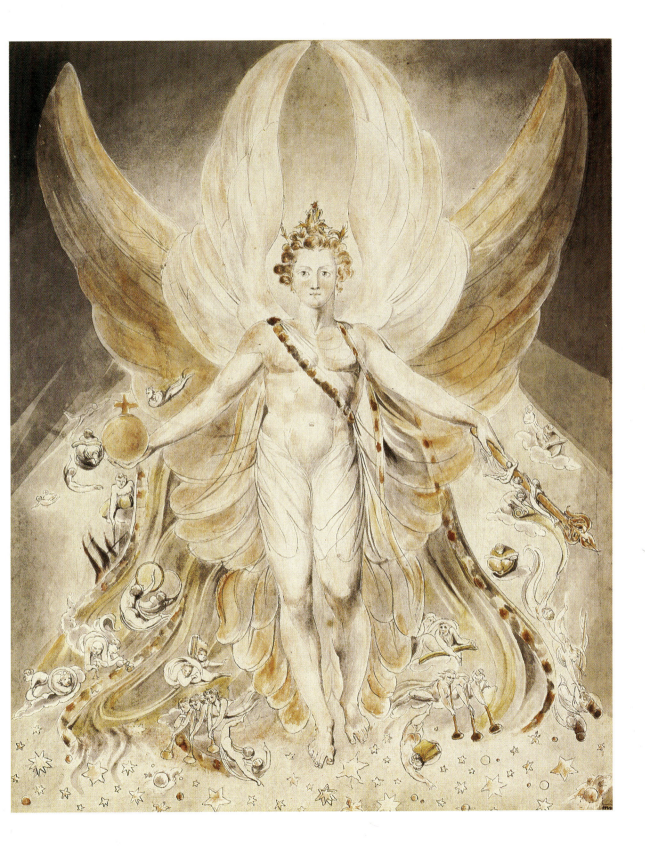

41. The Angel rolling the Stone away from the Sepulchre

circa 1805
Pen and watercolour, 41.5 × 31.1 *cm*
Victoria and Albert Museum, London

This numinous watercolour, painted for Thomas Butts, is Blake's conception of *Matthew* XXVIII.2–3:

> And, behold, there was a great earthquake: for the angel of the Lord descended from heaven, and came and rolled back the stone from the door, and sat upon it.
> His countenance was like lightning, and his raiment white as snow.

It is a highly dramatic rendering of one of the most important events in Christian belief: the three angels, especially the one in the centre removing the stone from the tomb, seem literally to glow with the spiritual light emanating from Christ himself. Those on the left and right are removing the winding-sheet from the body of Jesus, who has just awakened and is looking at his three heavenly visitors. The beatified silence within the tomb can almost be felt.

In the commentary to plate 28, attention was drawn to the small size of Adam's head; the same feature occurs here, for the head of Jesus appears to be little larger than his neck, again providing a distortion that helps to remove the work from the natural world. The same applies to his narrow adolescent hips and disproportionately long legs.

The garment of the central angel is similarly removed from reality: its flowing folds, closely clinging to his body, and its voluted hem, seem to be made of light. Again, by appearing to be both inside and outside the tomb at the same time, he transcends the laws of material substance. There is tremendous strength in his figure (his widespread wings perhaps providing an added reference to the Resurrection) – he lifts the great stone door as effortlessly as if it were a sheet of cardboard. In contrast, the other angels are posed in rapt immobility. Blake disregards the Gospel description that the stone was *rolled* back, which suggests a round boulder, not a rectangular slab; and his door is different both in shape and size from the aperture. In these respects, as always, Blake's interpretation was his own.

Blake makes little of Jesus' wounds, which he has shown as scarcely more than grazes. This is probably a hint that the spiritual aspect of the Passion is at least as important as the literal suffering of the victim. As in so many matters, Blake's attitude to the Crucifixion was complicated and varying; at times he saw it as the ultimate sacrifice of the selfhood, but on the other hand he once told the diarist Henry Crabb Robinson (10 December 1825) that Jesus 'was wrong in suffering Himself to be crucified. He should not have attacked the Government. He had no business with such matters.' He wrote of another aspect of the Crucifixion in *The Everlasting Gospel* (*circa* 1818):

> He took on Sin in the Virgin's Womb
> And put it off on the Cross & Tomb
> To be Worship'd by the Church of Rome. (K.749)

(See also commentary to plate 35.)

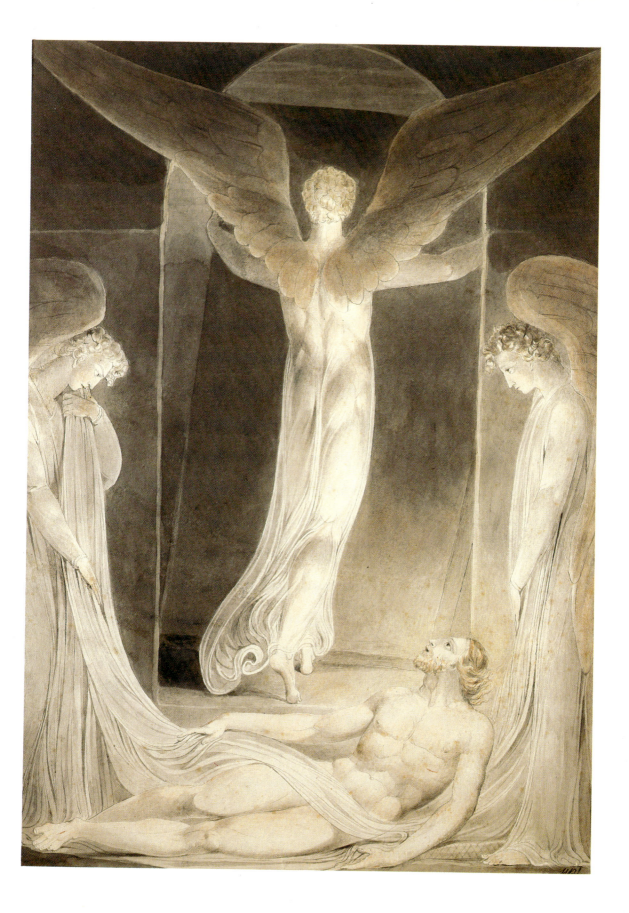

42. Jacob's Dream

circa 1805
Pen and watercolour, 39.8 × 30.6 cm
British Museum, London

Jacob's Dream is based on *Genesis* XXVIII.10–12:

And Jacob went out from Beersheba, and went toward Haran.

And he lighted upon a certain place, and tarried there all night, because the sun was set; and he took of the stones of that place, and put them for his pillows, and lay down in that place to sleep.

And he dreamed, and behold a ladder set up on the earth, and the top of it reached to heaven: and behold the angels of God ascending and descending on it.

Jacob is depicted asleep, resting on stones, on the summit of a hill, his arms outstretched, with one hand resting on his shepherd's crook and a little cloud hovering above him; his right foot is given prominence to denote that his spiritual self is in the ascendant. Against a sky full of brilliant stars an enormous spiral staircase rises up to the sun and on out of sight into the sun's depth. The rays of the sun dominate most of the sky. Men, women and children ascend and descend the stairs, some embracing and some assisting others; one plays a lyre, another unrolls a long scroll which she shows to a man passing her, who carries a pair of long dividers and a pair of scales. Nearer to Jacob two winged angels descend, one unrolling a scroll, the other carrying a book; close to his head are two women, one carrying a child on her shoulder and exchanging glances with the other, who carries a basket in one hand and a wine pitcher on her head; an angel gazes at the world from the bottom step – he holds a basket laden with bread. This angel and the woman with a pitcher symbolise God's gifts to mankind, what Blake described as 'The Bread of sweet Thought & the Wine of Delight'. (K.800)

The composition may also be understood in terms of Blake's own mythology, with Jacob as a dreaming Albion seeing a representation of two of the four spiritual states Blake envisaged – briefly, Ulro (single vision, the world of materialism); Urizen (twofold vision, the world of restrictive law and measurement – for the significance of Urizen as a personification see commentary to plate 5); Beulah (threefold vision, the subconscious world of dreams and inspiration); and Eden (fourfold vision, eternity). In this work the stairway first climbs through the pleasant nocturnal Beulah world of the dreaming Jacob/Albion, and then rises to the radiant eternity of Eden, symbolised by the sun.

Blake exhibited this work at the Royal Academy at Somerset House in 1808 with another watercolour, *Christ in the Sepulchre, guarded by Angels* (Victoria and Albert Museum, London). He exhibited only five times at the Academy and never after 1808. He included similar spiral stairways in two other works: a pencil sketch from his designs for Dante (British Museum; see plates 59–61) and a watercolour, *Epitome of James Hervey's 'Meditations among the Tombs'* (Tate Gallery, London).

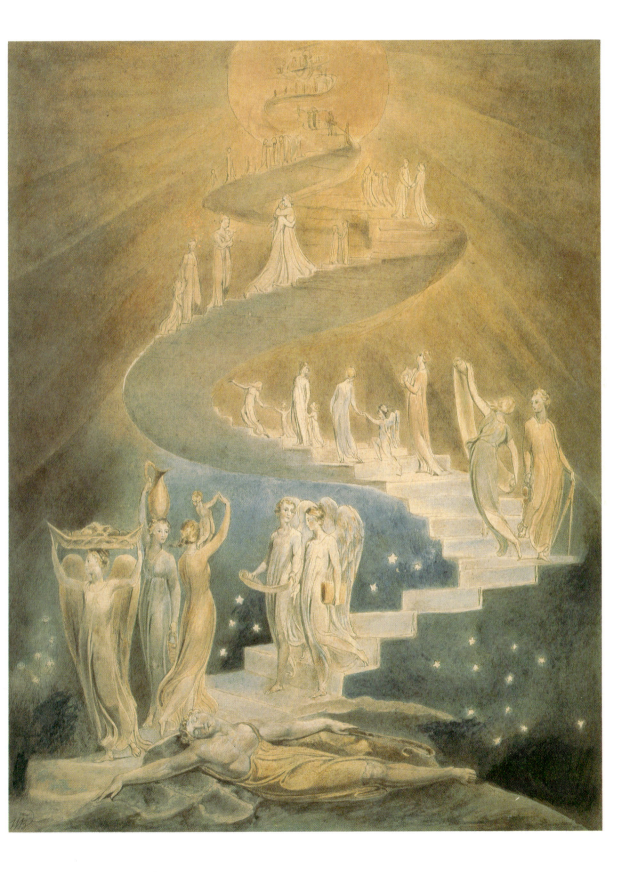

43. Jacques and the Wounded Stag

1806

Pen and watercolour, 22 × 15.8 cm
British Museum, London

The Rev. Joseph Thomas, who in about 1801 had commissioned from Blake eight illustrations to Milton's *Comus* (see plate 33), returned to him later and commissioned six watercolours to extra-illustrate a second folio (1632) edition of Shakespeare. Three, including this one, were painted in 1806, and three more in 1809. Other artists took part in the project, and between 1801 and 1809 supplied Thomas with thirty more watercolours which were inserted into the same volume: they included John Flaxman, William Hamilton, William Mulready, Robert Ker Porter, and John Varley, who contributed a view of Stratford upon Avon.

Jacques and the Wounded Stag is based on *As You Like It* II.i, which is set in the Forest of Arden. The banished Duke and his retinue, dressed as foresters, decide to hunt deer, but the Duke expresses some pity for the quarry – 'poor dappled fools', he calls them – which prompts one of his attendants to speak of Jacques, another of his followers:

> Indeed my lord,
> The melancholy Jacques grieves at that;
> And, in that kind, swears you do more usurp
> Than doth your brother that hath banish'd you.
> To-day my Lord of Amiens and myself
> Did steal behind him as he lay along
> Under an oak whose antique root peeps out
> Upon the brook that brawls along this wood;
> To the which place a poor sequester'd stag,
> That from the hunters' aim had ta'en a hurt,
> Did come to languish; and, indeed, my lord,
> The wretched animal heav'd forth such groans
> That their discharge did stretch his leathern coat
> Almost to bursting, and the big round tears
> Cours'd one another down his innocent nose
> In piteous chase; and thus the hairy fool,
> Much marked of the melancholy Jacques,
> Stood on the extremest verge of the swift brook,
> Augmenting it with tears. (ll.25–42)

He goes on to describe how Jacques moralised on the scene, comparing the deer, 'that poor and broken bankrupt', to men who 'fright the animals . . . in their assign'd and native dwelling-place'.

Blake's watercolour is a literal representation of the incident, and portrays the wounded and weeping deer lapping at the brook, while the melancholy Jacques looks upward, pointing to the animal with one hand and raising the other in expostulation. Through the oak grove more deer are seen standing at bay and starting in fright.

The watercolour is executed in strong outlines of ink and broad washes, with a technique reminiscent of the *Comus* watercolours for the same patron (see plate 33). The predominantly brown colouring imparts an appropriately melancholy and romantic atmosphere.

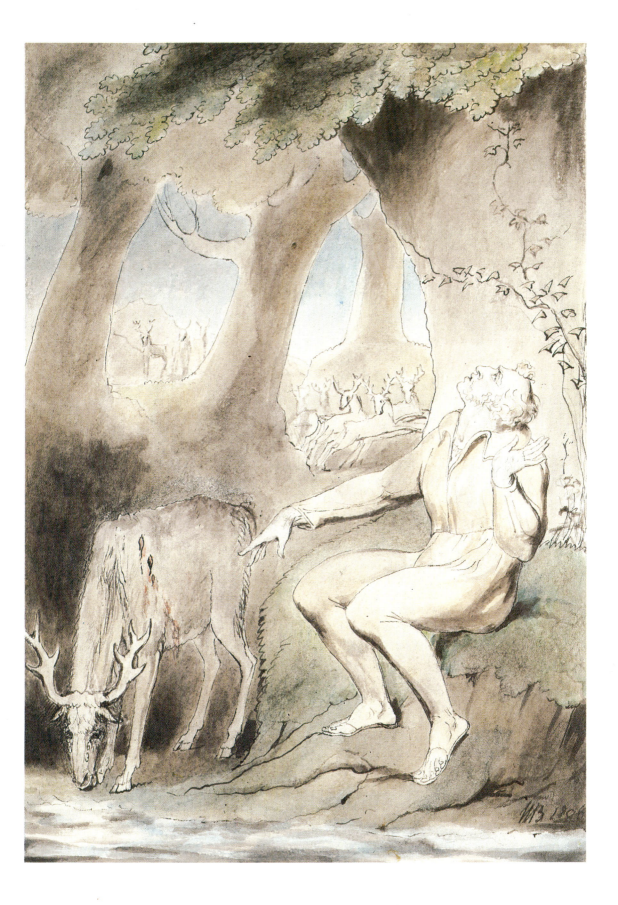

44. The Vision of Queen Katharine

1807
Pen and watercolour over pencil, 40.1 × 31.3 cm
Fitzwilliam Museum, Cambridge

Blake portrayed this subject several times: in a watercolour of *circa* 1790–3 (also in the Fitzwilliam Museum); in another of 1809 for the Rev. Joseph Thomas (British Museum; see commentary to plate 43); in this work, executed for Butts; and in a watercolour of *circa* 1825 (National Gallery of Art, Washington, D.C.). It is taken from the stage directions in Shakespeare's *King Henry VIII* IV.ii describing the happy dream of Katharine of Aragon:

> The Vision. Enter, solemnly tripping one after another, six Personages, clad in white robes, wearing on their heads garlands of bays, and golden vizards on their faces; branches of bays or palm in their hands. They first congee [bow ceremoniously] unto her, then dance; and, at certain changes, the first two hold a spare garland over her head; at which, the other four make reverend curtsies: then, the two that held the garland deliver the same to the other next two, who observe the same order in their changes, and holding the garland over her head: which done, they deliver the same garland to the last two, who likewise observe the same order, at which, – as it were by inspiration, – she makes in her sleep signs of rejoicing, and holdeth up her hands to heaven: and so in their dancing they vanish, carrying the garland with them. The music continues.

Blake sets the scene in a hall, where the Queen reclines on a couch curiously decorated with Gothic motifs. She looks in wonderment at her vision, her arms outstretched and her hands turned upwards; the slightly forward position of her right foot symbolises spirituality. At the left, Griffith, her gentleman-usher, sits asleep with his head resting on one arm; her maid, Patience, sits opposite him in a similar pose. The 'Personages' – angels or fairies – rise spirally in a light cloud from the floor to the ceiling. Here Blake has used considerable licence: the two personages holding a garland over the Queen's head are depicted, and all are clad in white robes, and some are garlanded; but none wears a 'golden vizard', many hold or play musical instruments, others carry baskets of flowers, and the number of 'six Personages' is much exceeded and includes putti. As she awakes, Katharine asks Griffith:

> Saw you not, even now, a blessed troop
> Invite me to a banquet; whose bright faces
> Cast thousand beams upon me, like the sun?
> They promis'd me eternal happiness,
> And bought me garlands, Griffith, which I feel
> I am not worthy yet to wear . . . (ll.87–92)

There is considerable evidence of Fuseli's influence on Blake in this work, for instance the spiral of fairies in Fuseli's *The Shepherd's Dream* (1793; Tate Gallery, London) may have suggested Blake's portrayal of the personages. And the positions of the Queen and her attendants are close to those in Fuseli's *Queen Katharine's Dream*, engraved by Blake for *The Plays of William Shakespeare* (1805).

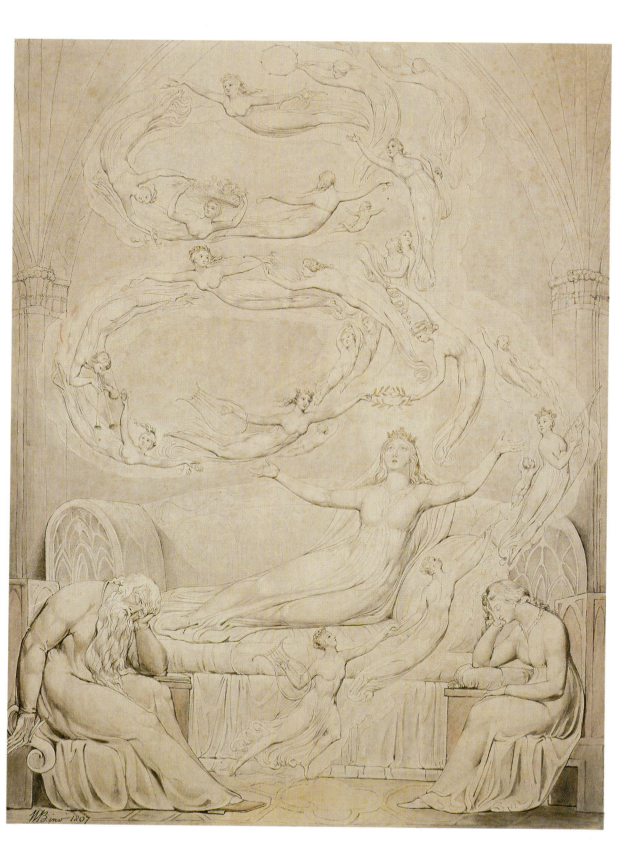

45. The Rout of the Rebel Angels

1807

Pen and watercolour, 25.7 × 20.8 cm

Henry E. Huntington Library and Art Gallery, San Marino, California

This is one of a series of twelve watercolours illustrating Milton's *Paradise Lost* (all in the Huntington Library and Art Gallery) which belonged originally to Blake's patron the Rev. Joseph Thomas; it refers to the passage in Book VI that culminates in the rebel angels throwing themselves

> Down from the verge of Heav'n, Eternal wrauth
> Burnd after them to the bottomless pit. (ll.865–6)

The Son is depicted kneeling within the circle of a nimbus (compare plate 75) in a posture expressing enormous strength, which is emphasised by the surrounding circle. He draws back with his right (spiritual) arm the string of a longbow with several arrows pointing from its edge, one at the centre of the bow, and three more on each side. The nimbus is surrounded by six cherubim, in whose faces may be read a fearful admiration of the vast power of the Deity. Beneath the nimbus the rebels, some with despairing countenances, some clasping their heads in horror, plunge headlong into the flames of the pit. But the terror of the spectacle is all in the design, and is not contributed to by the subdued colouring.

The plunging figures were probably derived from engravings of Michelangelo's *Last Judgment* in the Sistine Chapel, and from pencil and ink drawings by John Flaxman which Blake may have seen, for instance *Falling Angels* and *Michael seizing the Rebel Angels* (both in the British Museum).

The arrows represent intellectual power, and in this setting such symbolism would be appropriate to Blake's view: the intellectual energy of God overpowering the Error of the rebel angels. For by this period of his life Blake was taking a more sympathetic view of the Creator than hitherto (see commentaries to plates 5 and 12), and while he still recognised the necessity of Satan's energy, he now saw God as a less Urizenic, more benign being; and indeed here his expression is less that of the conquering Son of this section of *Paradise Lost* than that of the saviour who later in the poem offers himself to redeem man.

The design of *The Rout of the Rebel Angels* was derived from an illustration Blake made for 'The Progress of Poesy' in Gray's *Poems* (see plates 18 and 19): a beautiful Hyperion in the chariot of the sun draws his bow, while the sun's rays appear as 'glittering shafts of war', some pointing down at the fleeing spectres of the night, just as the Son's arrow points at the falling angels in this watercolour. Both works evoke the famous lines in Blake's epic *Milton* (1804–8):

> Bring me my Bow of burning gold:
> Bring me my Arrows of desire:
> Bring me my Spear: O clouds unfold!
> Bring me my Chariot of fire. (K.481)

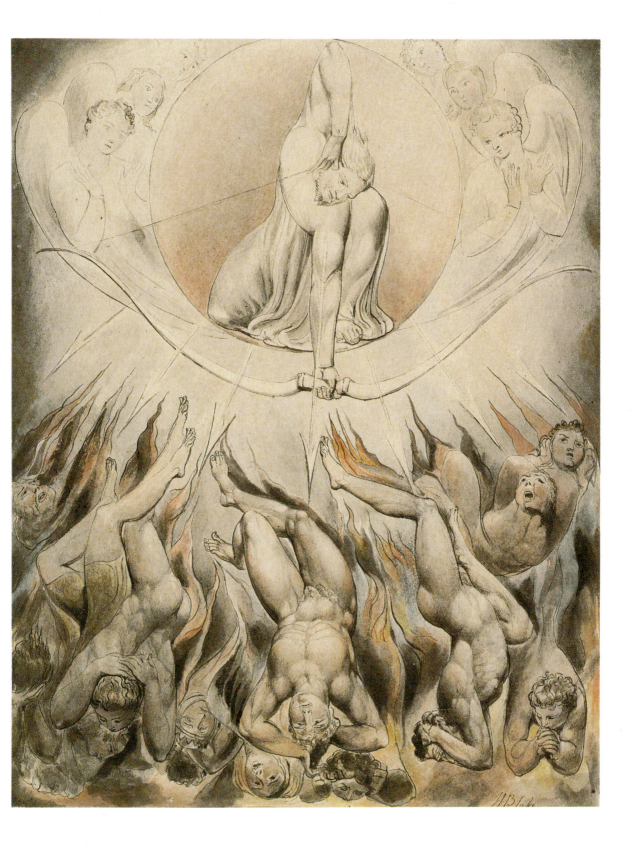

46. Design for the Dedication of Blair's *The Grave*

1807

Pen and watercolour over pencil, 30.2 × 23.8 cm (irregular)

British Museum, London

The shabby treatment meted out to Blake by Robert Hartley Cromek, in connection with the illustrations to *The Grave* by Robert Blair, has been mentioned in the Introduction. This is the design on which Blake intended his dedication to Queen Charlotte to be printed. He submitted it to Cromek, mentioning that his fee would be four guineas (£4.20), and received instead a scurrilous letter; the design was not used and the dedication was printed without it:

TO THE QUEEN
The Door of Death is made of Gold,
That Mortal Eyes cannot behold;
But, when the Mortal Eyes are clos'd,
And cold and pale the Limbs repos'd,
The Soul awakes; and, wond'ring, sees
In her mild Hand the golden Keys:
The Grave is Heaven's golden Gate,
And rich and poor around it wait;
O Shepherdess of England's Fold,
Behold this Gate of Pearl and Gold!

To dedicate to England's Queen
The Visions that my Soul has seen,
And, by Her kind permission, bring
What I have borne on solemn Wing
From the vast regions of the Grave,
Before Her Throne my Wings I wave;
Bowing before my Sov'reign's Feet,
 'The Grave produc'd these Blossoms sweet
 'In mild repose from Earthly strife;
 'The Blossoms of Eternal Life!' (K.442)

The design is a literal interpretation of these verses: a shrouded corpse lies on the ground, separated from the upper part of the design by a cloud representing the division of the material world from that of the spirit. The ascending (female) soul, dressed in a diaphanous gown and holding 'the golden Keys', one in each hand, floats towards the heavenly 'Gate of Pearl and Gold' – a Gothic double door with two keyholes, overarched by branches of a weeping tree, perhaps 'The Blossoms of Eternal Life'. The work is lightly and delicately executed.

It is sad to think that the project of *The Grave* illustrations brought such unhappiness to the trustful Blake, who in a letter of 1805 to William Hayley had referred to 'the Spirited Exertions of my Friend Cromek'. (K.861) It is little wonder that later he raged against Cromek in his Notebook (Rossetti MS):

Cromek Speaks
I always take my judgment from a Fool
Because his judgment is so very Cool,
Not prejudic'd by feelings great or small.
Amiable state! he cannot feel at all . . . (K.549)

Of all Blake's original watercolours for *The Grave* only this one and a few others, all rejected, survive. For the designs which were engraved several pencil sketches exist, but the watercolours have all disappeared.

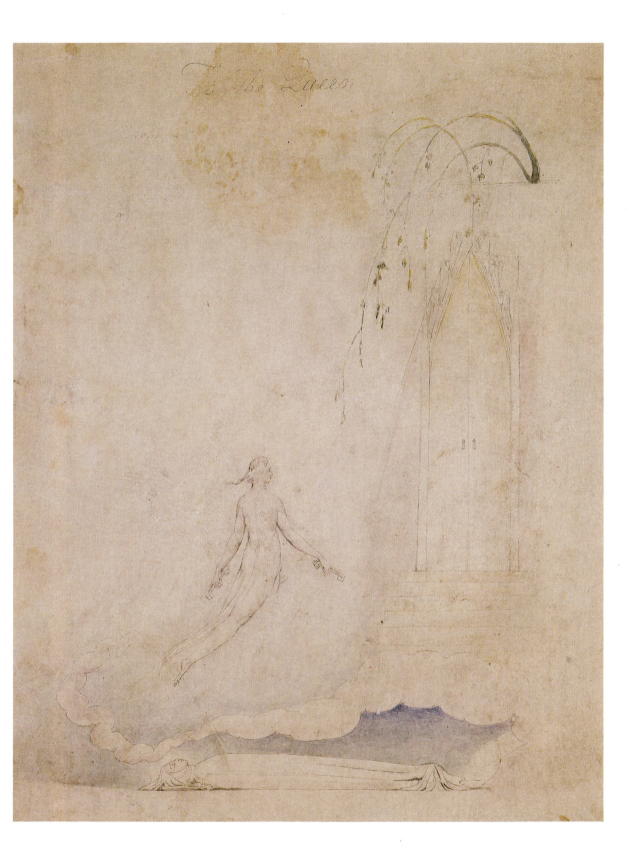

47. A Vision of the Last Judgment

1808
Pen and watercolour over pencil, 51 × 39.5 *cm*
H. M. Treasury, The National Trust, Petworth House, Sussex

Blake painted several versions of this subject, including a large tempera untraced since 1827. The watercolour reproduced here was commissioned by the Countess of Egremont on the suggestion of the miniaturist Ozias Humphry. Blake described the work in detail in a letter to Humphry ('left' and 'right' are used in the heraldic manner, i.e. as if one were looking out of the picture):

> Christ seated on the Throne of Judgment: The Heavens in Clouds rolling before him & around him, like a scroll ready to be consumed in the fires of the Angels; who descend before his feet with their four trumpets sounding to the four Winds.
>
> Beneath; the Earth is convuls'd with the labours of the Resurrection. In the caverns of the Earth is the Dragon with seven heads & ten horns, Chained by two Angels & above his Caverns on the Earth's surface, is the Harlot also siezed & bound by two Angels with Chains while her Palaces are falling into ruins . . .
>
> Hell opens beneath the Harlot's seat on the left hand into which the Wicked are descending.
>
> The right hand of the Design is appropriated to the Resurrection of The Just; the left hand of the Design is appropriated to the Resurrection & Fall of the Wicked.
>
> Immediately before the Throne of Christ is Adam & Eve, kneeling in humiliation, as representatives of the whole Human Race; Abraham & Moses kneel on each side beneath them; from the Cloud on which Eve kneels . . . is seen Satan, wound round by the Serpent & falling headlong . . . many Figures Chain'd & bound together in various attitudes of Despair & Horror: fall thro' the air . . . others are howling & descending into the flames & in the act of dragging each other into Hell & of contending in fighting with each other on the brink of Perdition.
>
> Before the Throne of Christ on the right hand the Just in humiliation & in exultation, rise thro' the air, with their Children & Families: some of whom are bowing before the Book of Life which is open'd by two Angels on Clouds: many Groupes arise with Exultation: among them is a Figure crowned with Stars & the moon beneath her feet with six infants around her. She represents the Christian Church: The Green Hills appear beneath: with the Graves of the Blessed, which are seen bursting with their births of immortality . . .
>
> The whole upper part of the Design is a view of Heaven opened . . . (K.443–4)

Blake continues by pointing out the four living creatures (see commentary to plate 30), the seven angels with the seven vials of wrath, the four and twenty elders sitting in judgment (*Revelation* IV.4; XV.7), the Tabernacle with open veil, the candlestick, the shewbread on its table and the cross in place of the Ark watched over by cherubim. There are also symbols of baptism and communion, and infants in a glory 'representing the Eternal Creation flowing from The Divine Humanity in Jesus: who opens the Scroll of Judgment upon his knees before the Living & the Dead'. (K.444)

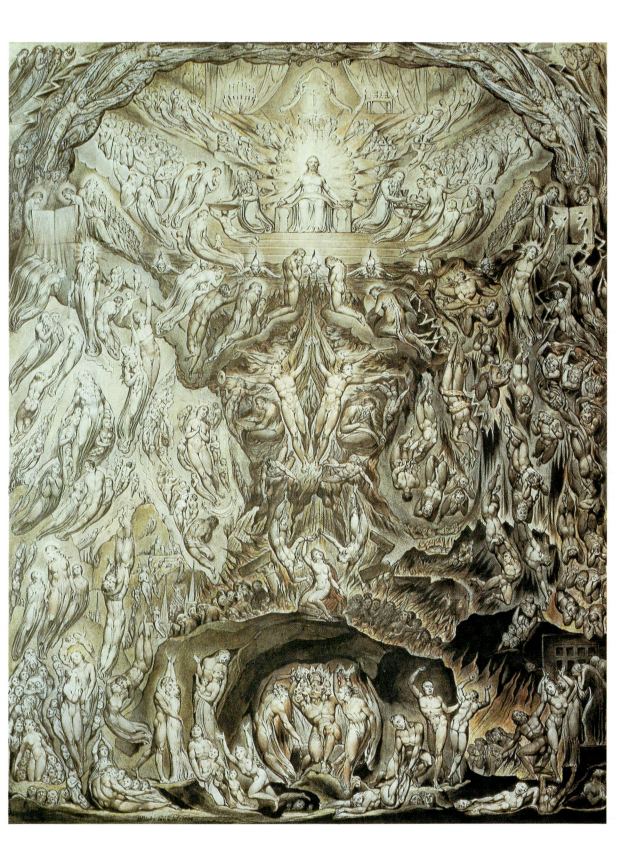

48. The Creation of Eve

1808
Pen and watercolour, 49.9 × 40 cm
Museum of Fine Arts, Boston, Massachusetts

An earlier version of this subject has already been discussed (plate 28); the one reproduced here, from a set of twelve illustrations to *Paradise Lost* painted for Thomas Butts, draws nearer to the traditional rendering in which Eve, created from one of Adam's ribs, is shown emerging from his side, for she is here depicted hovering above him with her left (earthly) foot pointing to his ribs. Another version of the same design, painted for John Linnell, is in the National Gallery of Victoria, Melbourne, Australia.

God is no longer represented as a Urizenic Jehovah figure, but in the person of Christ, indicating Blake's now more sympathetic view of the Creator. The presence of Christ also indicates Blake's belief that the creation of Eve was an act of mercy, by which Adam was given a companion, who, by her part in the Fall, paved the way for Christ's descent to earth to redeem man. Above God's extended arm a waning (female) moon shines in a clear nocturnal sky.

The figure of Christ is immense, with disproportionately large limbs, hands and feet. This massiveness, as in other instances of distortion (see commentaries to plates 2, 28 and 41), helps to place him on a different plane of being from that of his creatures. His marmoreal stance, in contrast to the supple bodies of Adam and Eve, also removes him from the natural level. Both Adam and Eve are extremely beautiful, with complete perfection of physique apart from their genitals, which are undeveloped – perhaps representing what Blake believed was the androgynous state of the sexes before the Fall.

Adam lies asleep, his body totally relaxed, on a flame-like leaf, and Christ stands on another. They are probably derivations of the oak leaf in the painting reproduced on plate 28. If so, the symbolism is similar, indicating Druidic Error and man's suffering; in this case Christ's firm stance on one of the leaves would represent his own supremacy over such Error and suffering.

The technique is meticulous, and everything is firmly defined and outlined, in accordance with Blake's aesthetic canon (see commentary to plate 16). Anthony Blunt (see bibliography) commented on the jewelled and cloisonné-like effect on the trees in the distant grove, the undergrowth beneath them and the herbage in the foreground.

The work is charged with poetic sentiment, and could almost be seen as an evocation of Blake's state of Beulah (see commentary to plate 42), as described in his unfinished epic *Vala, or the Four Zoas*:

> There is from Great Eternity a mild & pleasant rest
> Nam'd Beulah, a soft Moony Universe, feminine, lovely,
> Pure, mild & Gentle, given in Mercy to those who sleep. (K.266)

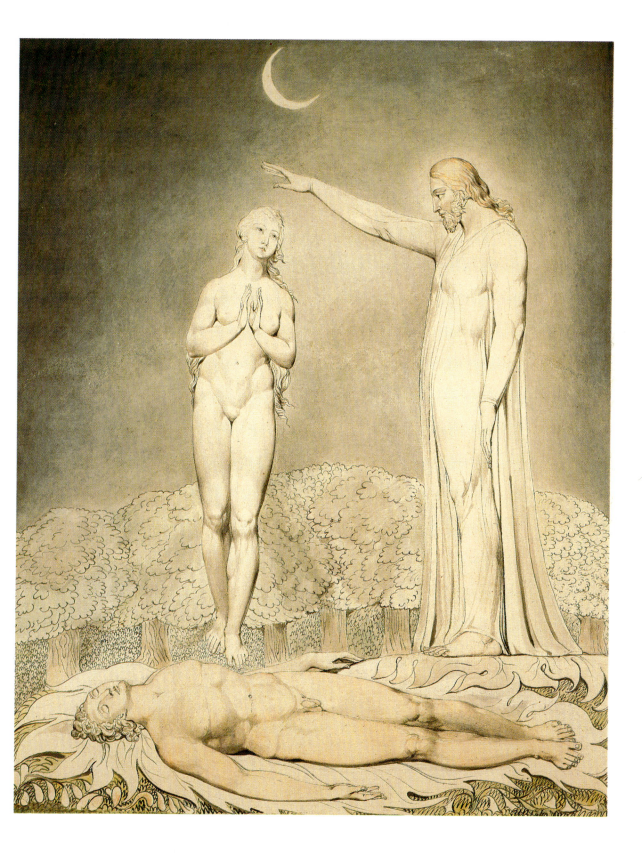

49. The Night of Peace

1809

Pen and watercolour over pencil, 25.6 × 19.3 cm
Whitworth Art Gallery, Manchester

Blake painted two sets of illustrations to Milton's 'On the Morning of Christ's Nativity' (1629): six watercolours, of which this is one, for the Rev. Joseph Thomas, in 1809, and another six for Thomas Butts (see plate 51). In addition he made separate pencil studies of three of the subjects. The Thomas set is in the Whitworth Art Galley, the Butts set in the Henry E. Huntington Library and Art Gallery, San Marino, California.

The Night of Peace illustrates the last two stanzas of the poem:

> So when the Sun in bed,
> Curtain'd with cloudy red,
> Pillows his chin upon an Orient wave,
> The flocking shadows pale,
> Troop to th' infernall jail,
> Each fetter'd Ghost slips to his severall grave,
> And the yellow-skirted *Fayes*,
> Fly after the Night-steeds, leaving their moon-lov'd maze.

> But see the Virgin blest,
> Hath laid her Babe to rest.
> Time is our tedious Song should here have ending:
> Heav'ns youngest teemed Star,
> Hath fixt her polisht Car,
> Her sleeping Lord with Handmaid Lamp attending;
> And all about the Courtly Stable,
> Bright-harnest Angels sit in order serviceable.

Blake shows the baby lying in a manger, while beside him the Virgin rests on a bed of straw, with Joseph watching anxiously over them; two oxen stand at the back. The star of Bethlehem – 'Heav'ns youngest teemed Star' – shines above, and Night, 'Handmaid Lamp' in her hand, is carried across the sky in a car pulled by two steeds on a cloud, against a sky of 'Beulah' stars (see commentary to plate 47). Armoured 'bright-harnest' Angels stand and sit on guard on either side of the thatched Gothic cattle-shed; two more hover above, playing harps, in a pose like the cherubim who guard the Ark of the Covenant.

The work is realised in vigorous pen drawing in brown, with added tints: the colouring is restrained and conveys the atmosphere of dusk – apart from the predominantly muted shades of brown and blue, the only slight accent of brighter colour is the red of the two oxen.

Blake's deep interest in Milton's poem is further illustrated in his prophetic book *Europe*, where there is perhaps a reminiscence of the first three lines of Milton's stanza I,

> It was the Winter wilde,
> While the Heav'n-born-childe,
> All meanly wrapt in the rude manger lies.

in Blake's

> The deep of winter came,
> What time the secret child
> Descended thro' the orient gates of the eternal day. (K.239)

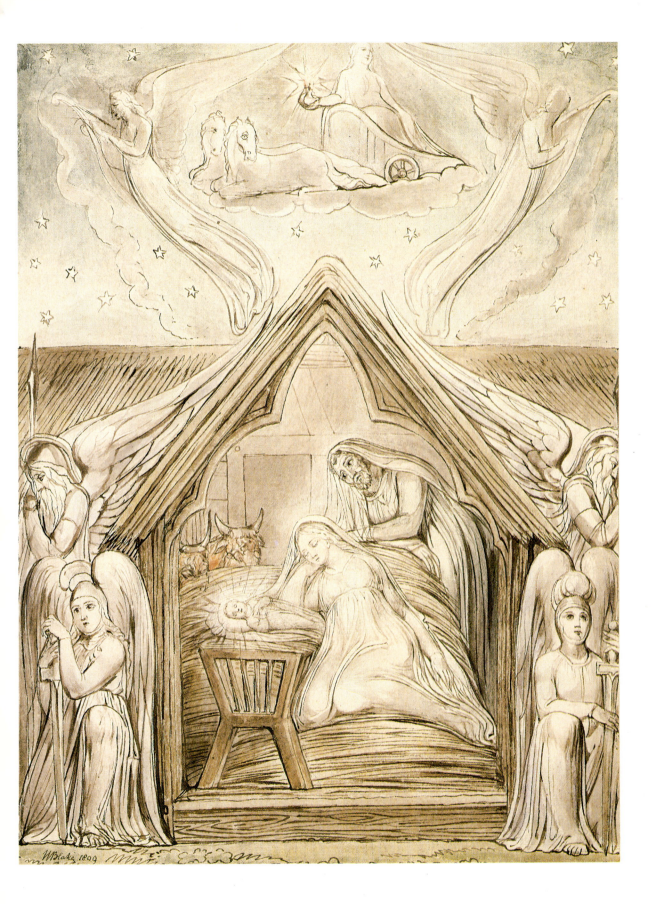

50. Christ blessing

circa 1810
Tempera on canvas, 75 × 62 cm (sight size)
Fogg Art Museum, Harvard University, Cambridge, Massachusetts

Between about 1810 and 1825 Blake produced a number of related tempera paintings for Thomas Butts, of which this ikon-like presentation of Christ is one. Others in the group include *Adam naming the Beasts* and *Eve naming the Birds* (*circa* 1810, both in the Stirling Maxwell Collection, Glasgow Art Galleries and Museum), and *The Virgin and Child in Egypt* (1810, Victoria and Albert Museum, London). The so-called *Black Madonna* (plate 71), also in the group, may not have been painted for Butts; its history before 1863 is not recorded.

The composition is completely formal and symmetrical, Jesus looking straight ahead with his right hand raised in blessing, and his left hand laid on his breast. The hands and fingers are elongated and elegant, sensitive, aesthetic, almost feminine; and there are no stigmata, so the portrait represents Christ in this life, before his Crucifixion. His hair and beard are arranged in almost complete symmetry from a centre parting, all of which adds to the ikon-like formality. The slight parting of the lips, the lambent depth of the eyes, and the complete lack of tension express a state of spiritual bliss; the effect is almost hypnotic. It is a benevolent version of the Great Pantocrator, the omnipotent Lord of the universe, who sternly looks down from the dome of Eastern Orthodox churches; and more, it is a vision of the Word, which St John tells us (I.14) 'was made flesh, and dwelt among us . . . full of grace and truth'.

Christ's robe is minutely painted, with the herringbone pattern of the weave and the knots and loops of the decoration drawn with the intense and detailed attention of a miniaturist. On either side of his head are laurel leaves growing from the stems of saplings, almost forming a pointed arch.

It is a powerful work, such as only a man of Blake's spiritual perception could create. Though a simple and formal composition, it yet presents, in pictorial form, Blake's view of the divine man Jesus, as related in *Jerusalem*:

> Then Jesus appeared standing by Albion as the Good Shepherd
> By the lost Sheep that he hath found, & Albion knew that it
> Was the Lord, the Universal Humanity; & Albion saw his Form
> A Man, & they conversed as Man with Man in Ages of Eternity. (K.743)

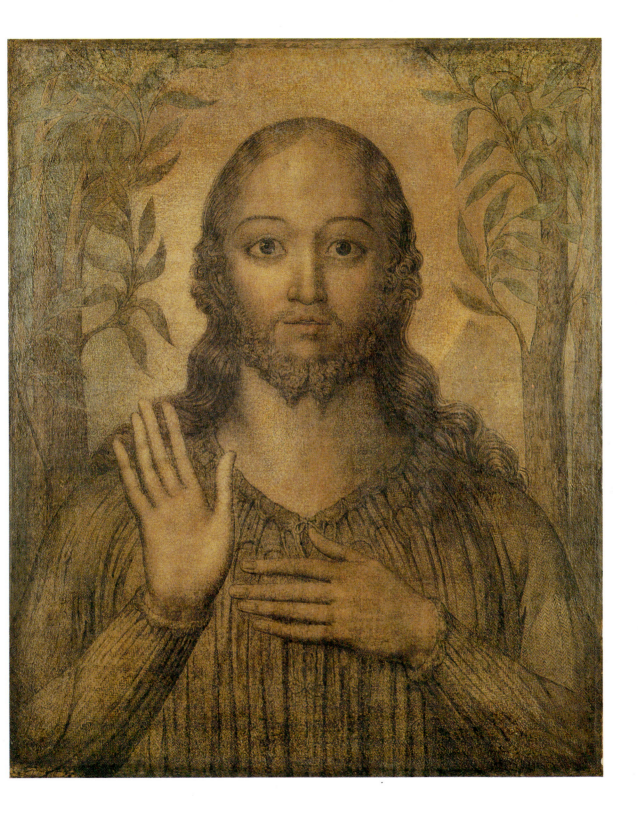

51. The Overthrow of Apollo and the Pagan Gods

circa 1815

Pen and watercolour, 15.7 × 12.3 cm

Henry E. Huntington Library and Art Gallery, San Marino, California

This is one of six watercolours painted for Thomas Butts in about 1815 (see commentary to plate 49). It illustrates stanza xix of Milton's 'On the Morning of Christ's Nativity', which begins an account (continuing to stanza xxiii) of the overthrow of the pagan deities, from Apollo to Ashtaroth and Moloch, initiated by the Nativity:

> The Oracles are dumm,
> No voice or hideous humm
> Runs through the arched roof in words deceiving.
> *Apollo* from his shrine
> Can no more divine,
> With hollow shriek the steep of *Delphos* leaving.
> No nightly trance, or breathed spell,
> Inspire's the pale-ey'd Priest from the prophetic cell.

The setting of Blake's watercolour is Delphos. The statue of Apollo is based on that of the Apollo Belvedere in the Vatican, which Blake must have known from prints. Apollo stands on a pedestal, holding out a longbow in his left hand, against a column around which a serpent twines; a quiver is strapped to his back, and he wears a cape. In front of this statue, flames envelop the table of an altar (symbol of the Delphic shrine), before which four nymphs prostrate themselves. To the left of this group is a classical structure.

At the right the demented Pythoness (priestess) sits in a cave, pressing her arms against the roof as if she were trying to enlarge it; a graceful tree, forming a primitive Gothic arch, grows around its opening. Above this, on an eminence, are some trilithons, symbolising Druidic Error, yet another aspect of paganism; from a fire burning before them on what is possibly an altar, flames and smoke rise into the sky bearing bat-like forms. Behind the statue of Apollo, a naked figure, representing his spiritual form, dives amidst an enormous flame towards the distant sea. A white form just below appears to be moving on the surface of the sea.

Blake's friend Flaxman, in a lecture delivered to the Royal Academy in 1810, had described the Apollo Belvedere as 'the Deliverer from Evil', and elsewhere he spoke of it as embodying more ideal beauty than any other statue. But in this illustration, Blake has turned his back on what, in a letter to George Cumberland written in 1800, he described as 'the Grecian light & glory which is coming on Europe' (K.797), and turned to Gothic art – evident in the figures of the nymphs, in the diving figure, and in the bat-like forms – as fitter to embody his intellectual ideal, and his view of the New Dispensation. By about 1820, some five years after painting this watercolour, he was writing on his etched plate *On Homer's Poetry & on Virgil*:

> Rome & Greece swept Art into their maw & destroy'd it; a Warlike State never can produce Art. It will Rob & Plunder & accumulate into one place, & Translate & Copy & Buy & Sell & Criticise, but not Make. Grecian is Mathematic Form: Gothic is Living Form, Mathematic Form is Eternal in the Reasoning Memory: Living Form is External Existence. (K.778)

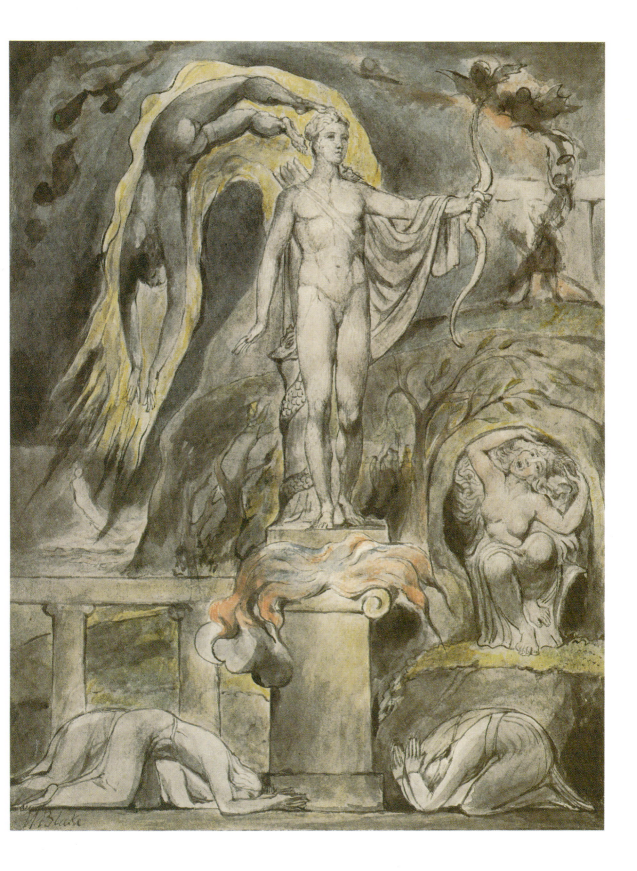

52. An Allegory of the Spiritual Condition of Man

1811 (?)

Pen (or point of brush) and tempera on canvas, 151.5 × 121.3 cm
Fitzwilliam Museum, Cambridge

Another symbolic painting in the same category as *A Vision of the Last Judgment* (plate 47), *An Allegory of the Spiritual Condition of Man* was painted for Thomas Butts. It is Blake's largest surviving picture and has sustained a certain amount of damage over the years, but has been twice restored, most recently in 1950.

In the foreground are three female figures: on the left Faith holding in her hands an open book, presumably the Bible; on the right Hope with her anchor. The central, crowned, figure was for long thought to be Charity, but Charity seems to be best personified by the figure hovering above, holding two children by the hand while others sport around her. It has now convincingly been suggested that the crowned figure is an aspect of Charity – the love of God, *amor dei* – while the figure with the children represents another aspect, the love of one's neighbour, *amor proximi*. In the view of the Church the second was of little value without the first. It is possible that the two figures flanking Charity in her *amor proximi* aspect refer to similar aspects of Faith and Hope.

At the apex of the composition is a kneeling woman, perhaps the soul of Charity, carried by two angels, with an aureole above her. She too is flanked by two figures, probably representing the spiritual aspects of Faith and Hope. Rays of light from above the aureole shine down on the whole composition.

A landscape of hills is visible, with the River of Life flowing between them. At the left are classical buildings (institutional religion) and Druidical structures (primitive religion or Error); on the right, under trees, is a piping shepherd (Innocence).

At the sides of the composition are several biblical scenes: on the left, reading downwards, the Creation by the angel of the divine presence; Adam and Eve in the Garden of Eden; Noah's Ark with the rainbow of the Covenant underneath; Abraham and Isaac and, to the right, Moses destroying Pharaoh's host in the Red Sea; the Judgment of Solomon; the Babylonian Captivity; and the Crucifixion (from behind). On the right, reading upwards, the scenes are the three Marys at the sepulchre; Pentecost; a martyr being burnt, and beside him what is possibly St Peter in prison; the seven-headed beast of the Apocalypse; angels blowing the last trump; and Christ in glory. The scenes represent the cycle of man's progress from the Creation, through the Fall and Redemption and the ascent to spiritual grace, the central motif being the symbolism of St Paul's *First Epistle to the Corinthians* XIII.13: 'And now abideth faith, hope, charity, these three; but the greatest of these is charity.'

The Spiritual Condition of Man is a work of great beauty, with delicate colouring, graceful forms, and the solution of a complicated composition; it affords some idea of what Blake would have done if he had chosen to work on a large scale.

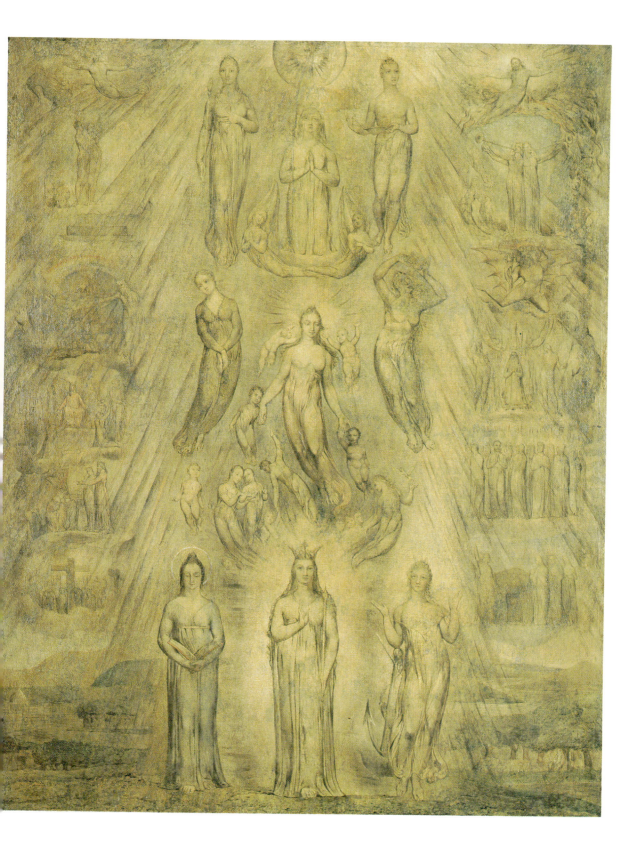

53. The Judgment of Paris

1811 (?)

Pen and watercolour over pencil, 38.5 × 46 cm
British Museum, London

Blake painted this classical subject for Thomas Butts; it is uncertain if the date at the lower right is 1811 or 1817, but the former is usually accepted. A related watercolour, perhaps also made for Butts, *Philoctetes and Neoptolemus* (Fogg Art Museum, Harvard University, Cambridge, Massachusetts), was painted in 1812, probably as a pendant to *The Judgment of Paris*.

At the right stand the three goddesses in the myth – Aphrodite between Hera at the left and Athena at the right. Paris, half in a dream, sits on a bank, his shepherd's crook in his right hand; with his left he hands the golden apple to Aphrodite, to the chagrin of Hera, who raises her left arm in imprecation and points her right hand at Paris. In answer to her curse the storm clouds gather over the distant city of Troy, and lightning cleaves the sky. Athena's reaction is quieter and she merely scowls at Paris. Behind the goddesses, Paris' sheep graze unconcernedly, and at his feet lies his sleeping dog, wearing a collar marked with his master's name in Greek letters.

To the left of Paris, Eros flies away in triumph; above, Hermes, with his sleep-giving caduceus, flies over the group, presenting the goddesses to Paris. Above him, separated by a wisp of cloud, is the distorted, three-headed and torchbearing monster, Discord, who will soon destroy Troy with his flames.

It has been claimed that Blake's composition is based on an account of the myth by Sallust, quoted in Thomas Taylor's *Dissertation on the Eleusinian and Bacchic Mysteries* (? 1790, p.71). Sallust speaks of the symbolic meaning of gods and myths and goes on to describe the Judgment of Paris:

> But we may perceive the mixed kind of fables, as well in many other particulars, when they relate that Discord, at a banquet of the gods, threw a golden apple, and that a dispute about it arising among the goddesses, they were sent by Jupiter to take the judgment of Paris, who, charmed with the beauty of Venus, gave her the apple in preference to the rest. For in this fable the banquet denotes the supermundane powers of the gods; and on this account they subsist in conjunction with each other; but the golden apple denotes the world, which, on account of its composition from contrary natures, is not improperly said to be thrown by Discord, or strife. But again, since different gifts are imparted to the world by different gods, they appear to contest with each other for the apple. And a soul living according to sense (for this is Paris) not perceiving other powers in the universe, asserts that the apple is alone the beauty of Venus.

Blake's interpretation of the myth is close to this account, especially in its emphasis on the figure of Discord and the want of perception of the torpid Paris, who seems to be offering the apple to Aphrodite without even being aware of Hera and Athena.

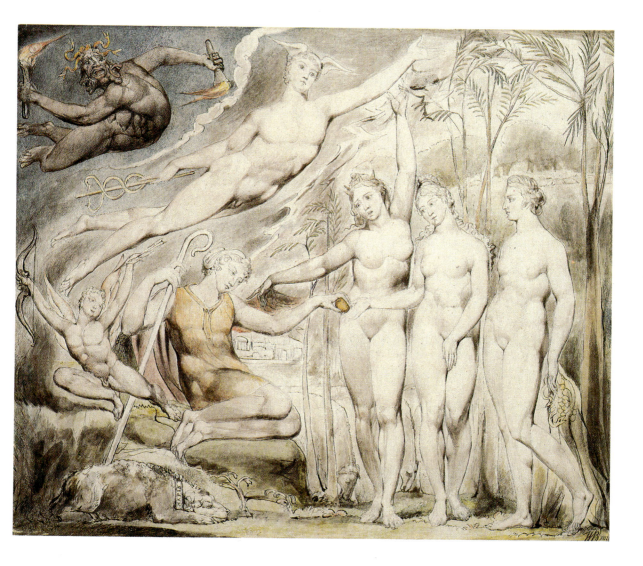

54. Mirth, from Milton's *L'Allegro*

circa 1816–20
Pen and watercolour, 16.1 × 12.1 cm
Pierpont Morgan Library, New York

Circa 1816–20 Blake painted twelve watercolours illustrating Milton's *L'Allegro* and *Il Penseroso* for his faithful patron, Thomas Butts; all are now in the Pierpont Morgan Library. They were once bound together in a folio volume, and though now disbound are still on the original sheets, which Blake inscribed with the passages illustrated and with his comments. The inscription on this watercolour reads:

> Mirth Allegro
>
> Heart easing Mirth
> Haste thee Nymph, & bring with thee
> Jest & Youthful Jollity,
> Quips & Cranks & Wanton Wiles
> Nods & Becks & Wreathed Smiles,
> Sport that wrinkled Care derides,
> And Laughter holding both his Sides.
> Come & trip it as you go
> On the light phantastic toe
> And in thy right hand lead with thee
> The Mountain Nymph Sweet Liberty.

These Personifications are all brought together in the First Design Surrounding the Principal Figure which is Mirth herself. (K.617–18)

(The quotation is from lines 25–36 with some omissions.)

The beautiful smiling figure of Mirth, poised on 'the light phantastic toe' with her right (i.e. spiritual) foot forward, her blonde hair floating in joyful abandon and a glory behind her head, dances towards the viewer, surrounded by her spiritual companions. Sweet Liberty, with a quiver of arrows slung behind her, holds Mirth's right hand. Above her, with his back towards us, is Wrinkled Care, derisively pointed to by Sport, who floats down with the figures of Nods to his left and Becks to his right. The boy and girl dancing to left and right of Mirth are Jest and Youthful Jollity; above the girl is Laughter holding his sides and below him are Wanton Wiles with bats' wings and ass's ears. Close to Mirth's uplifted hand are Quips, blowing a trumpet, and his companions; below him are the flying Cranks and his companions. Finally, around Mirth's glory are further tiny figures of Wanton Wiles.

Blake made an engraving of this design, of which there are two states. Only one impression of each is known; that of the first is in the British Museum, and that of the second belonged to the late Sir Geoffrey Keynes. The first state is a somewhat conventional stipple engraving, and Blake must have been dissatisfied with it, for he later rubbed down the plate and re-engraved it with a more vigorous rendering of the composition, but this he never finished. The first state is a more accurate rendering of the finely wrought watercolour; the second is more energetic.

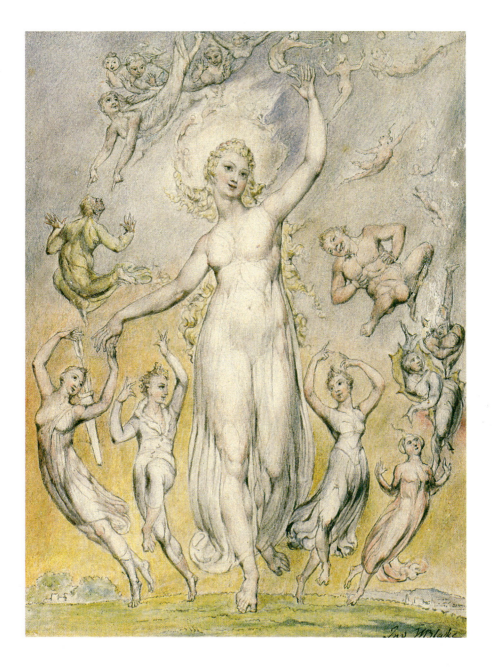

55. Melancholy, from Milton's *Il Penseroso*

circa 1816–20
Pen and watercolour, 16.2 × 12.2 cm
Pierpont Morgan Library, New York

The antithesis of Mirth (see plate 54), *Melancholy* is based on lines 31–60 of *Il Penseroso*:

> Com pensive Nun, devout and pure,
> Sober, stedfast, and demure,
> All in a robe of darkest grain,
> Flowing with magestick train,
> And sable stole of *Cipres* Lawn,
> Over thy decent shoulders drawn.
> Com, but keep thy wonted state,
> With eev'n step, and musing gate,
> And looks commercing with the skies,
> Thy rapt soul sitting in thine eyes:
> There held in holy passion still,
> Forget thy self to Marble, till
> With a sad Leaden downward cast,
> Thou fix them on the earth as fast.
> And joyn with thee calm Peace, and Quiet,
> Spare Fast, that oft with gods doth diet,
> And hears the Muses in a ring,
> Ay round about *Joves* Altar sing.
> And adde to these retired Leasure,
> That in trim Gardens takes his pleasure;
> But first, and chiefest, with thee bring,
> Him that yon soars on golden wing,
> Guiding the fiery-wheeled throne,
> The Cherub Contemplation,
> And the mute Silence hist along,
> 'Less *Philomel* will daign a Song,
> In her sweetest, saddest plight,
> Smoothing the rugged bow of night,
> While *Cynthia* checks her dragon yoke,
> Gently o're th' accustom'd Oke.

The 'pensive Nun', Melancholy, stands in the centre of the composition, against a background of trees, her left (material) foot forward. At the left is Peace, with a star-like halo, and holding a crook; she half turns towards Quiet, whose hands are joined in prayer. At the right, looking up at Melancholy, is Spare Fast, with the ring of Muses above her, dancing before the fiery altar of Jove. Farther to the right is Leisure, who, with folded arms, is taking his pleasure 'in trim Gardens'. In the starry sky at the left is the hag-like form of Mute Silence, with the naked Philomel beneath her. At the opposite side is Cynthia sitting on a waning moon towed by two bat-winged reptiles, her 'dragon yoke'. At the top of the picture is the Cherub Contemplation, with arms and golden wings outspread, on the 'fiery-wheeled throne'.

The two designs, of this plate and the previous one, may be taken together and seen as expressions of Blake's states of Innocence (*Mirth*) and Experience (*Melancholy*), for in the first he emphasises innocent and happy artlessness, and in the second sad dejection, reversing Milton's own preference:

> These pleasures *Melancholy* give,
> And I with thee will choose to live. (ll. 175–6)

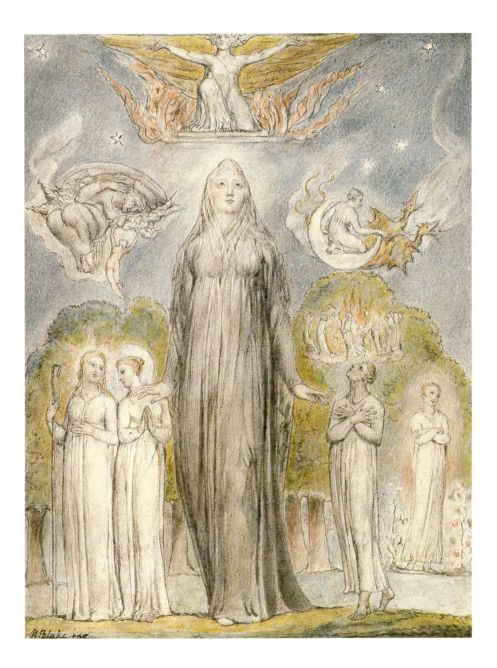

56. The Baptism of Christ

circa 1816–20
Pen and watercolour over pencil, 17.3 × 13.6 cm
Fitzwilliam Museum, Cambridge

Sometime between 1816 and 1820 Blake painted a set of watercolours illustrating *Paradise Regained*; this is one of them. John Linnell bought them from him and twice offered them for sale: in 1827 to Sir Thomas Lawrence, and in 1832 to the poet Samuel Rogers; it is possible that he also offered them to the sculptor Francis Chantrey. But he did not succeed in selling them, and they remained in the possession of his family until 1918. Deceptive copies by Linnell's son, J. T. Linnell, were exhibited at the Tate Gallery in 1913.

Blake painted two other versions of the Baptism: a tempera of *circa* 1799–1800 (Museum of Art, Rhode Island School of Design, Providence), and a watercolour of *circa* 1803 (Ashmolean Museum, Oxford). Neither is related in design or technique to this version.

The design is based on Book I, ll. 18–39, of Milton's poem:

> Now had the great Proclaimer with a voice
> More awful than the sound of Trumpet, cri'd
> Repentance, and Heav'ns Kingdom nigh at hand
> To all Baptiz'd: to his great Baptism flockd
> With aw the Regions round, and with them came
> From *Nazareth* the son of *Joseph* deemd
> To the flood *Jordan*, came as then obscure,
> Unmarkt, unknown; but him the Baptist soon
> Descri'd, divinely warnd, and witness bore
> As to his worthier, and would have resign'd
> To him his Heavn'ly Office, nor was long
> His witness unconfirmed: on him baptiz'd
> Heav'n op'nd, and in likeness of a Dove
> The Spirit descended, while the Fathers voice
> From Heav'n pronounc'd him his beloved Son.
> That heard the Adversary, who roving still
> About the World, at that assembly fam'd
> Would not be last, and with the voice divine
> Nigh Thunder-strook, th' exalted man, to whom
> Such high attest was giv'n, a while survey'd
> With wonder, then with envy fraught and rage
> Flies to his place, nor rests . . .

Jesus stands wearing only a loincloth, right (i.e. spiritual) foot slightly forward, in a graceful, almost dancing pose. He looks upwards as the Baptist pours Jordan water from a horn over his head. The Holy Ghost descends towards him in the form of a dove between flashes of lightning, and Satan, with his serpent of materialism (compare plate 12), and with a suggestion of fire, flies away at the right. At each side of the composition are women and children, their arms raised in joy, and behind those on the right an old man clasps his hands in prayer. In the background beyond the Jordan are hills and a town, presumably Bethabara, which according to *John* I.28 was the scene of the Baptism.

The technique is meticulous, and the work is finished in stipple as fine as in a miniature.

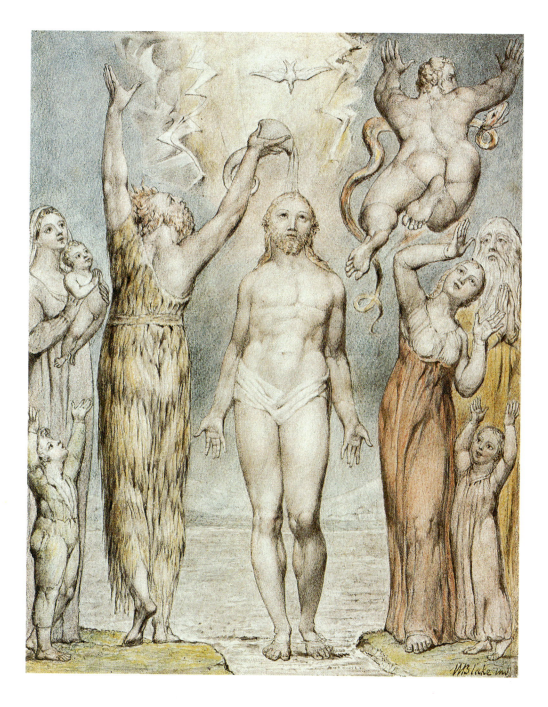

57. The Ghost of a Flea

circa 1819–20
Tempera with gold on panel, 21.4 × 16.2 cm
Tate Gallery, London

Between about 1819 and 1825, at the entreaty of John Varley, Blake made a series of 'visionary portraits', mostly in pencil. It is difficult to decide if, in creating these works, Blake was simply using his vivid imagination or actually seeing eidetic images; but the evidence – especially what is known of Blake's mind – favours imagination, despite Varley's testimony (below).

The Ghost of a Flea is related to the visionary heads and is probably derived from one of them (Private Collection, England) which was once in the now dismembered and dispersed *Blake–Varley Sketchbook* (1819), so named because it was used by both men. There is also a *Head of the Ghost of a Flea* from the same book (Tate Gallery), and this was engraved by Linnell for Varley's *Treatise on Zodiacal Physiognomy* (1828); it differs considerably from the head in the tempera. Varley gives a description in the *Treatise* (p. 55) of Blake drawing the *Head*:

> This spirit visited his [Blake's] imagination in such a figure as he never anticipated in an insect. As I was anxious to make the most correct investigation in my power, of the truth of these visions, on hearing of this spiritual apparition of a Flea, I asked him if he could draw for me the resemblance of what he saw: he instantly said, 'I see him now before me.' I therefore gave him paper and a pencil, with which he drew the portrait, of which a fac-simile is given in this number. I felt convinced by his mode of proceeding that he had a real image before him, for he left off, and began on another part of the paper, to make a separate drawing of the mouth of the Flea, which the spirit having opened, he was prevented from proceeding with the first sketch, till he had closed it. During the time occupied in completing the drawing, the Flea told him that all fleas were inhabited by the souls of such men, as were by nature blood-thirsty to excess, and were therefore providentially confined to the size and form of insects; otherwise, were he himself for instance the size of a horse, he would depopulate a great portion of the country.

Once the property of Varley, this tempera painting of the subject is one of Blake's most alarming works, yet its setting resembles the stage of a theatre, with parted curtains and boards that end abruptly against a backdrop of stars with a comet cleaving the sky. The figure of the ghost is a terrible conception, striding with its right foot forward (though it is the ghost of a flea, it is a ghost nevertheless, so its spiritual state is thus indicated); in its left hand is a bleeding bowl, in its right a dagger. The bulbous staring eyes and the tongue protruding from between sharp teeth, the finny formations above the ears, the brutish neck and powerfully muscled body all indicate a reptilian and malevolent presence, made more lurid by the exquisite illumination of the painted and gold-encrusted surface.

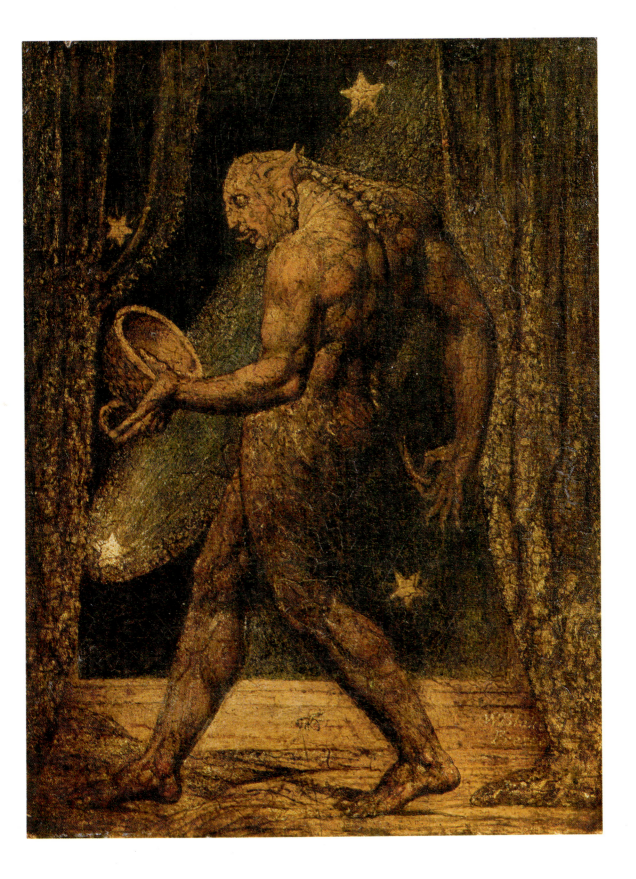

58. Old Parr when Young

1820
Pencil, 29.7 × 18.4 cm
Henry E. Huntington Library and Art Gallery, San Marino, California

One of Blake's 'visionary portraits' (see commentary to plate 57), this was drawn in August 1820, probably for Varley, for the inscriptions are in his hand. It was later owned by John Linnell.

The visionary portraits included a large number of historical people and several imaginary characters. Among the first group are *Caractacus, King Harold, King John, David, Saul, Solomon, Socrates, Mahomet, Wat Tyler* and *Owen Glendower*; among the second are *The Egyptian Taskmaster killed by Moses, Satan, The Tax-Gatherer killed by Wat Tyler, The Man who built the Pyramids* and *The Man who taught Blake Painting in his Dreams*. It hardly needs to be added that none is a portrait within the conventional meaning of the word, but Blake's view of the spiritual nature of the person represented.

Old Parr when Young belongs to the first category, for the subject was a real person, Thomas Parr, said on the slenderest authority to have been born in 1483. He died in 1635, the year in which he was presented to Charles I by the Earl of Arundel, who had him carried in a specially constructed litter from Shrewsbury to London. 'You have lived longer than other men', said Charles, 'what have you done more than other men?' 'I did penance when I was an hundred years old', replied Parr. This referred to an occasion when he did penance in a white sheet in the church of Alberbury, near Shrewsbury, after having reputedly fathered a bastard child on a girl named Katherine Milton.

Parr boasted that he had lived under ten monarchs. He married twice, the second time at the age (he claimed) of 122. It was said that he threshed corn when he was 130. William Harvey, the physician who discovered the circulation of the blood, carried out an autopsy on Parr's body and found that his main organs were in excellent condition; his death Harvey attributed to the change from the peaceful countryside – 'the open, sunny and healthy region of Salop' – to the unclean conditions in the capital.

The inscription at the lower left corner of the drawing states that the portrait is of 'Old Parr when young, Viz 40.' Blake depicts him as an unusually powerful and well-formed man, with more than a suggestion of the description of him by John Taylor, the water-poet:

> From head to heel his body hath all over
> A quick-set, thick-set, nat'ral hairy cover.

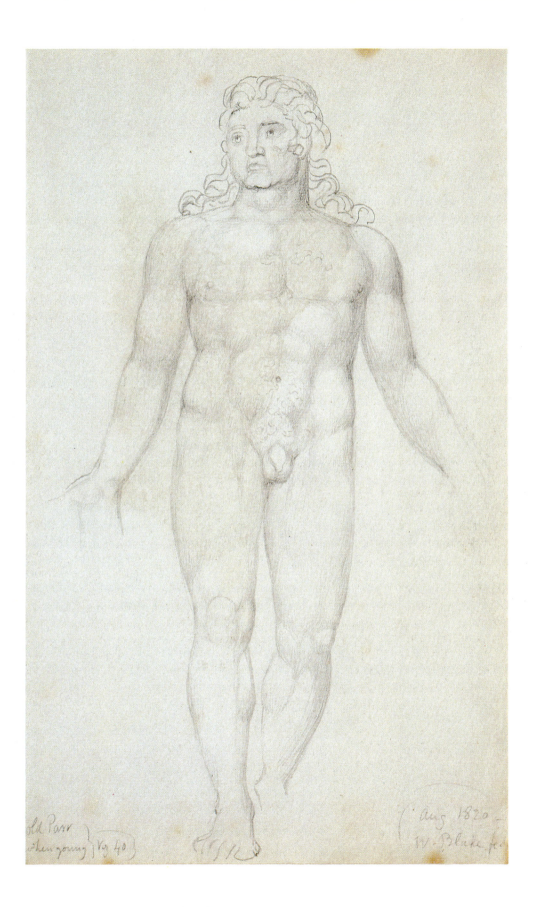

Old Parr
(when young) Vol 40.

Aug 1820
W. Blake fe.

59. Beatrice addressing Dante from the Car

1824–7

Pen and watercolour, 37.2 × 52.7 cm

Tate Gallery, London

It was probably during the summer of 1824 that Linnell gave Blake some excellent Dutch paper and commissioned from him a series of illustrations to Dante's *Divine Comedy* which it was planned eventually to engrave; Blake was to receive £2 or £3 weekly according to his needs, and was to do as little or as much as he wished in return. He was still working on this commission when he died in August 1827, by which time he had painted over a hundred watercolours and engraved seven plates.

Beatrice addressing Dante is based on passages in *Purgatorio* Cantos XXIX and XXX, in which Dante describes Beatrice riding on a triumphal car drawn by a gryphon and attended by nymphs. She stands on the car chiding Dante, dressed in diaphanous drapery which scarcely veils her beautiful body, and wearing a crown and a large fichu. Around her are, in the words of H. F. Cary's translation,

> Four animals, each crown'd with verdurous leaf.
> With six wings each was plumed; the plumage full
> Of eyes . . .

These parallel Ezekiel's four living creatures (see commentary to plate 30). The car is drawn by a great brilliantly coloured gryphon, near which stands Dante. Two nymphs, one wearing green, the other red, stand at the back of the car; one has five infants at her sides, one above another. A third nymph, dressed in white, stands between them, pointing with one hand at a book floating in vapour, and with the other pointing at Dante. The wheel of the car is a many-hued vortex containing eyes and female faces. The sky glows with all the colours of the spectrum.

There is much of Blake's symbolism in this. The vortex-wheel symbolises the passive female character which sped the Fall. It contains eight eyes, probably representing the seven eyes of God, and an eighth eye mentioned by Blake in some of his mythological poems and thought to symbolise the promise of man's spiritual awakening.

The four animals are to be equated with Blake's four Zoas (see commentary to plate 30): the eagle is Tharmas; the lion is Urizen; the bull is Luvah; and the man is Los. The nymphs and Beatrice represent the 'emanations' (female counterparts) of the Zoas: Beatrice is Vala (Nature), emanation of Luvah; the green nymph is Ahania (Pleasure), emanation of Urizen; the red nymph is Enion (Generative Instinct), emanation of Tharmas; the white nymph is Enitharmon (Spiritual Beauty), emanation of Los; the book to which she is pointing is the restrictive Book of Law, which is about to be swept into the vortex. The gryphon is related to Leviathan and Behemoth (see commentary to plate 36), and the cloud surrounding it symbolises its spiritual limitation. The five infants with the red nymph represent the five senses.

This watercolour, therefore, as well as being a recognisable illustration of a scene in Dante, represents the gamut of the world of Blake's spiritual and psychological symbolism.

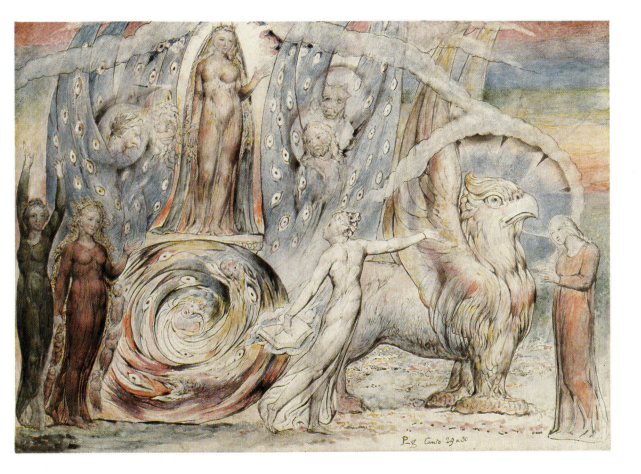

60. The Simoniac Pope

1824–7
Pen and watercolour, 52.7 × 36.8 cm
Tate Gallery, London

This is an illustration to *Inferno* Canto XIX in *The Divine Comedy*, where the fate of simoniacs (those who buy or sell positions in the Church) is described: each one is condemned to exist upside down in a well of fire and endure unending blazing torture. Here Virgil, who is Dante's guide, has carried him down to the mouth of a cavern in the third trench of the Eighth Circle of Hell, so that he can inspect one of the victims more closely – Gian Gaetani degli Orsini, Pope Nicholas III from 1277 to 1280, who was guilty not only of numerous acts of simony, but also of nepotism.

At first he thinks that Dante is one of his successors, Boniface VIII (1294–1303), but on discovering his mistake, he explains that Boniface, when he arrives, will take his place, pushing him down into the well, until he is himself pushed down by Clement V (1305–14), who will arrive in his turn. Before Virgil carries him off, Dante tells Nicholas, to his chagrin, that he has received no more than his deserts.

In Blakean terms the inverted Pope represents the Fall (in several places Blake uses diving or inverted men to symbolise this); the flames represent the suffering of man in his fallen state. Blake used the cavern more than once to indicate the limitation of human experience. For instance, in the opening lines of his *Europe: A Prophecy* (1794), a fairy sings of the 'cavern'd Man' and his five senses:

> 'Five windows light the cavern'd Man: thro' one he breathes the air;
> 'Thro' one hears music of the spheres; thro' one the eternal vine
> 'Flourishes, that he may recieve the grapes; thro' one can look
> 'And see small portions of the eternal world that ever groweth;
> 'Thro' one himself pass out what time he please; but he will not,
> 'For stolen joys are sweet & bread eaten in secret pleasant.' (K.237)

Greater perception can be achieved only by escaping from the cavern through its narrow openings – a concept which endows the senses with a spiritual dimension.

The drawing is realised in Blake's favourite technique of pen and watercolour and is notable for its sensitive yet firm drawing and above all for its lucent colouring. The wall of the well seems to be made of fiery glowing glass, for the naked Pope may be clearly seen within, like a fly in amber, while Dante and Virgil crouch rooted to the brink in horror.

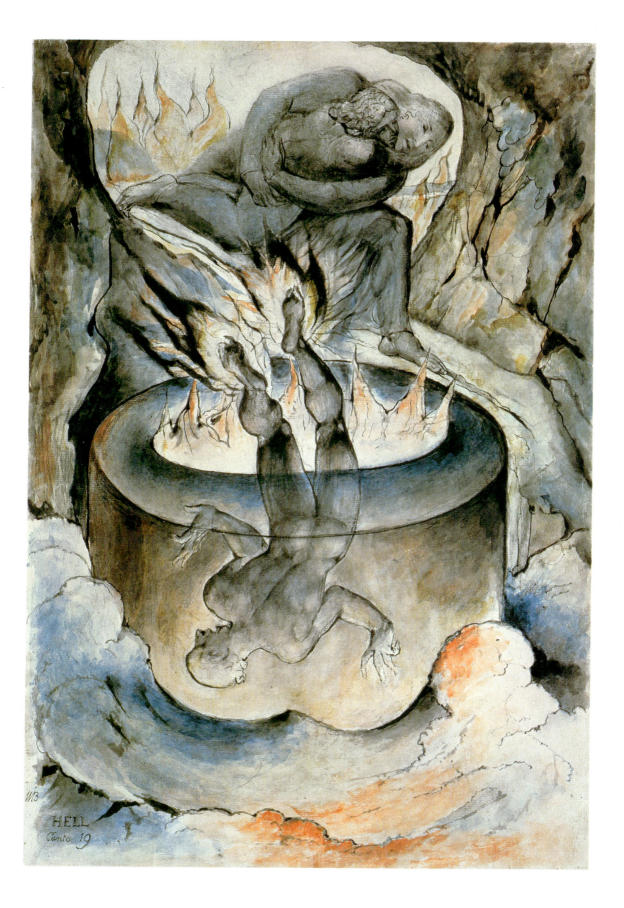

HELL
Canto 19

61. Antaeus setting down Dante and Virgil in the Last Circle of Hell

1824–7

Pen and watercolour, 52.6 × 37.4 cm
National Gallery of Victoria, Melbourne, Australia

This watercolour illustrates *Inferno* Canto XXXI in *The Divine Comedy*. It is a titanic conception, the giant Antaeus setting down Virgil and Dante in Cocytus, the Ninth Circle of Hell. Antaeus was the son of Poseidon and Ge (Earth); his strength was invincible so long as he retained contact with the earth, but Hercules discovered this secret, lifted him from the earth, and crushed him in the sky. In Hell, Antaeus is unfettered, because he did not join the other giants to fight against the gods. Virgil has appealed to him to help them into Cocytus, mentioning that Dante is to return to earth, where he could help to restore the giant's fame. Without a word, Antaeus picks them up and places them in the Ninth Circle.

He is balancing himself carefully on a cliff, grasping a rock with his left hand, and is about to place Dante, whom he holds between his finger and thumb and who clutches him round the wrist and little finger, safely beside Virgil. A band of cloud, with a hailstorm issuing from it, surrounds Antaeus, and there are flames in the sky.

The anatomy of the giant is vigorously drawn, and is as powerful as a nude by Michelangelo. Its twisted, almost anguished posture has something of the *Sturm und Drang* in works by Fuseli, such as *Achilles Grasps at the Shade of Patroculus* (1803; Kunsthaus, Zurich) or *Roland at Roncevalles (Fame)* (1800–10; Detroit Institute of Arts).

In his standard book on the Dante series, Albert S. Roe identifies recollections of Blake's Zoa Tharmas (the body) in the delineation of the giant, and sees him as Blake's idea of fallen man: beautiful and strong, but materialistic and without feeling, thought or imagination. The band of cloud around Antaeus is a symbol of the separation of the eternal word of the imagination (personified by the poets Virgil and Dante) from that of materialism (personified by Antaeus).

Like *The Simoniac Pope* (plate 60), this is a beautifully executed watercolour, exquisitely coloured. Although the series was created during Blake's last three years, when his health was often poor, the watercolours – and the engravings – are lively and inspired. Samuel Palmer, in his notebook, recalled Blake working on them:

> On Saturday, 9th October, 1824, Mr. Linnell called and went with me to Mr. Blake. We found him lame in bed, of a scalded foot (or leg). There, not inactive, though sixty-seven years old, but hard-working on a bed covered with books sat he up like one of the Antique patriarchs, or a dying Michael Angelo. Thus and there was he making in the leaves of a great book (folio) the sublimest designs from his (not superior) Dante. He said he began them with fear and trembling. I said 'O! I have enough of fear and trembling.' 'Then', said he, 'you'll do.' He designed them (100 I think) during a fortnight's illness in bed! And there, first, with fearfulness (which had been the more, but that his designs from Dante had wound me up to forget myself), did I show him some of my first essays in design.

(It is unlikely that Palmer meant that Blake made a hundred finished watercolours in two weeks; he was almost certainly referring to outlines of the designs.)

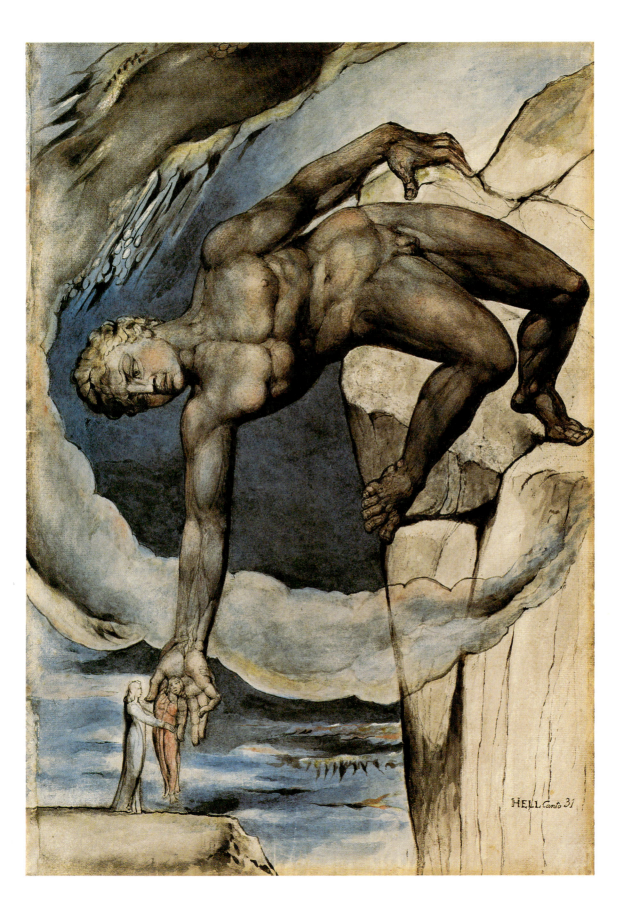

HELL. Canto 31

62. Christian reading in his Book

1824–7
Pencil, pen and watercolour, 17.2 × 12.6 cm
Frick Collection, New York

It is not known for whom Blake made his twenty-nine watercolours to illustrate John Bunyan's *The Pilgrim's Progress*, but it is likely that they were intended for John Linnell. If so, Linnell probably had reservations and did not accept them, for they were in the possession of Mrs Blake when she died, and then passed into the hands of Frederick Tatham, for whom they were sold at auction by Sotheby's in April 1862.

W. M. Rossetti, in his catalogue of Blake's works printed in Gilchrist's *Life*, described them disparagingly: 'These are rather small designs, having quite a sufficient measure of Blake's spirit in them, but much injured by the handiwork of Mrs Blake, the colour being untidy-looking and heavy, for the most part; crude where strength is intended. Two of the designs, at any rate, may be considered untouched by Mrs Blake.' It is true that their quality is uneven, and several have been retouched, sometimes clumsily, by a later hand; but others are well executed, this one being the best of all. Whether or not it was Mrs Blake who did the retouching is impossible to say.

Blake and Bunyan had much in common, not least their humble backgrounds and natural genius. But Bunyan's work is simpler and more direct in its appeal than Blake's esoteric symbolism, for which reason alone Bunyan achieved a contemporary fame denied to Blake. And Bunyan's Christian morality was far removed from Blake's views, expressed in such aphorisms as 'The Gospel is Forgiveness of Sins & has No Moral Precepts'. (K.395) Yet Blake was an ideal illustrator of Bunyan, for apart from such divergency of conclusions, each thought in a similar symbolic way; indeed it has been said that Blake's *Vision of the Last Judgment* (plate 47) was his *Pilgrim's Progress*.

In this watercolour, the only one certainly all by Blake, and not retouched, Christian, dressed in rags, has fled from the City of Destruction, and although bowed down by his burden, is reading his Bible. In the background are the city, a strip of woodland, a hill and a threatening and fiery sky. The drawing is very delicate, the figure of Christian especially being delineated with minute attention to anatomical detail; his anxious face is completely convincing. Stippling is used with great skill.

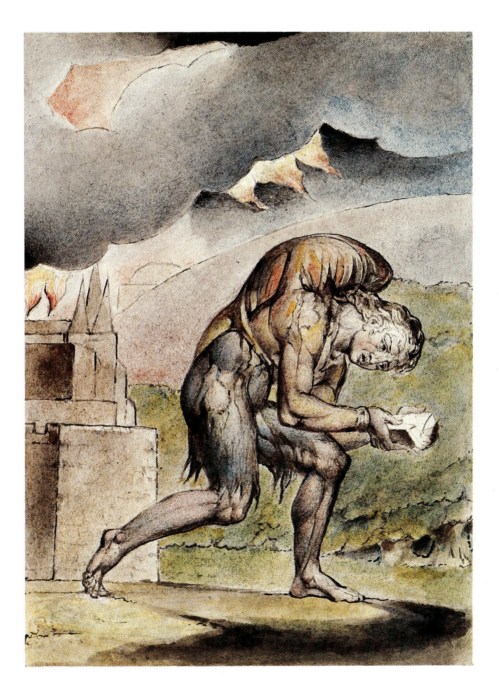

63. Two Preliminary Drawings for Thornton's *Virgil*

circa 1820

(i) The Blighted Corn

Pencil, pen and grey wash, 4.1 × 9.6 cm

Fitzwilliam Museum, Cambridge

(ii) 'Nor Fox, nor Wolf, nor Rat among our Sheep'

Pencil, pen and grey wash, 3.5 × 9.5 cm; sheet 3.8 × 9.8 cm

Beinecke Rare Book and Manuscript Library, Yale University, New Haven, Connecticut

John Linnell's family doctor, Dr Robert John Thornton, was also a well-known botanical and medical writer; among his many works were *The Temple of Flora* (issued in parts, 1787–1807), *A New Family Herbal* (1810) and *A Grammar of Botany* (1811). Linnell introduced Thornton to Blake in September 1818, and two years later Blake was working on engravings to illustrate the third edition of the doctor's book *The Pastorals of Virgil with a Course of English Reading adapted for Schools*, which appeared in 1821.

Blake's wood-engraved illustrations to Thornton's *Virgil* are among his happiest works (see plate 64), successfully capturing the mood of the First Eclogue, a dialogue between Thenot, a happy shepherd, and Colinet, an unhappy one, as translated by Ambrose Philips in Thornton's edition. The twenty preliminary drawings, many of which remain untraced since the 1930s, are delicate little studies, works of art in their own right. The two illustrated here are particularly attractive: the first, *The Blighted Corn*, is a scene of storm and eclipse; and in the second, *Nor Fox, nor Wolf*, a shepherd, with a dead sheep at his feet, rushes from his shelter, crook in hand, to chase a wolf which has taken a lamb; he is watched from behind a tree by a fox. The two drawings follow each other in the text and illustrate these lines:

THENOT

Sure thou in hapless hour of time wast born,
when blighting mildews spoil the rising corn,
or blasting winds o'er blossom'd hedge-rows pass,
to kill the promis'd fruits, and scorch the grass
or when the moon, by wizard charm'd, fore-shows,
blood-stain'd in foul eclipse, impending woes.
Untimely born, ill-luck betides thee still.

COLINET

And can there, THENOT, be a greater ill? –

THENOT

Nor fox, nor wolf, nor rat among our sheep:
from these good shepherd's care his flock may keep:
against ill-luck, alas! all forecast fails;
nor toil by day, nor watch by night, avails.

Philips' poetry has been dismissed by most critics; Samuel Johnson said he had 'added nothing to English poetry' and he was known to his contemporaries as 'Namby Pamby' from the pedestrian rhythm of his verse. But his First Pastoral at least had sufficient appeal to Blake to inspire some of his most attractive illustrations, and enabled him to open an aspect of his view of pastoral, apparent elsewhere only in some of his Job illustrations (see plates 68–70).

64. Four Wood-Engravings for Thornton's *Virgil*

circa 1820
Wood-engraving, 14.8 × 8.5 cm (irregular)
British Museum, London

The seventeen wood-engravings Blake made for Thornton's *Virgil* (see commentary to plate 63) were his only works in this medium, although he had earlier used a related technique on printer's metal, which he called wood-cutting on pewter.

Blake's wood-engravings are conceived in light and shadow, a completely different approach from that of his contemporary, the great wood-engraver Thomas Bewick, who composed in white lines. The poet Laurence Binyon well expressed the character of the *Virgil* blocks: 'Blake's conceptions in these illustrations did not take their final form in the drawings; they were only fully realised on the block itself. Hence they have the character of visions called up as if by moonlight out of the darkened surface of the wood, and seem to have no existence apart from it.'

There is a certain ambiguity in their technique. In conventional terms they are roughly executed: Blake's young disciple Edward Calvert said, 'They are done as if by a child; several of them careless and incorrect, yet there is a spirit in them, humble enough and of force enough to move simple souls to tears.' Their roughness has a certain gem-like quality, akin to that of early rough-hewn jewellery.

Powerful they certainly are. In the view of the young Samuel Palmer, 'They are visions of little dells, and nooks, and corners of Paradise; models of the exquisitest pitch of intense poetry . . . There is in all such a mystic and dreamy glimmer as penetrates and kindles the inmost soul, and gives complete and unreserved delight, unlike the gaudy daylight of this world.'

Thornton himself had considerable reservations about them and printed an apology when they were published: 'The Illustrations of this English Pastoral are by the famous BLAKE, the illustrator of *Young's* Night Thoughts, and *Blair's* Grave; who designed and engraved them himself. This is mentioned, as they display less of art than genius, and are much admired by some eminent painters.' This accompanied their appearance because some well-known artists, said to have included James Ward and Sir Thomas Lawrence, protested after Thornton had three of the designs re-engraved by a trade engraver. Although he was prevailed upon to let the rest stand, he still lacked confidence in them.

The proof reproduced here was taken from the block as first engraved by Blake. Afterwards the subjects were separated and thoughtlessly cut down so as to fit on the page, destroying much of their intensity.

65. Winter

circa 1820–5
Tempera on pine, 90.2 × 29.7 cm
Tate Gallery, London

This is one of three panels commissioned from Blake by the Rev. John Johnson, cousin of the poet William Cowper, whose miniature he painted in 1802 (plate 27). They were intended to decorate a fireplace in his house, Yaxham Rectory in Norfolk, though apparently they were never installed. The second panel is *Evening* (Private Collection, USA), and the third, now lost and probably destroyed, was a view of Olney Bridge, near Cowper's home. *Winter* and *Evening* were to stand, appropriately, on either side of the fireplace and *Olney Bridge* was to form a frieze above them. *Winter* and *Evening* illustrate passages from Cowper's poem *The Task*; that for *Evening* is from Book IV, ll. 243–60, and that for *Winter* from Book IV, ll. 120–9:

> Oh Winter, ruler of th' inverted year,
> Thy scatter'd hair with sleet like ashes fill'd,
> Thy breath congeal'd upon thy lips, thy cheeks
> Fring'd with a beard made white with other snows
> Than those of age, thy forehead wrapt in clouds,
> A leafless branch thy sceptre, and thy throne
> A sliding car, indebted to no wheels,
> But urg'd by storms along its slipp'ry way,
> I love thee, all unlovely as thou seem'st,
> And dreaded as thou art!

Blake makes Winter a sad Urizenic figure (see commentary to plate 5), but his painting is essentially a literal illustration of Cowper's lines. Winter's arms are crossed on his chest as if to contain his bodily warmth; his right hand holds his sceptre, 'a leafless branch', his left hand gathers his garment more closely to his breast. His 'sliding car, indebted to no wheels', presumably a sleigh, is curved around his feet, shaped like a crescent; his left (i.e. material) foot stands slightly forward on this.

Blake often refers to winter and to wintry things in his writings, and as early as 1783 he published in his *Poetical Sketches* a poem 'To Winter':

> O Winter! bar thine adamantine doors:
> The north is thine; there hast thou built thy dark
> Deep-founded habitation. Shake not thy roofs,
> Nor bend thy pillars with thine iron car.
>
> He hears me not, but o'er thy yawning deep
> Rides heavy; his storms are unchain'd, sheathed
> In ribbed steel; I dare not lift mine eyes,
> For he hath rear'd his sceptre o'er the world.
>
> Lo! now the direful monster, whose skin clings
> To his strong bones, strides o'er the groaning rocks:
> He withers all in silence, and in his hand
> Unclothes the earth, and freezes up frail life.
>
> He takes his seat upon the cliffs; the mariner
> Cries in vain. Poor little wretch! that deal'st
> With storms, till heaven smiles, and the monster
> Is driv'n yelling to his caves beneath mount Hecla. (K.2–3)

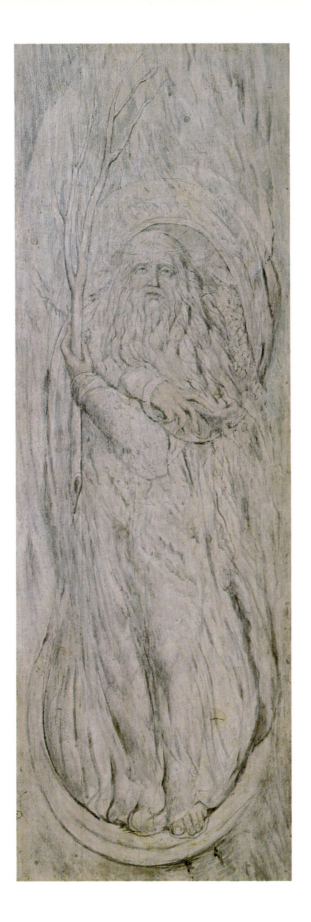

66. The Sea of Time and Space

1821

Pen, watercolour and body colour on a gesso ground on paper, 40 × 49.5 *cm*
The National Trust, Arlington Court, Devon

There is no general agreement on what this watercolour represents. The most convincing exegesis is by Kathleen Raine who, in *Blake and Tradition*, claims that it is based on Porphyry's treatise on Homer's 'cave of the nymphs' with additions from the *Odyssey* and from Platonic sources. She considers it a representation of the cycle of life, symbolised by the traveller leaving his native shore and later returning; or the cycle from eternity, through life, to eternity.

The red-robed figure with averted face and hands held out above the sea is Odysseus, who has just returned to his natal shore, near the cave of the nymphs in the cove of Phorcys the sea-god; Athena stands beside him. Odysseus' house is visible at the foot of the distant promontory. In the sea is Leucothea, the marine goddess, grasping a cloudy wreath above her head. This is the sea-girdle she lent Odysseus, which enabled him to arrive home in safety; he has thrown it back to her as she is driven away by her sea-horses.

Athena points to the scene in the sky, Helios the sun-god asleep in his chariot surrounded by celestial nymphs. At the right is a stairway to the cave, from which flow water and fire; on the stairway, nymphs holding shuttles weave on a loom. To the left a nymph lies on the ground holding a skein of wool above her head; another nymph unwinds this and passes it to the weavers, and to the right two nymphs take off the woven yarn. Other nymphs bear buckets, and yet another, at the foot of the stairway, lies asleep in the water on an overturned bucket. Farther up, beside the cave entrance, are two naked lovers and a naked nymph holding a hydria from which water is pouring. The three Fates and Phorcys lie in the water below Odysseus.

Odysseus symbolises man, and his return of Leucothea's sea-girdle represents the discarding of mortality. The water and flames issuing from the cave symbolise the flowing of life from its source in the cavern, which itself stands for the womb by which man enters generation. The Fates take the yarn of life from the loom of generation, measure it and cut it. The nymph pouring water symbolises the pouring of life from female energy. The buckets are symbols of spiritual knowledge: the bucket-bearing nymph at the base of the stairway is ascending towards the cave, but her way is barred by the weavers of the loom of generation. The sleeping nymph in the water is content to remain in generation.

This is only a summary of the Platonic interpretation of this watercolour, and it must be emphasised that other interpretations are possible; probably, as elsewhere in Blake, there are several layers of meaning.

The picture was hidden for many years, until it was discovered on the top of a cupboard in Arlington Court when that property was taken over by the National Trust in 1947; how it came to be there is not known.

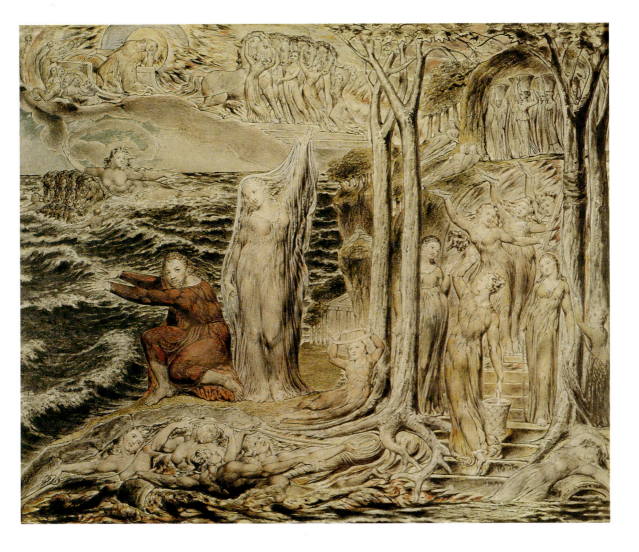

67. Moses placed in the Ark of Bulrushes

circa 1824 (?)
Pen and watercolour over pencil, 28.9 × 39.7 cm
Henry E. Huntington Library and Art Gallery, San Marino, California

When the Israelites were held in bondage in Egypt, an order went out to the Hebrew midwives that all male children were to be strangled at birth; so when Moses was born his parents used their ingenuity to ensure his survival, as described in *Exodus* II.1–4:

> And there went a man of the house of Levi, and took to wife a daughter of Levi.
> And the woman conceived, and bare a son: and when she saw him that he was a goodly child, she hid him three months.
> And when she could not longer hide him, she took for him an ark of bulrushes, and daubed it with slime and with pitch, and put the child therein; and she laid it in the flags by the river's brink.
> And his sister stood afar off, to wit what should be done to him.

Here Pharaoh's daughter came to bathe, and, as the parents of the child had hoped, she saw him and adopted him. By a trick, his mother was engaged as his nurse; and he was given the name of Moses, which means 'preserved from the waters'.

In Blake's interpretation of the event, the mother of Moses, fainting with grief, is supported by her husband, under the branches of a palm tree. The child floats on the River Nile among the flags (irises) in his ark, or basket, of bulrushes. Just beyond is a stepped wall with a sphinx on its lowest level; on the third step Moses' sister keeps watch. In the distance are two pyramids, a city and, among the buildings at the left, some brick-kilns – a reference to the bricks the Israelites were forced to make for their Egyptian taskmasters.

Blake may have seen in this subject a symbolic representation of the commencement of man's journey through generation; he may also have taken it (in accordance with traditional theology) as a 'type' or anticipation of the Holy Family's flight into Egypt. It could also have symbolised the survival of prophecy (Moses) amid superstition and materialism (the pyramids, the sphinx).

The composition was engraved for an illustration in the little gift-book *Remember Me! A New Year's Gift or Christmas Present*, published in 1825 by I. Poole for Dr R. J. Thornton (see commentary to plate 63), probably at the suggestion of Linnell. The engraving differs in some details from the watercolour, especially in its proportions: in the engraving only half of the pyramid at the left is shown, and there is less sky. In the watercolour the child is only indicated by light pencil lines, whereas in the engraving he is given form.

It has been suggested that Blake's inspiration for this work may have come from Poussin's painting *The Exposition of Moses* (Ashmolean Museum, Oxford), which was exhibited in London in 1798, when it was in the collection of the Duc d'Orléans.

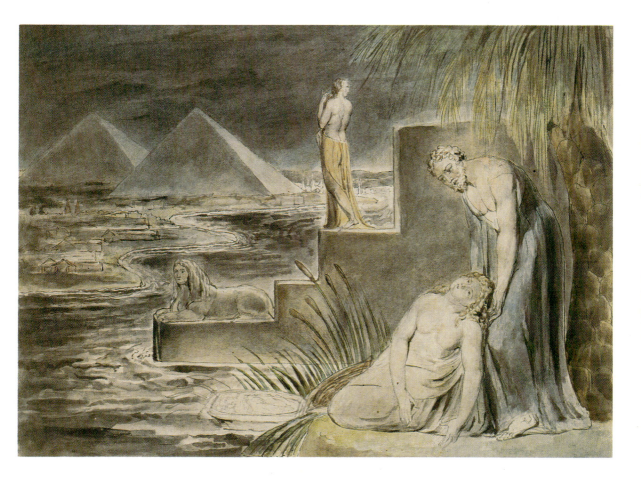

68. When the Morning Stars Sang Together

circa 1805–6
Pen and watercolour, 28 × 18.4 *cm*
Pierpont Morgan Library, New York

Blake made several sets of designs illustrating the Book of Job. One set of twenty-one watercolours, for Butts, was probably painted in about 1805–6, except for two subjects painted in the 1820s. A second set of twenty-one was made for Linnell in about 1821, and there are five sketches (in various collections) related to this set. There is also a sketchbook containing pencil sketches made in 1823, some lightly coloured, which were studies for the engraved series (see plate 70); they are now in the Fitzwilliam Museum, Cambridge. Another twenty-one watercolours, known as the 'New Zealand' set, are now generally thought to be copies by Linnell or his pupil Albin Martin, who emigrated to New Zealand, or by some other copyist.

Although these designs illustrate the biblical story of Job, they are more an expression of Blake's ideas. In the Bible Jehovah allows Satan to persecute Job as a test of his allegiance. In Blake's illustrations the conventionally religious Job passes from Innocence to Experience, and only regains Innocence by sacrificing his selfhood.

The design reproduced here (from the Butts set) follows *Job* XXXVIII.4–7, God's praise of his creation:

Where wast thou when I laid the foundations of the earth? declare, if thou hast understanding.
 Who hath laid the measures thereof, if thou knowest? or who hath stretched the line upon it?
 Whereupon are the foundations thereof fastened? or who laid the corner stone thereof;
 When the morning stars sang together, and all the sons of God shouted for joy?

The centre of the composition is occupied by the haloed Creator kneeling on his left knee, with his right (i.e. spiritual) foot in advance and his arm outstretched among clouds. Above, in the starry firmament of eternity, are angels (the morning stars) singing together, their wings spread behind them, and their arms uplifted. Below, in the area of time, the arms of God overspread, at left, Helios (Day) with his four horses, and at right, Selene (Night) with her dragons or serpents (these two figures were probably derived from antique gems). Below, in a cloud-encircled and cavernous space (generation), Job, in a pose reversing that of God, with his wife and friends – Eliphaz, Bildad and Zophar – kneel and look upwards in wonderment.

Here and throughout Blake's Job designs, God is depicted as having exactly the same form and appearance as Job, for God is seen as the 'Poetic Genius' or spirit of man: in other words Job (man), reversing Genesis, has made God in his own image.

Blake's source for the angelic frieze was probably an engraving of a relief at Persepolis in Vol. II of Bryant's *New System* (see commentary to plate 31). An engraving of a similar frieze at the Temple of Mithras Petraeus in Persia is in Vol. I.

In his recollections of Blake for Gilchrist's *Life*, Samuel Palmer mentioned that he 'asked him how he would like to paint on glass, for the great west window [in Westminster Abbey], his *Sons of God shouting for Joy*, from his designs in the *Job*. He said, after a pause, "I could do it!" kindling at the thought.'

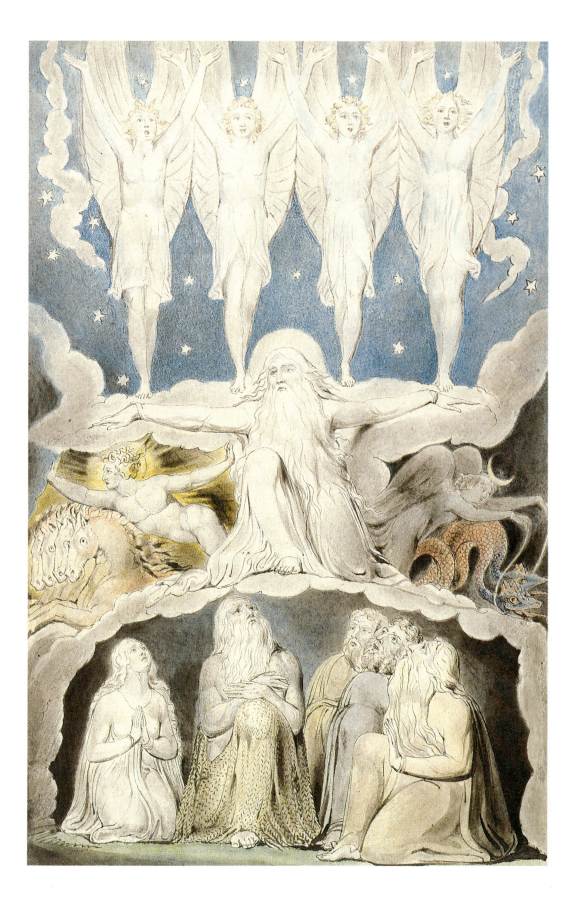

69. Job and his Family restored to Prosperity

1821

Pen and watercolour, 23.4 × 28 cm
National Gallery of Art, Washington, D.C. (Rosenwald Collection)

This is one of the watercolours from the set painted for Linnell (see commentary to plate 68); Blake borrowed Butts' set in order to try to obtain commissions for similar sets from other patrons, but only Linnell ordered one. This set is more richly coloured than the Butts set, and most of the designs are more freely handled. According to Linnell's journal, he traced the outlines from the Butts designs, and Blake finished and coloured them.

This design depicts the climax of the story: 'So the Lord blessed the latter end of Job more than his beginning' (XLII.12). In the first design of the series, Job and his family are seated at their evening devotions beneath a huge oak tree, for Blake a symbol of Error (see commentary to plate 26) and here linking Job's material prosperity with wrong ideas. Musical instruments, symbolising spontaneous praise, hang unused on the tree, for Job and his family are reading their devotions from books by mere habit. In this, the final design, the musical instruments have been taken down and are being played, and some members of the family sing praises from scrolls. On the sun, rising above the horizon at the right, is written, in Blake's hand: 'Great & Marvellous are thy Works Lord'. At the left a crescent moon rides in the sky near to a star; in the first design it was a waning moon. The symbolism is clear, for a waning moon denotes weakness and passivity, a crescent moon strength and energy. In the foreground are groups of sheep, tokens of the fourteen thousand sheep which, according to the biblical account, Job possessed in his second (spiritual) prosperity.

The musical aspect of the design has no counterpart in the biblical story, but is based on an apocryphal book, the *Testament of Job*. In this, Job, just before he died, instructed his daughters to praise God every day in music and song. It also claimed that Job knew the key to heavenly music, for which reason, in the Middle Ages, he was accepted as the patron saint of singers and musicians.

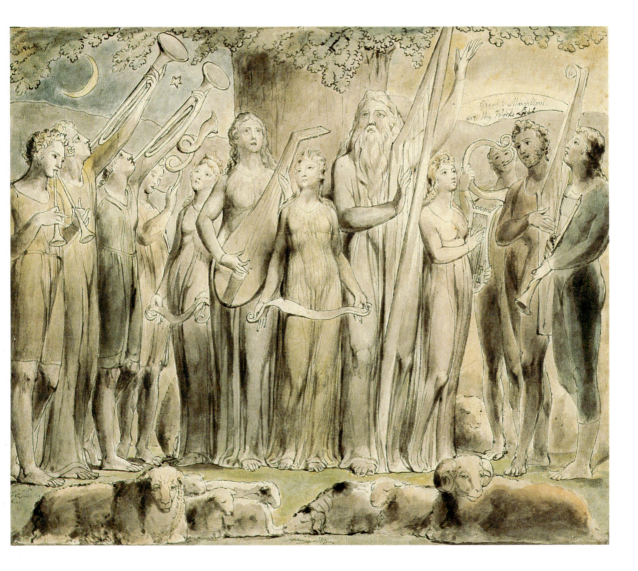

70. 'The Sons and the Daughters Were Eating and Drinking . . .'

1825
Line engraving with stipple and etching, 19.7 × 15.2 cm
Private Collection, England

Linnell was so impressed by Blake's *Job* designs that he commissioned a set of engravings from him:

Memorandum of Agreement between William Blake
and John Linnell March 25th 1823 –

W. Blake agrees to Engrave the Set of Plates from his own Designs of Job's Captivity in number twenty, for John Linnell – and John Linnell agrees to pay William Blake five Pounds pr Plate or one hundred Pounds for the set part before and the remainder when the Plates are finished, as Mr Blake may require it, besides which J. Linnell agrees to give W. Blake one hundred pounds more out of the Profits of the work as the receipts will admit of it.

Signed J. Linnell Will^m Blake

N.B. J.L. to find Copper Plates.

1823 March 25th

Cash on acc! of Plates in the foregoing agreement £5–0–0

W.B.

These engravings are considered by many to be Blake's masterpieces, but they realised no profit for Linnell for many years. Yet he paid Blake £150 for them – half as much again as the agreed price, and a more generous sum than Blake had ever received for such a commission. The money was paid to him in weekly amounts, which provided him with a steady income while the work progressed. Early subscribers included King George IV.

The third illustration of the series, reproduced here, shows Satan wreaking havoc on Job's children and the house of his eldest son; it is the beginning of Job's misfortunes. The bat-winged Satan has assailed the house, and exultingly squats above it. The building is completely devastated by smoke, fire and lightning. The sons and daughters have been struck down, and some are already dead; the corpse of one young woman at the front lies with her feet resting on a tambourine and her left hand on a lyre. The eldest son, in the centre of the confusion, like a struggling Laocoön, strives to hold a young child aloft and to pull one of the women from the flames; all in vain, for they too will soon be destroyed.

The marginal design adds a number of glosses to the scene. Clouds of smoke and tongues of fire rise from an altar, with scaly forms on each side; at the base of the altar are scorpions with flames behind them. There are also three inscriptions: 'The Fire of God is fallen from Heaven' (*Job* I.16); 'And the Lord said unto Satan Behold All that he hath is in thy Power' (I.12); 'Thy Sons & Thy Daughters were eating & drinking Wine in their Eldest Brothers house & behold there came a great wind from the Wilderness & smote upon the four faces of the house & it fell upon the young Men & they are Dead' (I.18–19).

The smoke and fire from the altar refer to the first of these inscriptions; the scaly forms signify materialistic values and are a reminder of the dangers of merely formal religion. Scorpions are traditional symbols of envy and hatred.

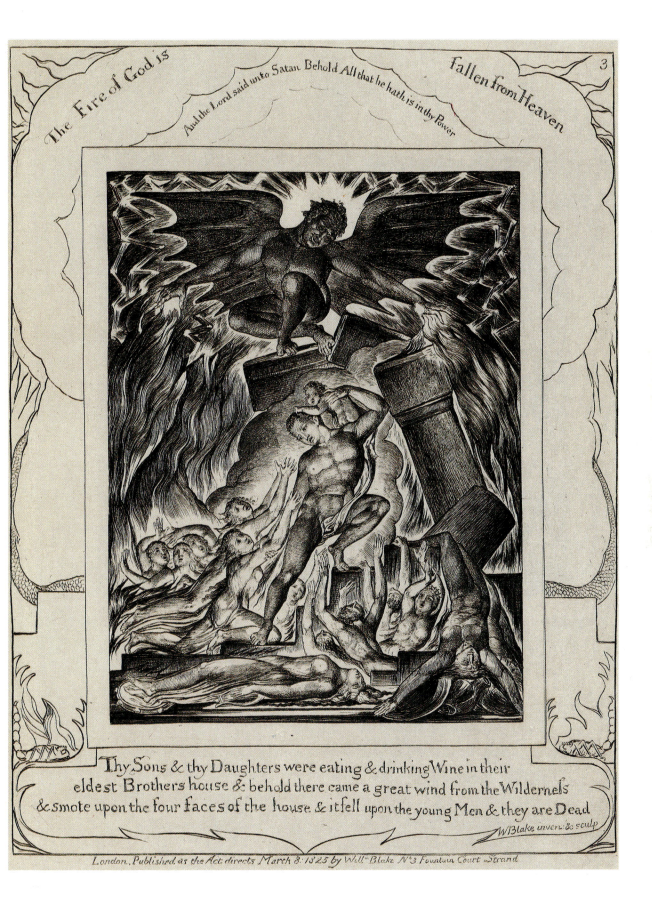

The Fire of God is And the Lord said unto Satan Behold All that he hath is in thy Power Fallen from Heaven

Thy Sons & thy Daughters were eating & drinking Wine in their
eldest Brothers house & behold there came a great wind from the Wilderness
& smote upon the four faces of the house & it fell upon the young Men & they are Dead

WBlake inven: & sculp

London, Published as the Act directs March 8: 1825 by Will.m Blake N.o 3 Fountain Court Strand

71. The Virgin and Child

1825 (?)
Tempera and gold on mahogany, 30.5 × 23.9 cm
Collection of Mr and Mrs Paul Mellon, Upperville, Virginia

'The Black Madonna', as this picture is sometimes called, because of its dark colouring – what W. M. Rossetti called its 'Byzantine appearance' – is one of Blake's finest temperas. Some have questioned the date, 1825, which appears above Blake's signature at the lower right corner, and consider that this might have been a mistake by a restorer, or even that, for some unexplained reason, Blake post-dated it. If these doubts have foundations, the picture probably belongs to a date somewhere between 1809 and 1820. (See also commentary to plate 50.)

It is the most moving of Blake's ikon-like representations (compare plate 50). Against a starry firmament the Madonna, with thorn-like rays surrounding her halo, sits with her hands raised in blessing, and with tears coursing down her cheeks. The infant Jesus rests on her lap, his hands similarly raised, and his halo similarly surrounded by thorn-like rays, but here reinforced by flame-red lights. The paint is thickly applied and a large amount of gold has been used, which makes the picture glow.

Here Blake has created a work that bears comparison with some Madonnas of masters of the trecento and quattrocento. But by showing the Madonna in tears and with reference in the two haloes to the crown of thorns, Blake added a tragic dimension to the work, presenting in the young mother a vision of the older *Mater Dolorosa*.

In this painting Blake shows a different aspect of Mary from that in *The Nativity* (see commentary to plate 23), unfolding another layer of meaning. Mary is no longer the frail young human girl depicted there, but the mother of Jesus the Saviour of Man. In Blake's view, it was unnecessary for her to have been a virgin. Her holy mission was in no way affected by her past, whatever it was, and in this devotional picture he depicted her as a human being, a state that to him was as holy as that assigned to her by the most devoted believer in the Blessed Virgin Mary:

> Thou art a Man, God is no more,
> Thine own Humanity learn to Adore. (K.750)

In any case complete consistency should not be expected from Blake or from his art, for his opinions and thoughts went through many variations and even contradictions throughout his life. As he wrote in *The Marriage of Heaven and Hell*: 'The man who never alters his opinion is like standing water, & breeds reptiles of the mind.' (K.156)

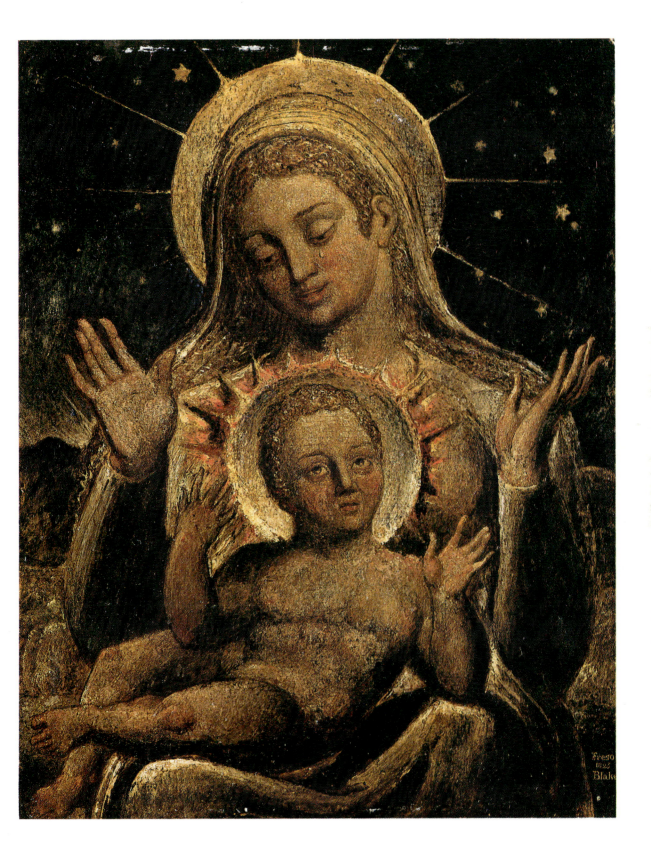

72. Count Ugolino and his Sons in Prison

circa 1826
Pen, tempera and gold on panel, 32.7 × 43 cm
Fitzwilliam Museum, Cambridge

An episode from *Inferno* Canto XXXIII in Dante's *Divine Comedy*. Ugolino de' Gherardeschi (died 1289) was a Guelph leader who twice (1284 and 1288) became master of Pisa by treachery. He was at last overthrown and imprisoned with two of his sons and two grandsons in the tower of a gaol. The door of their cell was nailed up and they were left to starve to death.

This tempera is based on a pencil drawing in the Dante series executed for Linnell (see plates 59–61). The composition is almost completely symmetrical, being basically one triangle inside another. The colouring is gem-like and the technique a closely worked stipple, approaching miniature.

Ugolino, who is of Urizenic type (see commentary to plate 5), sits at the centre in front of the door of the stone cell, with his knees drawn up to his chest. His arms encircle the shoulders of his two grandsons, Anselmuccio and Nino il Brigata, who sit at his side in similar poses. The old man stares ahead with horror, as does the grandson at his left; the other grandson appears more resigned. Ugolino's two sons, Gaddo and Ugoccione, sit at each side on the stone floor, with every sign of exhaustion. Above, two angels hover in divine light.

The Blakean interpretation of this scene is centred on the tryant Ugolino (Urizen), who finds his soul imprisoned in the stone cell (the fallen world), a situation he has brought upon himself by his tryanny (Urizen's restrictive laws). The hovering angels are a reminder that despite apparently hopeless situations, man can still commune in spirit with the love and forgiveness of God.

It was probably this tempera to which Blake referred in a letter to John Linnell dated 25 April 1827: 'As to Ugolino, &c, I never supposed that I should sell them; my Wife alone is answerable for their having Existed in any finish'd State. I am too much attach'd to Dante to think much of anything else.' (K.879)

Blake made several other studies of this subject, including a pencil sketch in his Notebook (Rossetti MS, British Museum), and a pencil drawing in the Victoria and Albert Museum, London. It was also used on plate 12 of his line-engraved emblem book *The Gates of Paradise* (1793, reissued in 1805), where it is inscribed, 'Does thy God, O Priest, take such vengeance as this?' (K.209, 768)

In *The Marriage of Heaven and Hell*, at the head of plate 16, there is an illustration closely resembling the Ugolino composition, showing an old bearded man with two figures on each side huddled against him and hiding their faces. However, the subject is different, as the figures represent 'The Giants who formed this world' (K.155), in other words, the five senses of man.

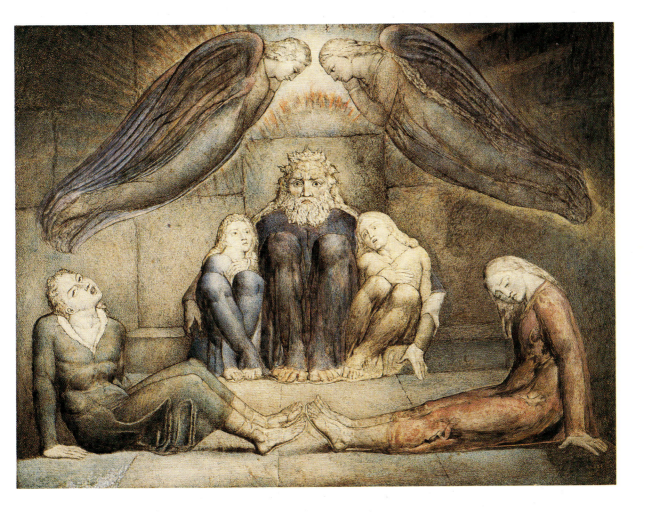

73. The Body of Abel found by Adam and Eve

circa 1826
Pen and tempera, in places over gold, on mahogany, 32.5 × 43.3 cm
Tate Gallery, London

Like the Ugolino panel (plate 72), this tempera is realised in gem-like colours and fine stipple. It was based on an earlier version in pen and watercolour, exhibited as no. XI in Blake's 1809 exhibition (now in the Fogg Art Museum, Harvard University, Cambridge, Massachusetts). Yet another version of the same composition, a small indian-ink drawing (now in the Fitzwilliam Museum, Cambridge), was in the collection of Sir Geoffrey Keynes. He believed it to be a design for a proposed, but unexecuted, plate for the annual *Remember Me!* (see commentary to plate 67), which however ceased publication after the 1825 edition (this was reissued with a new calendar for 1826, but the rest of the book remained unaltered); others think it is a replica by Linnell.

Adam, his arms outstretched in horror, kneels beside the corpse of Abel, and Eve bows over it in grief, her hands caressing the head. Cain, who has slain his brother and dug a grave in which to bury him, prepares to run away, tearing his hair, horrified at what he has done. A red mark is on his forehead: 'And the Lord set a mark upon Cain' (*Genesis* IV.15). A range of blue hills reaches to the horizon and the angry sky, blue-green and orange, is blackened with rolling clouds while others bar the face of the sullen sun. There are flames to the left of the sun, which indicate the presence of Jehovah.

In 1822, Blake etched his two-page verse drama, *The Ghost of Abel*, which is in many ways a literary forerunner of this panel. The scene is 'A rocky Country. Eve fainted over the dead body of Abel, which lays near a Grave. Adam kneels by her. Jehovah stands above.' The ghost of Abel calls to Jehovah, demanding 'Life for Life!' and declares

> . . . My Soul in fumes of Blood
> Cries for Vengeance, Sacrifice on Sacrifice, Blood on Blood!

He sinks into his grave, from which arises Satan, who demands 'Human Blood & not the Blood of Bulls or Goats' without atonement. The Elohim Jehovah of the heathens supports this, promising

> . . . Eternal Death
> In Self Annihilation, even till Satan, Self-subdu'd, Put off Satan
> Into the Bottomless Abyss . . .

The drama ends with a chorus of angels singing in praise of Elohim Jehovah of the Christians, who at last triumphs in the power of the creative human imagination:

> The Elohim of the Heathen Swore Vengeance for Sin! Then Thou stood'st
> Forth, O Elohim Jehovah! in the midst of the darkness of the Oath, All Clothed
> In Thy Covenant of the Forgiveness of Sins: Death, O Holy! Is this Brotherhood.
> The Elohim saw their Oath Eternal Fire: they rolled apart trembling over The
> Mercy Seat, each in his station fixt in the Firmament by Peace, Brotherhood and Love.

(K.780–1)

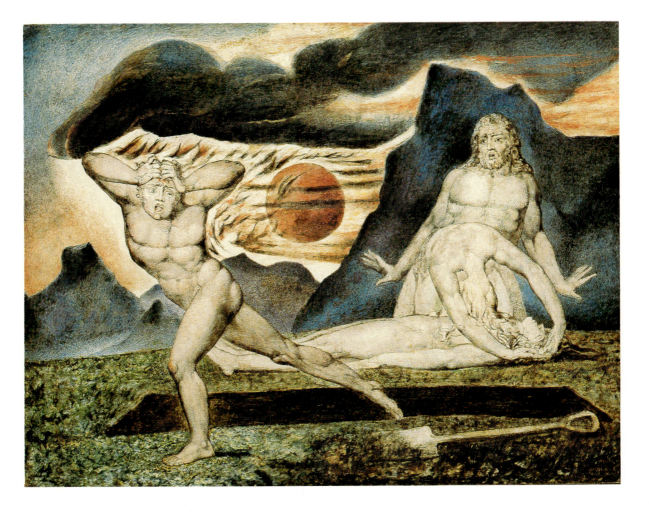

74. The Second Title Page to an Illustrated Copy of *Genesis*

circa 1826–7
Pencil, pen, watercolour and gold, 38 × 28 cm
Henry E. Huntington Library and Art Gallery, San Marino, California

In 1827 Blake began work on an illuminated Book of Genesis for John Linnell; he died during August of that year, leaving it unfinished. It occupies eleven leaves, worked on one side only, of which two are alternative title pages; that reproduced here is the second, which is the more complete. On those pages on which Blake had written a fair copy of the text, he had used Gothic lettering, and it seems obvious that he intended to make an illuminated manuscript of a more or less traditional type.

On the title page reproduced here the letters are arranged in three lines, one above the other: GE/NE/SIS, the I in the final line covering the loins of the central figure, who is probably intended to represent Adam; he is reaching up with his right hand to receive a scroll – a token of the divine mercy – from Jesus, who stands at the left with his arms outstretched in a sacrificial gesture, as if crucified. He stands with his left foot forward, probably indicating that he is present in the body. At the right is a patriarchal figure who, it has been suggested, may be Elijah, but who is more probably a representation of Jehovah. Along the base of the design are the four living creatures, or the four Evangelists; from left to right, the man (St Matthew), the eagle (St John), the lion (St Mark) and the bull (St Luke). The tree at the left is the tree of knowledge of good and evil, from which Eve plucked the apple; the one at the right is an oak tree, symbolising Natural Religion and Error (see commentary to plate 26). The running figure lightly indicated at the top of the design is difficult to identify, but the most likely explanation is that it represents the energy released by the act of creation.

The letters also carry a number of symbols. The three blooms hanging over the base of the G are probably flowers of the sacred lotus. At their left is an ear of corn, and at their right a stook of corn, denoting prosperity. Beside it, the letter E is decorated with roses, and a snake is spiralled around the upright; taken together these symbolise Eve's fall into temptation (the snake) and the suffering that resulted from it (the thorned roses, symbols of martyrdom). The letter N is decorated with a blue lotus, a symbol of creation in Hindu myths, with some at least of which Blake was familiar (see commentary to plate 36). The second E, at its side, is decorated with a rose-coloured Turk's cap lily, and as in the first E, a snake is entwined around its vertical. This flower was known as the Lily of Calvary and perhaps Blake had that in mind, and used the snake to symbolise the materialism overthrown by the Crucifixion. The two letters S are formed of grass and corn and the I is decorated to suggest a column.

75. The Ancient of Days

1827

Relief etching finished in gold, body colour and watercolour, 23.4 × 16.8 cm (approx.)
Whitworth Art Gallery, Manchester

The Ancient of Days or *God creating the Universe* is the frontispiece to Blake's prophetic book *Europe* (1794). The impression reproduced here is that which Blake coloured on his deathbed for Frederick Tatham, who recalled the occasion in his 'Life of Blake', written in about 1832 but first published in A. G. B. Russell's edition of *The Letters of William Blake* (1906):

> Life however like a dying flame flashed once more, gave one more burst of animation, during which he was cheerful, & free from the tortures of his approaching end. *He* thought he was better, and as he was sure to do, asked to look at the Work over which he was occupied when seized with his last attack: it was a coloured print of the Ancient of Days, striking the first circle of the Earth, done expressly by commission of the writer of this. After he had worked upon it he exclaimed 'There I have done all I can; it is the best I have ever finished. I hope Mr Tatham will like it.'

The design shows the Elohim, as Urizen, leaning from a heavenly globe between clouds, with his hair and beard blowing in a cosmic wind. He reaches down into the void with his left arm, holding dividers so as to place, by his act of creation, a limit or measurement on the world. It refers to a passage in the 'Preludium' of *Europe* containing the line 'And who shall bind the infinite with an eternal band?'. (K.239) And it recalls lines from Blake's *First Book of Urizen*, also published in 1794:

> And Urizen . . .
> . . . formed golden compasses,
> And began to explore the Abyss. (K.233–4)

It is probable that Blake's source for these passages was *Paradise Lost* VII, 225–7:

> He took the gold'n Compasses, prepar'd
> In God's Eternal store, to circumscribe
> This Universe, and all created things . . .

Blake's visual source, however, appeared to him in one of his visions, as related by his contemporary J. T. Smith in the second volume of *Nollekens and his Times* (2nd edn, 1829):

> He was inspired with the splendid grandeur of this figure, by the vision which he declared hovered over his head at the top of his staircase; and he has been frequently heard to say, that it made a more powerful impression upon his mind than all he had ever been visited by. This subject was such a favourite with him, that he always bestowed more time and enjoyed greater pleasure when colouring the print, than anything he ever produced.

As we have seen (commentary to plate 12), Blake considered the act of creation as Error; nevertheless it was a tremendous, unparalleled act, and this is fully conveyed in his presentation. In 1947 the design was used for the act-drop of the ballet *Job* by the Sadler's Wells Ballet; Sir Geoffrey Keynes, who wrote the 'book' of the ballet, commented that 'its magnificence was not lost when it was enlarged to a height of thirty feet'.

A rough pencil sketch of the composition is in Blake's Notebook (Rossetti MS, British Museum).

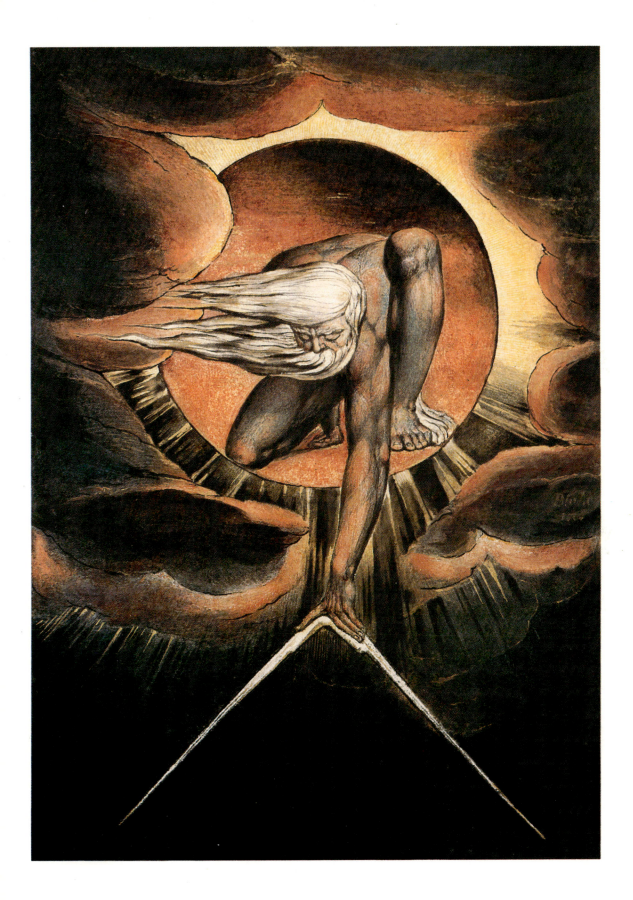

Suggestions for Further Reading

The literature on Blake is vast: Bentley in *Blake Books* lists over 2000 items issued before 1972 and hundreds published thereafter. This list provides only an introduction to what is available.

Bentley, G.E., jr. *Blake Books*, Oxford, 1977
 Blake Records, Oxford, 1969
 William Blake's Writings, 2 vols., Oxford, 1978
Bindman, David. *Blake as an Artist*, Oxford, 1977
 The Complete Graphic Works of William Blake, London, 1978
 William Blake: His Art and Times, London, 1982
Bishop, Morchard. *Blake's Hayley*, London 1951
Blake: An Illustrated Quarterly, ed. Morton D. Paley, Alberquerque, N.M., 1970—
Blunt, Anthony. *The Art of William Blake*, London, 1959
Butlin, Martin. *The Paintings and Drawings of William Blake*, 2 vols., New Haven and London, 1981
Damon, S. Foster. *A Blake Dictionary*, Providence, R.I., 1965
Davis, Michael. *William Blake: A New Kind of Man*, London, 1977
Erdman, David V. *Blake: Prophet against Empire*, Princeton, N.J., 1954
 The Illuminated Blake, New York, 1974
 The Poetry and Prose of William Blake [with commentary by Harold Bloom], Garden City, N.Y., 1965
 William Blake's Designs for Edward Young's 'Night Thoughts', 2 vols., Oxford, 1980
Essick, Robert N. *William Blake Printmaker*, Princeton, N.J., 1980
 The Visionary Hand, Los Angeles, 1973
 and Paley, Morton D. *Robert Blair's 'The Grave' Illustrated by William Blake*, London, 1982
Frye, Northrop. *Fearful Symmetry*, Princeton, N.J., 1947
Gilchrist, Alexander. *Life of William Blake*, 1863, ed. Ruthven Todd, London, 1942
Johnson, Mary L. and Grant, John E. *Blake's Poetry and Designs*, New York and London, 1979
Keynes, Geoffrey. *A Bibliography of William Blake*, New York, 1921 (repr. 1969)
 Blake Studies, London, 1949 (rev. Oxford, 1971)
 The Complete Writings of William Blake, Oxford, 1966
 William Blake: Poet, Printer, Prophet, London, 1964
Lindberg, Bo. *William Blake's Illustrations to the Book of Job*, Åbo, 1973
Lister, Raymond. *British Romantic Art*, London, 1973
 Infernal Methods: A Study of William Blake's Art Techniques, London, 1975
 William Blake, New York and London, 1968

Paley, Morton D. *Energy and the Imagination*, Oxford, 1970
 William Blake, London, 1978
Raine, Kathleen. *Blake and Tradition*, 2 vols., London, 1969
 The Human Face of God: William Blake and the Book of Job, London, 1982
 William Blake, London, 1951
Roe, Albert S. *Blake's Illustrations to the Divine Comedy*, Princeton, N.J., 1953
Tayler, Irene. *Blake's Illustrations to the Poems of Gray*, Princeton, N.J., 1971
Todd, Ruthven. *William Blake the Artist*, London, 1971
Wilson, Mona. *The Life of William Blake*, London, 1927 (rev. ed. Geoffrey Keynes, London, 1971)

Facsimiles

There are many facsimiles of Blake's illuminated books, and some of his other works. Most of them are expensive limited editions, but can be consulted in public and museum libraries. Notable are those issued by the William Blake Trust (since 1951). Of especial interest is the facsimile of pages from *Songs of Innocence and of Experience* produced and published by the Manchester Etching Workshop (1983). This was printed from electrotypes in the Victoria and Albert Museum, London, which were made from Blake's original plates, now lost. It was coloured by hand, in watercolours made from eighteenth-century recipes, in exact imitation of a copy of the book in the British Museum. It is accompanied by a study by Joseph Viscomi, 'The Art of William Blake's Illuminated Prints'.

Other facsimiles and publishers of them include:

Bogen, Nancy, ed. *The Book of Thel*, Brown University Press, Providence, R.I., 1971
Easson, Kay P. and Roger R., eds. *The Book of Urizen* and *Milton*, Shambhala Publications in association with Random House Inc., New York, 1978, and Thames and Hudson, London, 1979
Keynes, Geoffrey, ed. *Songs of Innocence and of Experience*, Rupert Hart Davis Ltd, London, 1967
 The Marriage of Heaven and Hell, Oxford University Press, London, 1975
The American Blake Foundation (since 1974)
Dover Publications Inc. (including *America* and *Europe* in one vol.) (since 1974)
Ernest Benn Ltd (c. 1926–7)
J. M. Dent & Sons Ltd (1927–37)

Some hand-coloured and uncoloured facsimiles were published during the nineteenth century and early in this century, but they are now rare, and many of them have less value for the study of Blake than those produced more recently.